THE
MEDIUM-FORMAT
MANUAL

THE
MEDIUM-FORMAT
MANUAL

A COMPREHENSIVE GUIDE TO SELECTING AND USING ROLL-FILM CAMERAS AND EQUIPMENT

MICHAEL FREEMAN

A FIRESIDE BOOK
PUBLISHED BY SIMON & SCHUSTER INC.
NEW YORK LONDON TORONTO SYDNEY TOKYO

THE MEDIUM-FORMAT MANUAL
MICHAEL FREEMAN

Edited and designed by Mitchell Beazley
International Ltd, Artists House, 14-15 Manette
Street, London W1V 5LB.

Editor Simon Ryder
Art Editor Mike Brown
Production Ted Timberlake
Executive Editor Robert Saxton

A Fireside Book
Published by Simon & Schuster Inc.
Simon & Schuster Building
Rockefeller Center, 1230 Avenue of the
Americas, New York, New York 10020

FIRESIDE and colophon are registered
trademarks of Simon & Schuster Inc.

First published in Great Britain in 1988 by
Mitchell Beazley Publishers, London.

10 9 8 7 6 5 4 3 2 1

**Library of Congress Cataloging in
Publication Data**

Freeman, Michael, 1945–
 The medium-format manual.

 "A Fireside book."
 Bibliography: p.
 Includes index.
 1. Medium format cameras. I. Title.
TR257.F74 1988 770'.28'22 88-18543
ISBN 0-671-67061-1 (pbk.)

The publishers have made every effort to ensure
that all instructions given in this book are
accurate and safe, but they cannot accept liability
for any resulting injury, damage or loss to either
person or property whether direct or
consequential and howsoever arising.

The author and publishers will be grateful for any
information which will assist them in keeping
future editions up to date.

Typeset by Servis Filmsetting Ltd, Manchester,
England.
Color reproduction by Colourscan, Singapore.
Printed and bound in Spain by Graficromo S.A.,
Córdoba.

CONTENTS

INTRODUCTION

Compared with 35mm cameras, medium-format offers a significant gain in image size; compared with large-format view cameras, it offers greater ease of handling. It is precisely this balance of image size with convenience of use that is the basis for the format's popularity among discerning photographers.

The course of camera technology has been one of miniaturization: squeezing ever better image quality out of each square inch of film. Plate and sheet film (for view cameras) had long been the established format when roll-film was introduced with the first Kodak camera in 1888. It was a major breakthrough: for the first time a series of frames could be carried on one length of film, thus speeding up the rate at which photographs could be taken. When 35mm sprocketed film was introduced in the 1920s, its reduced size, together with the easier transport system enabled by the sprockets, rapidly made it popular. Small-format 110 cartridge film has since established itself as the format for the casual amateur. This process has been one of diversification rather than rigidly linear evolution: each film type, instead of being superseded by the next development, has acquired a special area of use.

The current ascendancy of 35mm film for serious amateurs and many professionals depends on familiarity. Most photographers work with nothing else, and so they miss the opportunity to see just how good image quality can be. The larger the image on film, the less enlargement it needs to produce the finished photograph. It reduces the overlay of grain that breaks up smooth tones, and the slight softness of detail that marks the limits of resolution. Medium-format photography offers the possibility of truly sharp images – ones in which the detail goes deeper than the eye can distinguish.

The other principal benefit for the medium-format user is the wide range of film formats and camera types to choose from. You can select a system that is perfectly tailored to your requirements as a photographer – whether your main interest is landscape, still-life, portraiture, architecture, wildlife or something more specialized.

EQUIPMENT

Apart from the straightforward difference in scale, several factors distinguish medium-format cameras from their 35mm counterparts. Most obvious of these are the greater diversity among makes and the choice of frame sizes.

In 35mm photography, camera design has converged, and one camera make handles much like another. However, in the medium-format market the opposite process has happened – one of diversification. This reflects the professional appeal of the equipment. These cameras are produced in fewer numbers than 35mm cameras and are sold to photographers who are, on the whole, knowledgeable, and specific in their demands. There is little pressure in the market to conform to other manufacturers' standards. This diversity can be puzzling: if you are choosing a medium-format system, the differences you need to think about are *major*.

Not only is the equipment diverse: to complicate matters further there is not even one fixed frame size. The traditional format is $2\frac{1}{4} \times 2\frac{1}{4}$in/6x6cm, but the range is from $1\frac{3}{4} \times 1\frac{3}{4}$in/ 4.5x4.5cm to $2\frac{1}{4} \times 6\frac{11}{16}$in/6x17cm (greater, if you include motorized panoramic cameras). This is not just a choice between makes of camera that offer different frames: the point is that most systems have interchangeable film magazines in a range of frame sizes.

Interchangeable magazines allow you to switch from one frame size to another. Even more important is the choice of film type that they offer. It is a straightforward matter to shoot two, or even three different film stocks at the same time, such as color transparency and black-and-white. This is much easier than using a second body, which would be the 35mm way of doing things, as the body and lens can stay in position with all the settings unchanged. Interchangeable magazines also have the advantage of allowing you to test the shot on instant film, with a Polaroid back.

In the medium-format market, there are no independent producers of lenses or accessories: this is the other crucial difference from 35mm. It is therefore especially important to choose your system carefully. There is no possibility of adding to the manufacturer's range. Before making your choice, it is worth making a careful comparison of what is available in each system. To facilitate such a comparison is the main purpose of this first section of the book. A comparative summary of equipment is provided in chart form on the following pages.

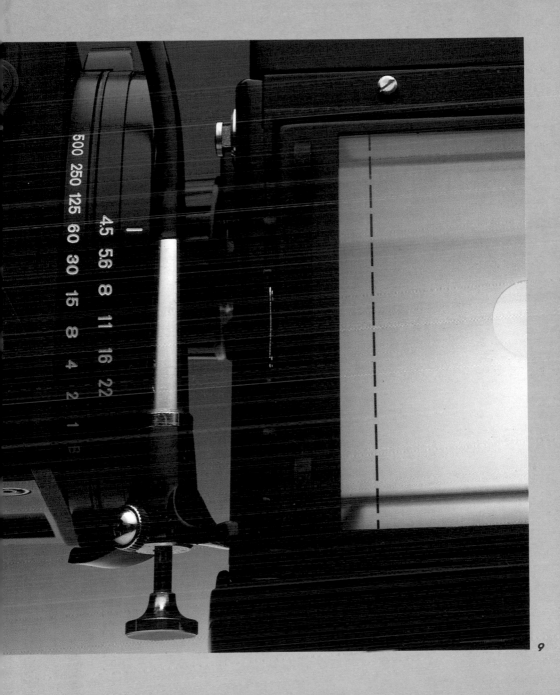

CAMERA CHART

As a condensed summary of the model-by-model review that follows, all the cameras are compared here, in a chart. I have used both frame size and basic design to classify the models. The main frame sizes are $2\frac{1}{4} \times 2\frac{1}{4}$in/ 6x6cm (Sq), $2\frac{1}{4} \times 2\frac{3}{4}$in/6x7cm (I) and $2\frac{1}{4} \times 3\frac{1}{4}$in/6x9cm (Ex). A more recent frame size, which represents a distinct sub-group, is the $1\frac{3}{4} \times 2\frac{1}{4}$in/ 4.5x6cm format, usually referred to as 645. When considering the basic design, there are major operational and handling differences between the most common SLR waist-level construction (which can usually be used at eye-level as well), the SLR eye-level models, rangefinders, viewfinders and twin-lens reflexes. In addition, the choice of lenses really needs to be considered at the point of buying the camera – with no independent lens manufacturers, you are limited to what the camera manufacturer produces.

Key

Acc: Accessory
AP: Aperture priority metering
B-I: Built-in
Cur. Curved end
D-B: "Double-back"
Ex: $2\frac{1}{4} \times 3\frac{1}{4}$in/6x9cm
F-P: Focal-plane
Hel: Helicoid
I: $2\frac{1}{4} \times 2\frac{3}{4}$in/6x7cm
Ins: Insert only
Iv: $2\frac{3}{4} \times 2\frac{1}{4}$in/7x6cm
L-S: Leaf-shutter
L-T: Lazy-tong
Mot: Motorized
OTF: Off-the-film
Pan 35mm: $1\frac{3}{4} \times 2\frac{1}{8}$in/ 24x54mm
PX 35mm: $1\frac{3}{4} \times 2\frac{3}{4}$in/ 24x69mm
R&P: Rack and pinion

S-P: "Straight path"
SP: Shutter priority metering
Sq: $2\frac{1}{4} \times 2\frac{1}{4}$in/6x6cm
SS: $1\frac{3}{4} \times 1\frac{3}{4}$in/ 4.5x4.5cm
TTL: Through-the-lens
V: Vertical
Var: Variable
+/-: Over- under-exposure monitor
35mm: $1\frac{7}{8} \times 1\frac{1}{4}$in/ 24x36mm
612: $2\frac{1}{4} \times 4\frac{3}{4}$in/6x12cm
617: $2\frac{1}{4} \times 6\frac{11}{16}$in/ 6x17cm
645h: $1\frac{3}{4} \times 2\frac{1}{4}$in/ 4.5x6cm
645v: $2\frac{1}{4} \times 1\frac{3}{4}$in/ 6x4.5cm
68: $2\frac{1}{4} \times 3$in/6x8cm

Model	Basic format	Other formats	No. of lenses	Standard lens
SLR WAIST-LEVEL				
1 Hasselblad 500C/M	Sq	Sq, 645v, 645h, SS	15	80mm f2.8
2 Hasselblad 500ELX	Sq	Sq, 645v, 645h, SS	15	80mm f2.8
3 Hasselblad 2000FCW	Sq	Sq, 645v, 645h, SS	6	80mm f2.8
4 Mamiya RB67	I	Iv, 645v	11	90mm f3.8
5 Mamiya RZ67	I	Iv, 645v	13	90mm f3.5
6 Rolleiflex SL66X	Sq	645h	14	80mm f2.8
7 Rolleiflex SL66SE	Sq	645h	14	80mm f2.8
8 Rolleiflex 6006	Sq	645h	15	80mm f2.8
9 Rollieflex 6002	Sq	645h	15	80mm f2.8
10 Bronica SQ-A	Sq	645h, 35mm, Pan 35mm	11	80mm f2.8
11 Bronica SQ-Am	Sq	645h, 35mm, Pan 35mm	11	80mm f2.8
12 Bronica GS-1	I	Sq, 645h, 645v, 35mm, PX 35mm	8	100mm f3.5
13 Fuji GX680	68	86	9	135mm f5.6
SLR EYE-LEVEL				
14 Pentax 6x7	I	–	18	90mm f2.8
15 Exacta 66	Sq	–	12	80mm f2.8
SLR 645				
16 Mamiya M645 1000S	645h	35mm	20	80mm f2.8
17 Mamiya M645 SUPER	645h	35mm	20	80mm f2.8
18 Pentax 645	645h	–	12	75mm f2.8
19 Bronica ETRS	645h	35mm, Pan 35mm	12	75mm f2.8
RANGEFINDER				
20 Fuji GW690II	Ex	–	1	90mm f3.5
21 Fuji GSW690II	Ex	–	1	65mm f5.6
22 Fuji GW670II	I	–	1	90mm f3.5
23 Fujica GS645	645h	–	1	75mm f3.4
24 Fuji GS645S	645h	–	1	60mm f4
25 Fujica GS645W	645h	–	1	45mm f5.6
26 Plaubel Makina 670	I	–	1	80mm f2.8
27 Plaubel Makina 67W	I	–	1	55mm f4.5
28 Mamiya Universal Press	Ex	Sq, I, 645v	7	127mm f4.7
VIEWFINDER				
29 Hasselblad SWC/M	Sq	645v, 645h, SS	1	38mm f4.5
30 Plaubel 69W proshift	Ex	–	2	47mm f5.6
TWIN-LENS REFLEX				
31 Rollei 2.8GX	Sq	–	1	80mm f2.8
32 Mamiya C220f	Sq	–	7	80mm f2.8
33 Mamiya C330s	Sq	–	7	80mm f2.8
PANORAMIC				
34 Linhof Technorama 612PC	612	–	1	65mm f5.6
35 Fuji G617	617	–	1	105mm f8
36 Widelux 1500	612	–	1	50mm f2.8
37 Panoscope 65/70	6xVar	Var	1	65mm f4

Widest wide-angle lens	Longest telephoto lens	Shift/Tilt	Focusing mechanism	Shutter type	Polaroid back	Film transport	Metering	Motor drive	Weight (lb oz/grams)	
40mm	500mm	No/No	Hel	L-S	Yes	D-B	Manual acc finder	–	3lb 5oz/1,500g	1
40mm	500mm	No/No	Hel	L-S	Yes	D-B	As above + OTF flash	B-I	4lb 11oz/2,130g	2
50mm	350mm	No/No	Hel	F-P	Yes	D-B	Manual acc finder	Acc	3lb 10oz/1,640g	3
50mm	500mm	No/No	R&P	L-S	Yes	D-B	Manual acc finder	Acc	6lb/2,705g	4
50mm	500mm	Yes/No	R&P	L-S	Yes	D-B	Semi-auto acc finder	Acc	5lb 8oz/2,400g	5
40mm	1000mm	Yes/Yes	R&P	F-P	Yes	D-B	OTF flash	–	4lb 8oz/2,060g	6
40mm	1000mm	Yes/Yes	R&P	F-P	Yes	D-B	Manual TTL + OTF flash	–	4lb 9oz/2,065g	7
40mm	500mm	Yes/No	Hel	L-S	Yes	D-B	Auto SP	B-I	4lb 14oz/2,200g	8
40mm	500mm	Yes/No	Hel	L-S	No	D-B	Auto SP	B-I	3lb 15oz/1,800g	9
40mm	500mm	Yes/No	Hel	L-S	Yes	D-B	AP acc finder	–	3lb 5oz/1,500g	10
40mm	500mm	Yes/No	Hel	L-S	Yes	D-B	AP acc finder	B-I	4lb 3oz/1,925g	11
50mm	500mm	No/No	Hel	L-S	Yes	D-B	AP acc finder	–	4lb/1,830g	12
80mm	300mm	Yes/Yes	R&P	L-S	Yes	D-B	TTL, +/- monitor	B-I	9lb 2oz/4,146g	13
45mm	1000mm	Yes/No	Hel	F-P	No	S-P	Manual acc finder	–	4lb 14oz/2,240g	14
40mm	250mm	Yes/No	Hel	F-P	No	S-P	Semi-auto acc finder	–	4lb 3oz/1,900g	15
35mm	500mm	Yes/No	Hel	F-P	Yes	D-B	AP acc finder	–	2lb 2oz/965g	16
24mm	500mm	Yes/No	Hel	F-P	Yes	D-B	AP acc finder	Acc	1lb 15oz/895g	17
45mm	600mm	No/No	Hel	F-P	No	D-B	Programmed auto/manual	B-I	2lb 13oz/1,280g	18
40mm	500mm	No/No	Hel	L-S	Yes	D-B	AP auto	Acc	3lb/1,345g	19
–	–	No/No	Hel	L-S	No	S-P	–	–	3lb 3oz/1,440g	20
–	–	No/No	Hel	L-S	No	S-P	–	–	3lb 5oz/1,480g	21
–	–	No/No	Hel	L-S	No	S-P	–	–	3lb 3oz/1,445g	22
–	–	No/No	Hel	L-S	No	S-P	Semi-auto	–	1lb 13oz/820g	23
–	–	No/No	Hel	L-S	No	S-P	Semi-auto	–	1lb 11oz/750g	24
–	–	No/No	Hel	L-S	No	S-P	Semi-auto	–	1lb 8oz/680g	25
–	–	No/No	L-T	L-S	No	S-P	Semi-auto	–	3lb/1,345g	26
–	–	No/No	L-T	L-S	No	S-P	Semi-auto	–	2lb 12oz/1,250g	27
50mm	250mm	No/No	Hel	L-S	Yes	Cur	–	–	4lb 1oz/1,860g	28
–	–	No/No	Hel	L-S	Yes	D-B	–	–	3lb/1,360g	29
–	–	Yes/No	Hel	L-S	No	Cur	–	–	3lb 8oz/1,600g	30
–	–	No/No	R&P	L-S	No	V	Semi-auto	–	2lb 13oz/1,275g	31
55mm	250mm	No/No	R&P	L-S	No	V	Manual acc finder	–	3lb 5oz/1,500g	32
55mm	250mm	No/No	R&P	L-S	No	V	Manual acc finder	–	3lb 5oz/1,500g	33
–	–	Yes/No	Hel	L-S	No	S-P	–	–	4lb 3oz/1,920g	34
–	–	No/No	Hel	L-S	No	S-P	–	–	5lb 1oz/2,310g	35
–	–	No/No	Hel	L-S	No	S-P	–	–	4lb 1oz/1,850g	36
–	–	No/No	Hel	L-S	No	Mot	–	B-I	10lb 1oz/4,600g	37

MEDIUM-FORMAT LENSES

As it is usually the lens, rather than the film, that limits image quality in medium-format photography, it is a good idea to buy the best lens that you can afford. No other part of the camera system has such a decisive effect on the style of photography. A 35mm user coming to medium-format photography will notice a number of differences between the lenses available for the two formats: the range of medium-format lenses is more limited (especially at the longer focal lengths), and the lenses themselves are bigger and slower (that is, they have smaller maximum apertures).

To cover the larger frame size, medium-format lenses need a proportionally longer focal length than their 35mm counterparts (table, opposite page). If, at the same time, they had to be as fast as 35mm lenses, they would soon reach an unacceptable size (and cost) – as it is, the Hasselblad 500mm f8 lens, equivalent to a 300mm f4.5 lens on a 35mm camera, weighs nearly four pounds (1.8kg), is over a foot (30cm) long, 3.5 f-stops slower and by no means easy to handle.

One consequence of the limited speed of medium-format lenses is that they have a reduced depth of field; it is therefore important to focus accurately and optimize the depth of field available (below).

Few photographers start with a comprehensive set of lenses, partly for reasons of cost and partly because it takes time and experience to decide which lenses are valuable for

LENS MOVEMENTS
Moving a lens relative to the film in order to alter the perspective of the image is a familiar technique to large-format photographers. There are several ways that the medium-format user can achieve the same effect. Some medium-format cameras, such as the Rollei 66 and Fuji GX680, use a bellows focusing system in which the whole lens can be moved. Alternatively, some systems include a lens with built-in lens movements. Projecting knobs allow you to shift the lens to one side, or tilt it at an angle to the film plane. The effect that this has on the image is shown on pages 88-89.

Shift Tilt

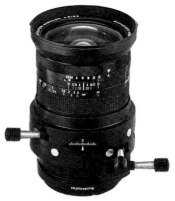

A 55mm f4.5 Shift/Tilt lens

1 Using the scale

| 22 | 16 | 11 | 8 | 5,6 | 4 | 2,8 |

| 16 | 11 | 8 | 4 | 4 | 8 | 11 | 16 |

| 4 | 5 | 7 | 10 | 20 | ∞ |

| 22 | 16 | 11 | 8 | 5,6 | 4 | 2,8 |

| 16 | 11 | 8 | 4 | 4 | 8 | 11 | 16 |

| 4 | 5 | 7 | 10 | 20 | ∞ |

2 Previewing

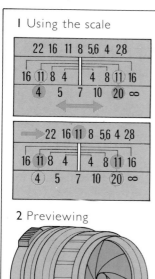

DEPTH OF FIELD
There are 2 ways to make efficient use of the depth of field available: one is to set the focus to maximize the depth of field, the other is to use the preview button.
1 Focus on the near and far limits of the scene, and for each note the distance on the focusing ring. Turn the ring until these limits are equally spaced on either side of the focus mark. Read off the aperture that will cover the depth of field needed.
2 Use the preview button to close down the lens diaphragm to the working aperture so that you can visually check the depth of field. This, however, darkens the image.

particular ways of working. The most common set for $2\frac{1}{4}\times2\frac{1}{4}$in/6x6cm users is 50mm, 80mm and 150mm – moderate wide-angle, standard and moderate telephoto. This is a fairly conservative approach to focal length. In particular, the telephoto choice is a slight anomaly: the medium-format equivalent of a 135mm telephoto is a lens of over 200mm. However, the size of roll-film is at least part compensation for the relatively weak showing of telephoto lenses. It is common practice to crop into the negative when printing (the large film size permits this with only a slight loss of image quality), and one of the effects of this is to reduce the angle of view, as if a longer focal length lens had been used.

The names used to describe medium-format lenses – Biogon, Distagon, Tele-Tessar, and so on – refer to the lens design. Different manufacturers often use different designs for the same focal length.

Some cameras use a leaf shutter situated in the lens, while others have a focal-plane shutter in the camera body. When comparing the two it is worth keeping the following points in mind: focal-plane shutters can operate at higher speeds (normally up to $\frac{1}{1000}$ sec compared with the usual $\frac{1}{500}$ sec limit with a leaf shutter), but are noisier. On the other hand, when it comes to synchronizing the shutter with a flash unit, leaf shutters can be used up to $\frac{1}{500}$ sec while focal-plane cameras are usually restricted to $\frac{1}{90}$ sec or less.

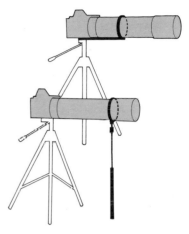

SUPPORTING THE LENS
Apart from a tripod to steady the camera, there are various secondary supports (above) that can be used to stabilize a long telephoto lens.

FORMATS AND FOCAL LENGTH
The usual way of classifying the focal length of a lens – wide-angle, standard, telephoto – depends on the film format. The term "standard" is applied to a lens that gives a normal-looking perspective, close to that of the unaided eye. This occurs when the length of the frame diagonal is approximately the same as the focal length – the diagonal of a $2\frac{1}{4}\times2\frac{1}{4}$in/6x6cm square is 79mm long, which makes an 80mm lens standard for the square format. In 35mm photography you can change the perspective of a shot by changing the lens: in medium-format, where interchangeable backs allow you to choose between a number of different formats, you also have the option of changing the frame size. The chart below lists the focal lengths that would be required with the various medium formats to give similar perspectives to those of the basic set of lenses in 35mm photography.

	FOCAL LENGTH		
FORMAT	Wide-angle	Standard	Telephoto
35mm ($\frac{15}{16}\times1\frac{7}{8}$in/24x36mm)	35mm	50mm	135mm
645 ($1\frac{3}{4}\times2\frac{1}{4}$in/4.5x6cm)	50mm	75mm	180mm
Square ($2\frac{1}{4}\times2\frac{1}{4}$in/6x6cm)	60mm	80mm	250mm
"Ideal" ($2\frac{1}{4}\times2\frac{3}{4}$in/6x7cm)	80mm	100mm	300mm
"Extended" ($2\frac{1}{4}\times3\frac{1}{4}$in/6x9cm)	90mm	105mm	350mm

HASSELBLAD 500C/M

For many, Hasselblad is the doyen of medium-format camera manufacturers. Although the 500C/M was not the first professional camera to use roll-film – manufacture began in 1948, 19 years after the first Rollei – it was the first "system" camera in this format. Hasselblad in general, and the 500C/M in particular, have become something of a standard by which all other single-lens reflex medium-format cameras are judged.

At the core of the 500C/M is a mechanically straightforward, box-like body that incorporates an auxiliary shutter at the rear. This shutter is used not to make the actual exposure (the leaf shutter in the lens does that) but instead to protect the film from light during focusing, viewing and when the lens is changed. When the shutter release is pressed, the leaf shutter in the lens closes, the aperture closes down to its setting, the auxiliary shutter opens, the mirror flips up, and finally, the leaf shutter opens to make the pre-set exposure. The range of shutter speeds is from "B" and I second to $\frac{1}{500}$ sec, with an "X" setting for flash synchronization at all speeds.

One complete revolution of the winding crank recocks both the lens and accessory shutters; it also advances the film

1 *Viewing hood*
2 *Winding crank*
3 *Film magazine*
4 *Camera strap lug*
5 *Film winder crank*
6 *Film plane indicator*
7 *Magazine status indicator*
8 *Frame counter window*
9 *Shutter status indicator*
10 *Focusing ring*
11 *Cross-coupling button*
12 *Shutter speed ring*
13 *Aperture ring*
14 *Exposure value scale*
15 *Time exposure lock*
16 *Shutter release*
17 *Tripod attachment*

Hasselblad 500C/M with 80mm f2.8 Planar CF lens

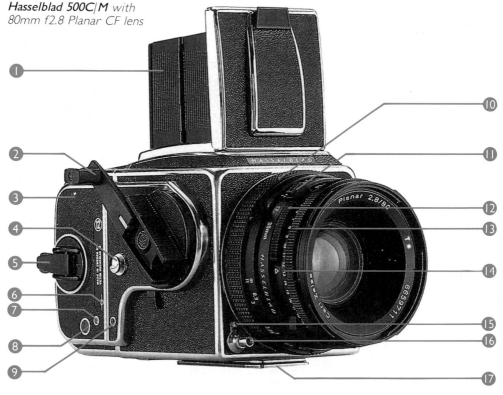

by one frame. An alternative winding knob can be used which has a built-in selenium cell exposure meter. It has a diffuser for taking incident light readings.

The ingenuity of the Hasselblad design, since imitated by other manufacturers, is that the film, in separate backs, can be attached and detached at will, even in the middle of a roll. If you have a sufficient number of film magazines, shooting can alternate between color and black-and-white, negative and transparency, from frame to frame. The interchangeability of film magazines allows different picture formats (standard $2\frac{1}{4}$x$2\frac{1}{4}$in/6x6cm, $1\frac{3}{4}$x$2\frac{1}{4}$in/4.5cmx6cm horizontal, $2\frac{1}{4}$x$1\frac{3}{4}$in/4.5x6cm vertical, and $1\frac{3}{4}$x$1\frac{3}{4}$in/4.5x4.5cm) and different types of film (120, 220, 70mm, Polaroid and cut sheet film).

The least sophisticated feature of the 500C/M is its metering. At a time when most cameras offer through-the-lens (TTL) metering as standard, Hasselblad maintain it as an extra, and a peripheral one at that. The metering offered is in the form of an optional prism head (pages 20–21). This displays exposure values on an EV scale from 2 to 19. The 500C/M is not designed for fast shooting in uncertain lighting conditions.

SLR WAIST-LEVEL MODELS

ADVANTAGES
* Through-the-lens viewing
* No parallax problems
* Depth of field preview is available on most lenses
* Focusing screen gives a 2-dimensional image which is useful when composing
* Full variety of formats
* Polaroid back available

DISADVANTAGES
* Viewfinder image is laterally reversed
* Relatively heavy and bulky
* Noisy: mirror action can cause vibration
* Mirror obscures the finder image during shooting

ATTACHING THE BACK
The interchangeable film backs connect to the body by means of lugs at the bottom and a sliding button at the top.
1 Locate the magazine on the lugs. Slide the button to the right and swing the magazine upward until it is flat against the back of the camera. Release the button and check that it locks to the left.
2 Remove the protective dark slide. This thin metal slide is part of a double safety mechanism: it

protects the film from fogging when the magazine is removed; also, the shutter release is disabled until the slide has been removed.

3 Check the magazine and shutter status indicators to ensure that they match.
4 If the magazine indicator is white (film unexposed) and the shutter red (fired), remove the magazine, wind-on the camera, reattach the magazine. Both should now be white. If the magazine indicator is red (film exposed) and the shutter white (cocked), remove the magazine, fire the camera, reattach the magazine and rewind. Both should now be white. **15**

HASSELBLAD 500ELX

Hasselblad's approach to motorizing the 500C/M has been to make a completely separate camera, the 500ELX. In common with all motor-driven cameras, the ELX is faster and easier to use than a manual version, and offers fewer handling distractions. In place of the winding crank – the 500ELX cannot be operated manually – there is a motor-drive selection dial. The motor drive is powered by two rechargeable NiCad batteries, with a 1.6amp ($\frac{3}{16} \times \frac{3}{4}$in/5x20cm) fuse. Each battery will power approximately 1,000 exposures, and recharging takes 14 hours.

One advantage of the motor is that it allows the 500ELX to be fired remotely. Sockets at the side and front accept release cords and connecting cords, supplied by Hasselblad as accessories (pages 24–25). As triggering involves little more than the closing of an electrical contact, it isn't difficult to make up your own cord from individual electrical components. Other Hasselblad accessories include an intervalometer (for time-lapse photography) and a command unit (for simultaneous triggering of more than one camera).

1 *Viewing hood*
2 *Motor-drive selector*
3 *Film winder crank*
4 *Film plane indicator*
5 *Magazine status indicator*
6 *Film counter window*
7 *Shutter status indicator*
8 *Battery charging/ remote release socket*
9 *Time exposure/battery charging selector lever*
10 *Focusing ring*
11 *Cross-coupling button*
12 *Shutter speed ring*
13 *Aperture ring*
14 *Exposure value scale*
15 *Motor drive*
16 *Shutter release plate*
17 *Tripod attachment*

Hasselblad 500ELX with 80mm f2.8 Planar CF lens

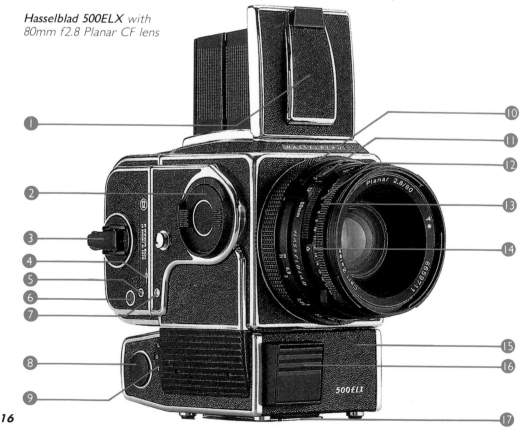

Apart from powering the motor drive and the shutter mechanism, the 500ELX's electronics have been extended to include a flash sensor system. The sensor measures the light reflected off the surface of the film at the moment of exposure. This through-the-lens, off-the-film system is connected to the film speed selector dial on the body, and works only when connected to an SCA300 or SCA500 system flash unit, via an SCA390 or SCA590 adapter. The flash is quenched as soon as the sensor detects a predetermined level of reflected light. A diode under the left edge of the focusing screen lights up when the flash is ready, and after exposure to show whether or not sufficient light was discharged. Flash synchronization is possible at all speeds from "B" and 1 second to $\frac{1}{500}$ sec. One drawback of this system is that all the available flash units are portable: it won't work with regular studio flash units.

As with the 500C/M, through-the-lens exposure metering is available in the form of an optional prism head. Aperture and shutter speed settings have to be set manually.

MOTOR-DRIVE OPTIONS
"O" After each shot the camera is automatically reset for the next exposure.
"A" Same as above, but at 1 exposure per second.
There are 3 pre-release settings, in which the camera is readied, leaving only the lens shutter to function when the release plate is pressed.
"S" The camera is pre-released for 1 shot, then returns to "O".
"RS" Remains in pre-release until setting is changed.
"AS" Automatic pre-release at 1 frame per second.

CROSS-COUPLING BUTTON
When this button is pressed, the aperture and shutter speed rings are locked together. Once one possible aperture/shutter speed combination has been found for a particular shot (1), the button can be used to change the combination without altering the amount of light reaching the film (2). The EV (exposure value) scale on the speed ring can be used in conjunction with a meter that gives EV readings for rapid exposure setting.

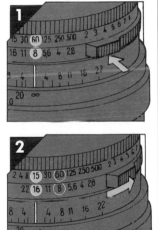

TIME EXPOSURE/ RECHARGING
The lever on the right-hand side of the motor drive has 3 positions:
"O" For normal operation
"T" For time exposures
"L" For recharging the batteries

HASSELBLAD 2000FCW

Hasselblad, in a break with their own conservative attitude toward major design changes, launched a completely new camera in 1978, based on a focal-plane shutter rather than the traditional between-the-lens leaf shutter. Although the 2000FCW has its own range of shutterless lenses (the F series), it is designed to integrate with the entire Hasselblad system, and so can be used also with the leaf-shutter C and CF series lenses. With the exception of the standard 80mm Planar lens, all the shutterless F series lenses are faster than their C and CF counterparts, and will focus slightly closer.

The 2000FCW is the fastest medium-format camera available, with a top speed of $\frac{1}{2000}$ sec. However, because it uses a focal-plane shutter, the highest flash synchronization speed is only $\frac{1}{90}$ sec. For synchronization up to $\frac{1}{500}$ sec, a leaf-shutter lens of the CF series must be used. Unlike the Hasselblad 500C/M, which works only mechanically, the 2000FCW has a 6 volt battery to power its shutter speed circuit. However, when a CF series lens is attached, this circuit can be bypassed leaving the leaf shutter to work mechanically.

To enable the 2000FCW to integrate with C and CF lenses, there are extra selection controls. With an F series lens,

1 Viewing hood
2 Winding crank
3 Mirror mode selector
4 Camera strap lug
5 Film winding crank
6 Film plane indicator
7 Magazine status indicator
8 Film counter window
9 Shutter status indicator
10 Pre-release button (mirror lock)
11 Cross-coupling button
12 Aperture ring
13 Exposure value scale
14 Shutter release button
15 Tripod attachment

Hasselblad 2000FCW with 110mm f2 Planar F lens

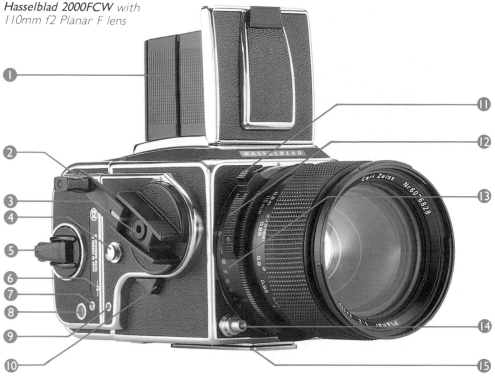

nothing special needs to be done. With the C and CF lenses there is a choice between using the leaf shutter or the focal-plane shutter. To use the leaf shutter, turn the shutter speed ring to "C", and lock it there with the small locking lever on the left-hand side of the camera. To use the focal-plane shutter with CF series lenses, you lock out the leaf shutter by pressing the green button on the speed ring and turning the ring to "F"; in the case of the older C series lenses, you set the speed to "B" and the synchronization lever to "X".

In most respects the 2000FCW looks and handles like the 500C/M. Focal-plane shutter speeds, even though they operate inside the body, are selected by a ring that connects to the base of the lens. In use, the shutter speed ring feels like a lens control, making it that bit more familiar to 500C/M users. Hasselblad have also retained the cross-coupling button (page 17).

In order to protect the focal-plane shutter when changing film backs, the shutter curtain is automatically retracted when the magazine is removed. For the same reason, the 2000FCW will not accept the Polaroid 80 magazine: this magazine has a protruding glass screen which would damage the shutter curtain.

Hasselblad 2000FCW with 110mm f2 Planar F lens, motorized winder, and Prism Finder PME. The motorized winder has a 6 volt motor, powered by 5 batteries – either rechargeable NiCad or standard alkaline. It allows continuous exposures to be taken at a speed of 1.3 frames per second.

MIRROR ACTION MODES
The mode selector is inside the winding crank.
"0" Mirror lock mode: the mirror is locked up to minimize vibration.
"1" No return mode: after each exposure, the camera has to be rewound before the mirror will descend for viewing.
"2" Instant return mode: the mirror returns to the viewing position after each exposure.

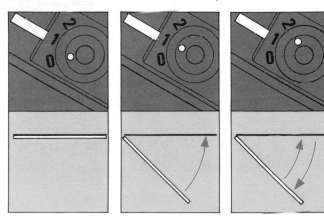

19

HASSELBLAD SYSTEM/1

The range of components and accessories for the Hasselblad is both comprehensive and specialized, as befits a camera aimed at the top of the professional market. Few of the Hasselblad accessories are just gadgets: most are essential for their specific tasks. While the three main cameras (500C/M, 500ELX, 2000FCW) make full use of the system, the SWC/M with its fixed lens and optically separate viewfinder, is interchangeable only in its range of film magazines. The complete system is shown on pages 24-25, the lenses on pages 22-23, and a selection of magazines and viewfinders are illustrated on this page.

The range of interchangeable film magazines offers the photographer the choice of four frame sizes and five types of film (below). There is the standard $2\frac{1}{4} \times 2\frac{1}{4}$in/6x6cm square frame, the horizontal $1\frac{3}{4} \times 2\frac{1}{4}$in/4.5x6cm frame, the vertical $2\frac{1}{4} \times 1\frac{3}{4}$in/6x4.5cm format and the "superslide" $1\frac{3}{4} \times 1\frac{3}{4}$in/4.5x4.5cm. ("Superslide" is the largest picture area that will fit into the outer dimensions of a 35mm slide mount.) The two rectangular frame sizes are useful because of their more natural proportions. The $1\frac{3}{4} \times 2\frac{1}{4}$in/4.5x6cm frame is positioned length-ways across the film, which allows 16 exposures per roll of 120 film: all the other formats will give only 12 exposures per roll. (There is a special magazine that fits at least 19 $1 \times 2\frac{1}{8}$in/24x55mm panoramic frames on a 36-exposure 35mm film.)

The standard viewer is a plain hood that collapses when not in use and is fitted with a 5x folding magnifier. Alternative accessories include a magnifying hood with eyepiece and diopter-correcting ring which gives a $3\frac{1}{2}$x magnification, and three prism viewfinders which give eye-level, laterally-

Meter Prism
Finder PME

Prism
View-
finder
PM

Reflex
View-
finder
RM-2

VIEWFINDERS
Of the 3 eye-level
viewfinders, the PM and
PME have a 45° sighting
angle, while the RM-2 has a
90° sighting angle, diopter-
correcting eyepiece, and a
longer viewing tube for use
with the bulky 70mm
magazines. Of the two 45°
finders, the PME has a
silicon cell meter that
displays settings on an
exposure value scale, while
the PM is unmetered.

FILM BACKS
Hasselblad have produced a film back for each type of film, in a range of formats — the complete selection is shown in the system chart: pages 24-25. Apart from the regular 120/220 roll-film back, there is a bulky magazine that accepts 70mm film cassettes (70 exposures), and a sheet-film holder for any type of sheet film so long as it is cut down to $2\frac{1}{2} \times 2\frac{1}{2}$in/6.5x6.5cm. Finally, there is a Polaroid back which accepts film types 665, 667, 668 and 669, exposing a $2\frac{1}{4} \times 2\frac{1}{4}$in/6x6cm square image.

120/220 back

Polaroid back

Sheet
film
adapter

Sheet
film
holder

70mm back

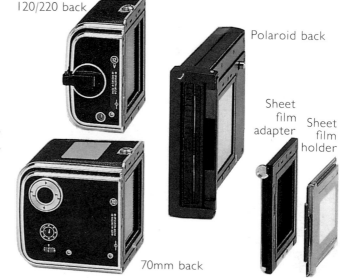

corrected views (left). Two non-optical viewers – a frame finder and a sports viewfinder – are also available, for rapid sighting.

A comprehensive set of remote triggering accessories is available for the motorized 500ELX, including power supply accessories such as the recharger (there is one also for the 2000FCW's accessory winder), battery compartment and line power supply units for either 110 volt or 220 volt AC.

The weight of medium-format cameras makes support accessories more useful than they would be for smaller, lighter equipment. A pistol grip is the basic support accessory, one for the 500C/M and 2000FCW, another for the 500ELX. These are gripped by the left hand, and work to their best advantage when the camera is held at eye-level with a prism finder. There is also a double grip for use with the motorized 500ELX. With this the angle of the grips and position of the base screw can be adjusted for the center of gravity of the camera (which depends on what lenses and accessories are fitted). Other handling accessories include a quick-focusing handle, a tripod attachment for the zoom lens, and a quick-release tripod plate.

Close up photography accessories include bellows, extension tubes (one of them variable), supplementary lenses and a macro flash unit. Microscope attachments are also available. For copying, there is a mirror set for obtaining a parallel alignment (to within two minutes of arc) between the film plane and the object to be copied, and an attachment for copying transparencies and negatives.

There is an extensive selection of carrying cases (both hard and soft), camera cases, lens pouches, straps and covers.

SLIDE PROJECTOR
Only 2 medium-format camera manufacturers produce a $2\frac{1}{4}$x$2\frac{1}{4}$in/6x6cm slide projector: Hasselblad and Rollei. The Hasselblad PCP80 (below) uses a rotary slide magazine and Zeiss lenses (75mm, 150mm, 250mm). Accessories include a remote control unit with which you can control focusing and forward/reverse slide changes, power cords for European and American plugs, and a protective cover and carrying case.

PCP80 Slide projector

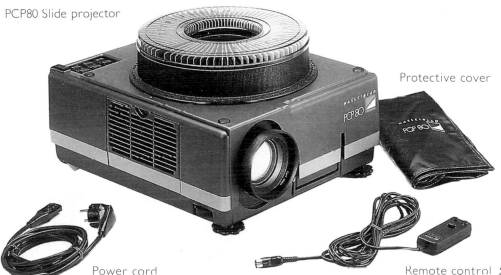

Protective cover

Power cord

HASSELBLAD SYSTEM/2

Lenses for the Hasselblad models are supplied by two top-ranking German lens manufacturers. Most are made, to Hasselblad specifications, by Carl Zeiss. The single zoom lens is supplied by Schneider. All the lenses are, as might be expected, of extremely high quality. These same manufacturers also produce lenses for Rollei's cameras.

Since the launch of the Hasselblad 2000FCW in 1978, there have been two parallel ranges of lenses: the shutterless F series, designed specifically for the 2000FCW, and the leaf-shutter CF series. The CF series, which replaces the C series, offers the greater choice, with a range of 14 lenses. This range includes a 105mm UV-Sonnar with extended sensitivity down to 215 nanometers in the ultra-violet (the visible light range is from 400nm to 700nm), and a 250mm Superachromat that has virtually perfect chromatic aberration to the point where accurate visual focus extends into the infra-red as far as 1,000nm. At present there are only 6 lenses in the F series. With fewer design restrictions (because the shutter is in the camera not the lens), these F lenses have wider apertures and can focus more closely than their CF counterparts.

CF NORMAL LENSES

80mm f2.8 Planar CF

100mm f3.5 Planar CF

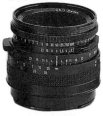

CF WIDE-ANGLE LENSES

40mm f4 Distagon CF

60mm f3.5 Distagon CF

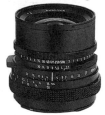

30mm f3.5 Distagon CF

50mm f4 Distagon CF

CF TELEPHOTO LENSES

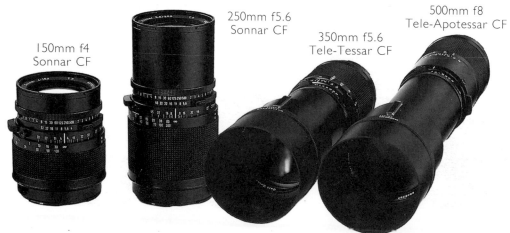

150mm f4 Sonnar CF

250mm f5.6 Sonnar CF

350mm f5.6 Tele-Tessar CF

500mm f8 Tele-Apotessar CF

22

CF SPECIAL LENSES

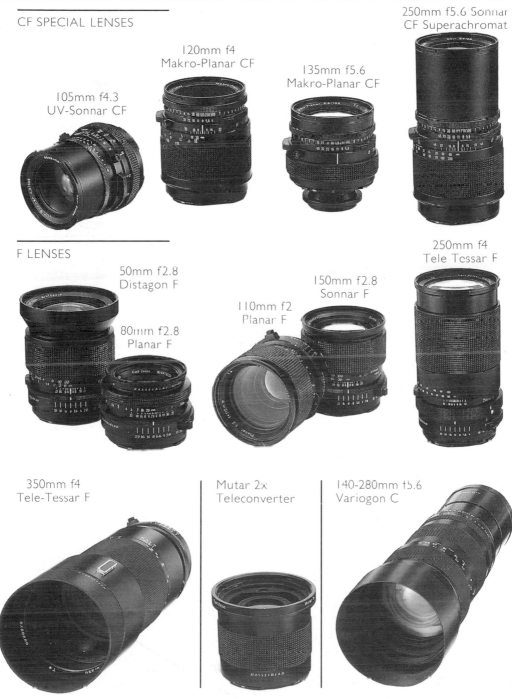

105mm f4.3
UV-Sonnar CF

120mm f4
Makro-Planar CF

135mm f5.6
Makro-Planar CF

250mm f5.6 Sonnar
CF Superachromat

F LENSES

50mm f2.8
Distagon F

80mm f2.8
Planar F

110mm f2
Planar F

150mm f2.8
Sonnar F

250mm f4
Tele Tessar F

350mm f4
Tele-Tessar F

Mutar 2x
Teleconverter

140-280mm f5.6
Variogon C

Hasselblad originated the medium-format system. Since then they have built their own 500C/M-500ELX-2000FCW-SWC/M system into one of the most comprehensive on the market. At the core are the 3 main Hasselblad cameras (the 500C/M, the 500ELX and the 2000FCW). The SWC/M (pages 78-79) is more peripheral, using only the range of film backs.

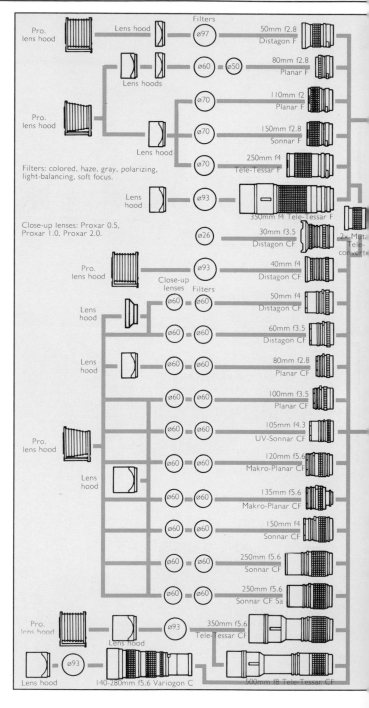

Pro. lens hood — Lens hood — Filters ø97 — 50mm f2.8 Distagon F

Pro. lens hood — Lens hoods — ø60 — ø50 — 80mm f2.8 Planar F

ø70 — 110mm f2 Planar F

ø70 — 150mm f2.8 Sonnar F

Lens hood — ø70 — 250mm f4 Tele-Tessar F

Filters: colored, haze, gray, polarizing, light-balancing, soft focus.

Lens hood — ø93 — 350mm f4 Tele-Tessar F

Close-up lenses: Proxar 0.5, Proxar 1.0, Proxar 2.0.

ø26 — 30mm f3.5 Distagon CF — 2x Mutar Tele-converter

Pro. lens hood — Close-up lenses — Filters — ø93 — 40mm f4 Distagon CF

Lens hood — ø60 — ø60 — 50mm f4 Distagon CF

Lens hood — ø60 — ø60 — 60mm f3.5 Distagon CF

Lens hood — ø60 — ø60 — 80mm f2.8 Planar CF

ø60 — ø60 — 100mm f3.5 Planar CF

Pro. lens hood — ø60 — ø60 — 105mm f4.3 UV-Sonnar CF

ø60 — ø60 — 120mm f5.6 Makro-Planar CF

Lens hood — ø60 — ø60 — 135mm f5.6 Makro-Planar CF

ø60 — ø60 — 150mm f4 Sonnar CF

ø60 — ø60 — 250mm f5.6 Sonnar CF

ø60 — ø60 — 250mm f5.6 Sonnar CF Sa

Pro. lens hood — Lens hood — ø93 — 350mm f5.6 Tele-Tessar CF

Lens hood — ø93 — 140-280mm f5.6 Variogon C — 500mm f8 Tele-Tessar CF

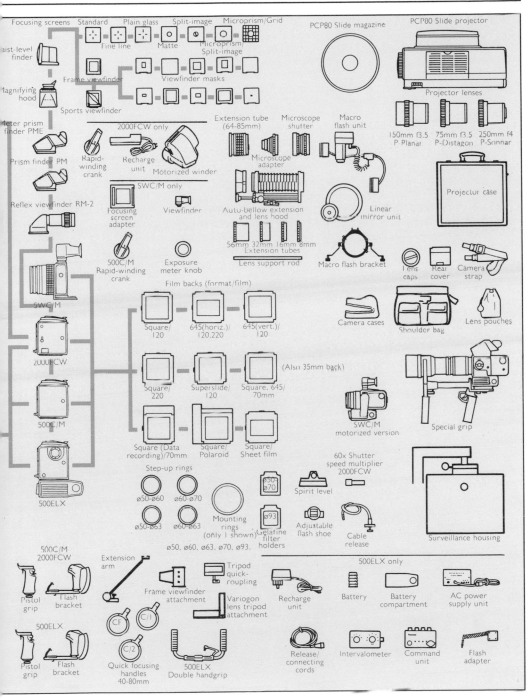

MAMIYA RB67/RZ67

The Mamiya RB67 was the first medium-format camera to offer serious competition to Hasselblad, by offering alternatives to the few weak points in the Hasselblad design. The main innovations were a more conventional picture format (rectangular instead of square), the ability to shoot both vertically and horizontally without having to change backs, and a built-in bellows focusing operation that allowed simple close-up photography. The RB67 is the original, mechanical design. The RZ67 is based on the RB67, but has more electronic features and some mechanical improvements that make handling simpler.

The most distinctive design feature of these Mamiya single-lens reflex models is the $2\frac{1}{4}$x$2\frac{3}{4}$in/6x7cm format. There is a mechanical problem with this rectangular format: either the film or the camera must be turned on its side to change between a horizontal and vertical frame. Considering the waist-level viewing, Mamiya chose to make the film magazine rotate through 90° (page 28).

Conventional modern focusing works by rotating part of the lens barrel to move lens elements back and forth, but the Mamiya 67 models have fixed focal length lenses and a rack-and-pinion system. The front part of the body slides forward for close focusing, while a flexible bellows keeps the camera

1 *Viewfinder hood*
2 *Film advance lever*
3 *Revolving back adapter*
4 *Revolving film back*
5 *Shutter cocking lever*
6 *Dark slide*
7 *Focusing knob*
8 *Breech-lock lens mount*
9 *Flash synch socket*
10 *Shutter speed ring*
11 *Aperture ring*
12 *Exposure compensation scale*
13 *Shutter release*
14 *Film winding knob*
15 *Revolving back lock/ multiple exposure lever*
16 *Film winding/shutter cocking lever*

Mamiya RB67 *with 90mm f3.8 Mamiya-Sekor C lens*

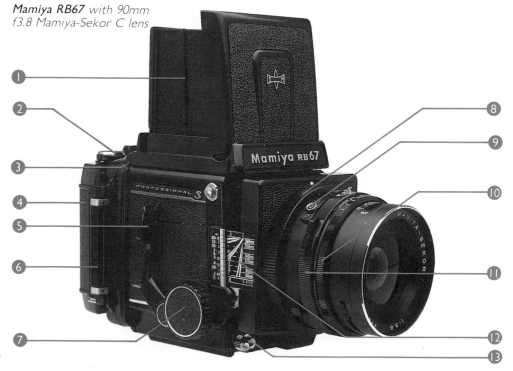

light-tight. The lens can be extended up to $1\frac{13}{16}$in/46mm. Thus, without any other close-up accessories, a standard 90mm lens can give $\frac{1}{2}$x magnification, while a wide-angle 50mm lens can be extended to give an image that is almost life-size. The penalties for this convenience are bulk and weight: the RZ67 with a 110mm lens weighs 5lb 5oz/2.4kg against the 2lb 14oz/1.9kg of a similarly equipped Hasselblad 2000FCW.

As with the Hasselblad, film backs are interchangeable, there is a similar range of lenses, and the variety of accessories is adequate for most uses. Through-the-lens metering is an optional extra, in the form of additional finders (page 28).

All the RB67's lenses have a mechanical shutter with speeds from 1 second (and "T") to $\frac{1}{400}$sec, and flash synchronization at all speeds. The RZ67, on the other hand, uses an electronic leaf shutter and can operate from 8 seconds (and "T") to $\frac{1}{400}$sec, with full flash synchronization. The shutter is controlled from a dial on the left-hand side of the body, and all the lens information can be displayed in the accessory prism metering head.

One mechanical improvement in the RZ67 is a single lever for cocking the shutter and advancing the film (the RB67 has one for each). In addition, an optional motorized winder offers both rapid and remote operation.

Mamiya RZ67 with 110mm f2.8 Mamiya Sekor Z lens

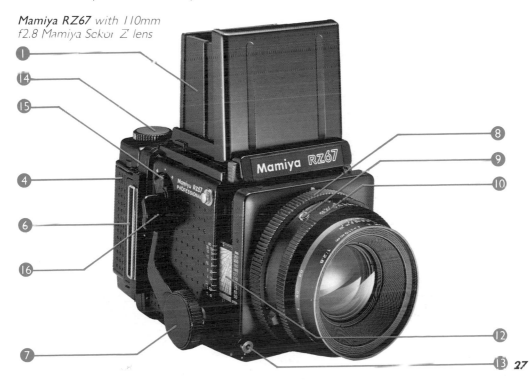

MAMIYA *RB67/RZ67 SYSTEM/1*

The RZ67 has been designed to take full advantage of the range of accessories available to the older RB67. All the parts originally designed for the RB67 body can be used with the RZ67, with some limitations; for example, the RZ67's range of electronic leaf-shutter lenses cannot be used with the mechanical RB67 body. Because the two systems are so closely linked, a combined RB67/RZ67 system chart is given on pages 30–31.

The two ranges of lenses – designated "C" for the RB67, "Z" for the RZ67 – are similar to each other and to the Hasselblad range (pages 22–23). Because the $2\frac{1}{4}\times2\frac{3}{4}$in/6×7cm format is a little larger than the traditional $2\frac{1}{4}\times2\frac{1}{4}$in/6×6cm square, the 90mm lens is considered the standard focal length. As well as screw-in lens hoods made specifically for individual focal lengths, there is an adjustable bellows lens hood that can be used with all the "C" lenses from the standard 90mm to the telephoto 360mm.

Because the rack-and-pinion focusing system allows a respectable extension – and a variable one at that – close-up accessories are limited to extension tubes. There are two sizes of these, and they can be stacked for greater magnifications. These tubes are automatic in the sense that the linkages between lens and body are maintained.

The original RB67 design uses a revolving adapter, which fits between the film holder and the camera body, to rotate the film backs. There are four adapters: the standard adapter, the P-Adapter (for the Polaroid film back) and two M-Adapters which allow film backs from the Mamiya Universal Press system (page 77) to be used. The newer RZ67 film backs carry their own rotating mechanisms, which include an automatic viewfinder masking system (opposite). With a G-Adapter, RB67 holders can be used on the RZ67 body, but not the other way round. This is a useful feature, as the RB67 has a larger range of film backs, including a 70mm film holder that permits 55 exposures per cassette, a motorized power drive that takes both 120 and 220 film, and a double sheet-film holder (the film must first be cut to $2\frac{1}{4}\times3\frac{1}{4}$in/6×9cm).

ROTATING THE FILM MAGAZINE
To change from a horizontal to a vertical format simply grip the back and turn through 90°, until it clicks into place. When the back is in the midway position (right) the shutter release is disabled.

EXPOSURE METERING

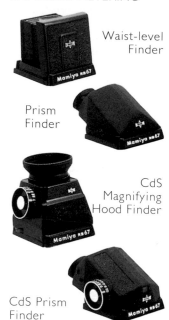

Waist-level Finder

Prism Finder

CdS Magnifying Hood Finder

CdS Prism Finder

The RB67 has a range of 4 viewfinders (above), all of which can be used on the RZ67. Two of these have a CdS metering system which takes average, center-weighted readings. All speed and aperture settings have to be set manually. In addition, the RZ67 has 3 finders of its own, the most sophisticated of these is the metered AE Prism Finder RZ (below). This takes either spot or average readings and is automatically linked to aperture, shutter and film speed settings.

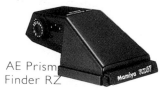

AE Prism Finder RZ

HORIZONTAL/VERTICAL SHOOTING

When the film magazine is rotated, the viewfinder is masked. In the RB67 (right) two red lines appear when the format is horizontal, while in the RZ67 (below) the frame is automatically masked both horizontally and vertically.

EXPOSURE COMPENSATION SCALE

As the lens is extended forward for close focusing, less light reaches the film. A scale on the right-hand side of the camera shows the exposure correction required for each lens extension combination. There is no need to use the scale when one of the through-the-lens metered prism heads is attached.

MAMIYA-SEKOR Z LENSES

The full range of electronic, leaf-shutter lenses for the RZ67 is shown below. This includes a recent addition, the 100–200mm f5.2 zoom lens.

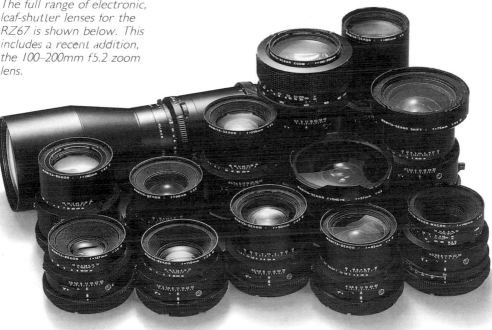

Although not quite as elaborate as the Hasselblad system, the Mamiya RB67 and RZ67 have a range of accessories that cover all normal, and some specialized, applications. As most of the accessories can be used with either camera, the two systems are shown here combined.

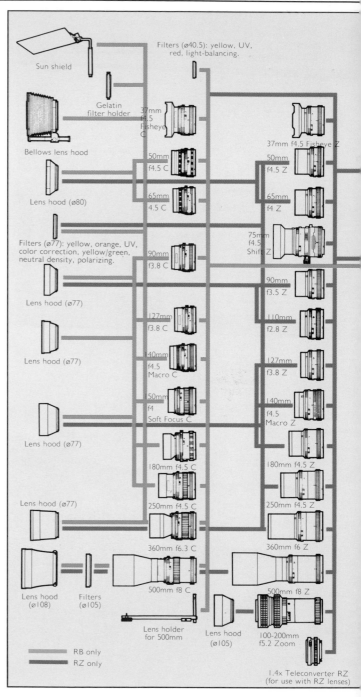

Sun shield

Filters (ø40.5): yellow, UV, red, light-balancing.

Gelatin filter holder

Bellows lens hood

Lens hood (ø80)

Filters (ø77): yellow, orange, UV, color correction, yellow/green, neutral density, polarizing.

Lens hood (ø77)

Lens hood (ø77)

Lens hood (ø77)

Lens hood (ø77)

Lens hood (ø108)

Filters (ø105)

37mm f4.5 Fisheye C

50mm f4.5 C

65mm 4.5 C

90mm f3.8 C

127mm f3.8 C

140mm f4.5 Macro C

150mm f4 Soft Focus C

180mm f4.5 C

250mm f4.5 C

360mm f6.3 C

500mm f8 C

37mm f4.5 Fisheye Z

50mm f4.5 Z

65mm f4 Z

75mm f4.5 Shift Z

90mm f3.5 Z

110mm f2.8 Z

127mm f3.8 Z

140mm f4.5 Macro Z

180mm f4.5 Z

250mm f4.5 Z

360mm f6 Z

500mm f8 Z

Lens holder for 500mm

Lens hood (ø105)

100-200mm f5.2 Zoom

1.4x Teleconverter RZ (for use with RZ lenses)

— RB only

— RZ only

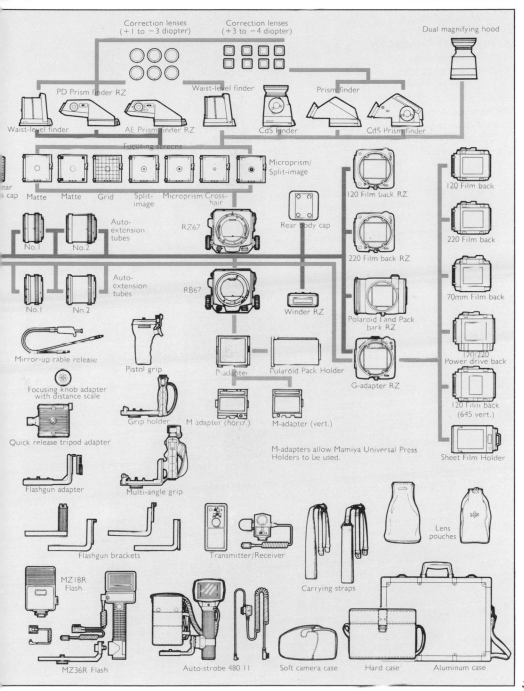

Correction lenses
(+1 to −3 diopter)

Correction lenses
(+3 to −4 diopter)

Dual magnifying hood

PD Prism finder RZ

Waist-level finder

Prism finder

Waist-level finder

AE Prism finder RZ

CdS finder

CdS Prism finder

Focusing screens

Microprism/
Split-image

Rear
cap

Matte Matte Grid Split-
image Microprism Cross-
hair

120 Film back RZ

120 Film back

Auto-
extension
tubes

No.1 No.2

RZ67

Rear body cap

220 Film back RZ

220 Film back

Auto-
extension
tubes

No.1 No.2

RB67

Winder RZ

Polaroid Land Pack
back RZ

70mm Film back

Mirror-up cable release

Pistol grip

M adapter

Polaroid Pack Holder

G-adapter RZ

120/220
Power drive back

Focusing knob adapter
with distance scale

Grip holder

M adapter (horiz.) M-adapter (vert.)

120 Film back
(645 vert.)

Quick release tripod adapter

M-adapters allow Mamiya Universal Press
Holders to be used.

Sheet Film Holder

Flashgun adapter

Multi-angle grip

Flashgun brackets

Transmitter/Receiver

Lens
pouches

MZ18R
Flash

Carrying straps

MZ36R Flash

Auto-strobe 480 II

Soft camera case Hard case Aluminum case

ROLLEIFLEX SL66X/SL66SE

The pioneer of medium-format photography, Rollei, produced its first $2\frac{1}{4}\times2\frac{1}{4}$in/6x6cm camera, the twin-lens reflex Rolleiflex, in 1929. In 1966 Rollei entered the competition for waist-level single-lens reflex cameras with the SL66. The two latest models in this series are the SL66X and SL66SE, both essentially mechanical rather than electronic models. The difference between the two is in the metering: the SL66SE has a through-the-lens (TTL) system, the SL66X model does not.

The distinguishing feature of these well-made cameras is not the size of the system or the number of lenses (these factors are comparable on most other makes), but the range of lens movements that the built-in bellows allows. Bellows are a feature of other medium-format cameras (notably the Mamiya 67 models), but the Rollei incorporates a tilt control as well (far right). The full bellows extension is 2in/50mm, only a little more than that of the Mamiya 67 models, but by mounting the lens in reverse the maximum extension can be increased – although this can only be done with the 50mm, 60mm, 80mm and 150mm lenses. The 50mm lens will give up to a 3x magnification with this method.

 1 *Film magazine*
 2 *Strap attachment*
 3 *Exposure counter*
 4 *Shutter speed dial*
 5 *Film crank*
 6 *Film speed dial*
 7 *Film winding crank*
 8 *Viewing hood*
 9 *Aperture ring*
10 *Shutter release*
11 *Exposure compensation dial*
12 *Depth of field preview*
13 *Distance/exposure compensation scale*
14 *Exposure meter switch*
15 *Depth of field scale*
16 *Focusing knob*
17 *Hot shoe*
18 *Tilt knob*

Rolleiflex SL66X with 80mm f2.8 Planar lens

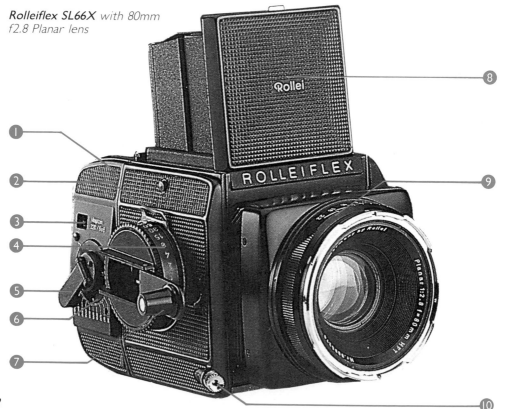

The SL66SE's TTL metering system is not linked automatically to the exposure controls, but simply shows over- and under-exposure on an LED scale. It is an integral part of the camera body and therefore works with all the viewfinders. As with most viewfinder displays, it is switched on by light pressure on the release button; it remains active for 15 seconds. There are two alternative metering methods: an averaging, bottom-weighted pattern, and a spot measurement that has a metering angle of about 3° with the standard 80mm lens. The SL66SE's built-in metering makes it more suitable for outdoor use in daylight than the SL66X. However, for rapid location work, Rollei's 6002 and 6006 may be a better choice. We look at these next.

Both the SL66SE and SL66X have an off-the-film (OTF) flash metering system which uses a special flash adapter, the SCA356. This must be used with the SCA300 flash system. Mounted on the side of the camera, the adapter links the dedicated functions with the flash unit, and gives fully automatic TTL metering. However, line-powered flash units call for manual exposure setting.

TILTING THE LENS
In both the SL66X and the SL66SE, the lens can be tilted, up or down, by up to 8°. This allows you to tilt the plane of sharp focus so that it coincides with the plane of the subject, thus bringing more of the subject into focus (page 88).

Rolleiflex SL66SE *with 80mm f2.8 Planar lens*

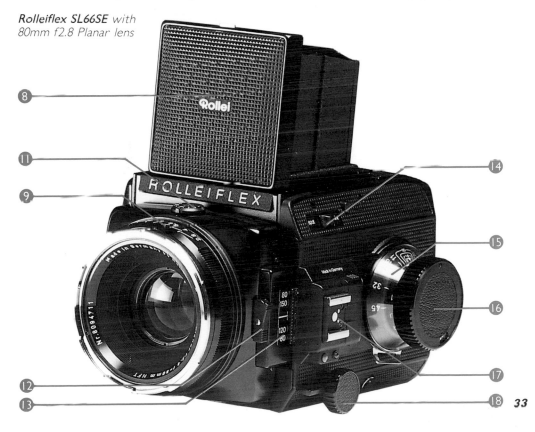

ROLLEIFLEX SL66X/SL66SE SYSTEM

The range of film magazines offers a choice of $2\frac{1}{4}$x$2\frac{1}{4}$in/ 6x6cm and $1\frac{3}{4}$x$2\frac{1}{4}$in/4.5x6cm frame sizes, each with 120, 220 or Polaroid film. Sheet film can also be used. The range of lenses for the SL66 models is similar to, but not as extensive as, that for the Hasselblad cameras; indeed, they share the same principal manufacturer, Carl Zeiss. However, because the SL66 models use a focal-plane shutter in the camera body, most of the Rollei lenses are shutterless; this allows them to be simpler and lighter. To allow flash synchronization at all speeds, there are two lenses available with between-the-lens leaf shutters: an 80mm standard lens and a 150mm portrait lens.

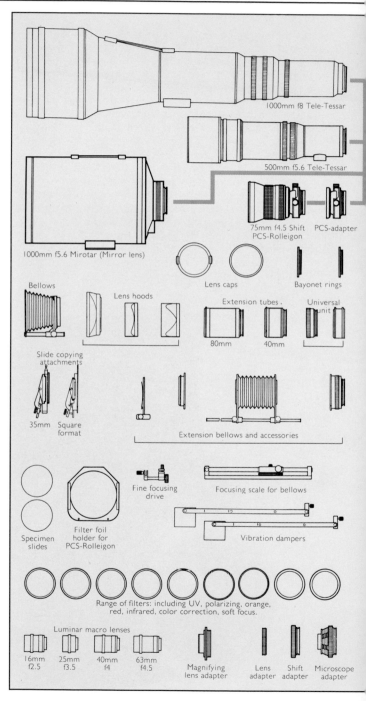

1000mm f8 Tele-Tessar

500mm f5.6 Tele-Tessar

75mm f4.5 Shift PCS-Rolleigon

PCS-adapter

1000mm f5.6 Mirotar (Mirror lens)

Lens caps

Bayonet rings

Bellows

Lens hoods

Extension tubes
80mm 40mm

Universal unit

Slide copying attachments

35mm Square format

Extension bellows and accessories

Fine focusing drive

Focusing scale for bellows

Specimen slides

Filter foil holder for PCS-Rolleigon

Vibration dampers

Range of filters: including UV, polarizing, orange, red, infrared, color correction, soft focus.

Luminar macro lenses

16mm f2.5 25mm f3.5 40mm f4 63mm f4.5

Magnifying lens adapter

Lens adapter

Shift adapter

Microscope adapter

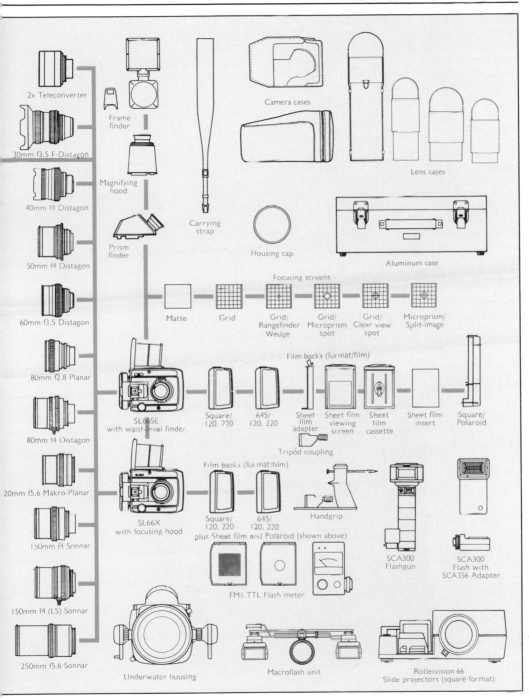

2x Teleconverter

30mm f3.5 F-Distagon

40mm f4 Distagon

50mm f4 Distagon

60mm f3.5 Distagon

80mm f2.8 Planar

80mm f4 Distagon

120mm f5.6 Makro-Planar

150mm f4 Sonnar

150mm f4 (LS) Sonnar

250mm f5.6 Sonnar

Frame finder

Magnifying hood

Prism finder

Carrying strap

Housing cap

Camera cases

Lens cases

Aluminum case

Focusing screens

Matte

Grid

Grid/ Rangefinder Wedge

Grid/ Microprism spot

Grid/ Clear view spot

Microprism/ Split-image

Film backs (format/film)

SL66SE with waist-level finder

Square/ 120, 220

645/ 120, 220

Sheet film adapter

Sheet film viewing screen

Sheet film cassette

Sheet film insert

Square/ Polaroid

Tripod coupling

Film backs (format/film)

SL66X with focusing hood

Square/ 120, 220

645/ 120, 220

plus Sheet film and Polaroid (shown above)

Handgrip

SCA300 Flashgun

SCA300 Flash with SCA356 Adapter

FM1 TTL Flash meter

Underwater housing

Macroflash unit

Rolleivision 66 Slide projectors (square format)

ROLLEIFLEX 6006/6002

Most manufacturers, when faced with the challenge of automating a medium-format camera with interchangeable backs, have opted for basically mechanical designs with electronic metering. Rollei have gone further: they have produced the most fully automated medium-format cameras available today. The 6006 is the original, professionally oriented design. The 6002, which has a fixed back and less expensive Rolleigon lenses (although it can also use all the 6006's lenses), is intended as a beginner's version. Both models feature a built-in motor drive (which advances the film and tensions the shutter after each exposure) and shutter-priority automatic through-the-lens metering.

The motor is a direct linear-drive design which has the advantage of not needing the usual springs, gears and levers. Its operating speed is 3 frames every 2 seconds, which is the same as that for the Bronica SQ-Am, but faster than the 1 frame per second of the Hasselblad 500ELX. The motor is fused for protection (0.8amp/250volt), and powered by a rechargeable NiCad battery pack. At full charge, about 600 exposures can be made at normal temperatures (around

1 *Viewing hood*
2 *Film magazine/back*
3 *Magazine/back release*
4 *Strap attachment*
5 *Shutter speed knob*
6 *Film speed indicator*
7 *Film speed setting dial*
8 *Mirror lock*
9 *Magazine release button*
10 *Remote accessories socket*
11 *Motor mode selector*
12 *Depth of field preview/exposure memory lock*
13 *Focusing ring*
14 *Aperture ring*
15 *Shutter release button*
16 *Cable release socket*
17 *Tripod attachment*

Rolleiflex 6006 with 80mm f2.8 Planar lens

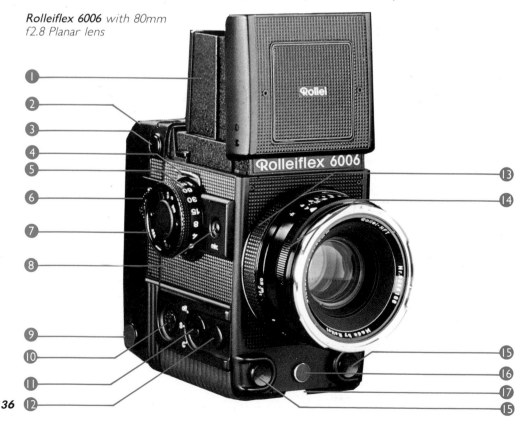

68°F/20°C) but this capacity falls with temperature. The remedy for cold-weather shooting is to carry the battery pack separately and in a warm place until you need to shoot. Battery failure leaves the camera useless.

The TTL metering system can be used automatically or manually. The measurement system is the usual lower-center-weighted pattern, and the reading compensates automatically for any stray light entering the body through the viewing screen. In automatic operation, the shutter speed is selected by means of the knob on the right side of the body, and is transferred electronically to the shutter in the lens. If the speed is too high or too low for the available range of aperture settings, a warning LED lights up in the viewfinder. The TTL flash metering system is virtually identical to that of the Rollei SL66 models (pages 32–33).

The 6002 has a choice of film inserts (120 and 220, both $2\frac{1}{4}\times2\frac{1}{4}$in/6×6cm and $1\frac{3}{4}\times2\frac{1}{4}$in/4.5×6cm), but these are not interchangeable in the sense that they can be switched in mid-roll. The 6006 magazines ($2\frac{1}{4}\times2\frac{1}{4}$in/6×6cm, $1\frac{3}{4}\times2\frac{1}{4}$in/4.5×6cm, 70mm and Polaroid) are fully interchangeable (right).

THE 6006 FILM MAGAZINE
To protect the film when changing backs in mid-roll, the 6006 magazine has a laminar roller blind – replacing the usual Hasselblad-style metal slide. It is operated by a sliding bar on the back of the magazine.

Rolleiflex 6002 with 80mm f2.8 Rolleigon lens

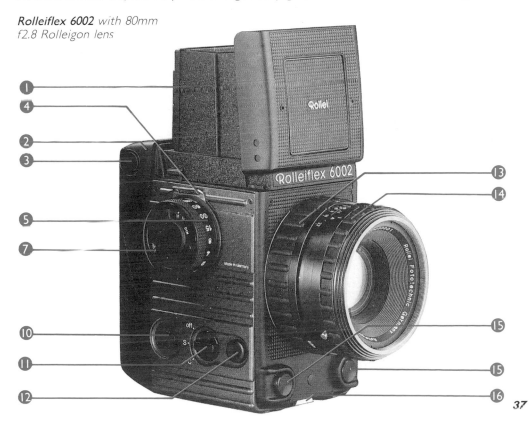

ROLLEIFLEX 6006/6002 SYSTEM

The Rolleigon lenses (50mm, 80mm, 150mm) have been designed to complement the 6002. They are less expensive than the rest of the range and, when used with the 2x converter, offer the beginner a relatively affordable selection of six focal lengths. However, the 6002 will accept all the other lenses in the system. Unlike the Rollei SL66X and SL66SE, which have a bellows focusing system (including a lens tilt mechanism), the only lens movements on offer to the 6002/6006 user are supplied by the 55mm f4.5 shift lens. Remote control is possible with the electrical hand-release accessory (MRC120); this can operate not only the shutter release but also the mirror lock-up/pre-release and the multiple exposure facility. At greater distances (up to 65yds/60m) the infrared transmitter/ receiver can be used.

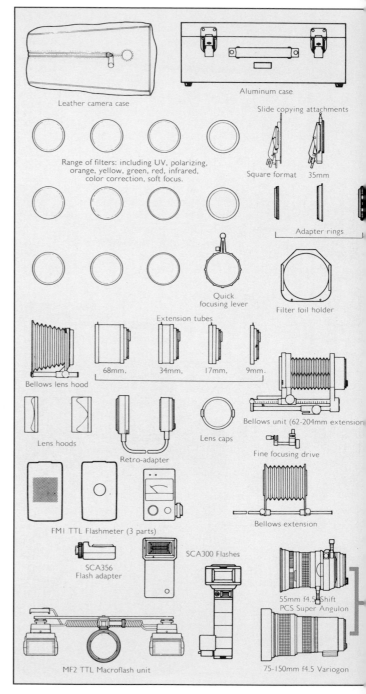

Leather camera case

Aluminum case

Slide copying attachments

Range of filters: including UV, polarizing, orange, yellow, green, red, infrared, color correction, soft focus.

Square format 35mm

Adapter rings

Quick focusing lever

Filter foil holder

Extension tubes

68mm. 34mm. 17mm. 9mm.

Bellows lens hood

Bellows unit (62-204mm extension)

Lens hoods

Retro-adapter

Lens caps

Fine focusing drive

FM1 TTL Flashmeter (3 parts)

Bellows extension

SCA356 Flash adapter

SCA300 Flashes

55mm f4.5 Shift PCS Super Angulon

MF2 TTL Macroflash unit

75-150mm f4.5 Variogon

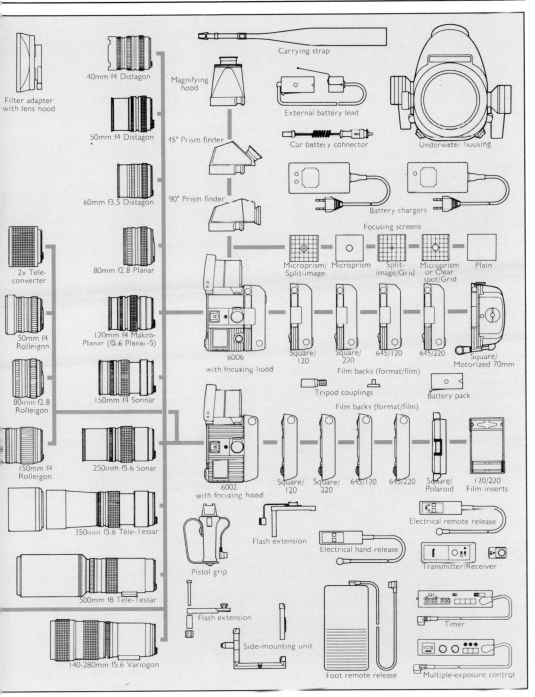

Filter adapter with lens hood

40mm f4 Distagon

50mm f4 Distagon

60mm f3.5 Distagon

80mm f2.8 Planar

120mm f4 Makro-Planar (f5.6 Planar -5)

150mm f4 Sonnar

250mm f5.6 Sonar

350mm f5.6 Tele-Tessar

500mm f8 Tele-Tessar

140-280mm f5.6 Variogon

2x Tele-converter

50mm f4 Rolleigon

80mm f2.8 Rolleigon

150mm f4 Rolleigon

Magnifying hood

45° Prism finder

90° Prism finder

Carrying strap

External battery lead

Car battery connector

Underwater housing

Battery chargers

Focusing screens

Microprism/ Split-image — Microprism — Split-image/Grid — Microprism or Clear spot/Grid — Plain

6006 with focusing hood

Square/ 120 — Square/ 220 — 645/120 — 645/220 — Square/ Motorized 70mm

Film backs (format/film)

Tripod couplings

Battery pack

Film backs (format/film)

6002 with focusing hood

Square/ 120 — Square/ 220 — 645/120 — 645/220 — Square/ Polaroid — 120/220 Film inserts

Pistol grip

Flash extension

Electrical hand release

Electrical remote release

Transmitter/Receiver

Flash extension

Side-mounting unit

Timer

Foot remote release

Multiple-exposure control

BRONICA SQ-A/SQ-Am

While by no means inexpensive, these standard Bronica models are competitively priced. As you can see from the photographs here, the SQ-A and SQ-Am bear more than a passing resemblance to the Hasselblad 500C/M and 500ELX – they have the same box-like body, bayonet-mounting lenses, hinged snap-on film magazines, right-hand film crank (SQ-A only) and a range of slide-on viewfinders. The standard of finish and detail may not be quite up to the same level, but it is certainly high. Fortunately, Bronica have not been content simply to copy its more expensive competitor: it has also made some useful improvements. At slightly more than half the price of their Hasselblad equivalents, the SQ models provide an entry into medium-format for many amateurs.

The difference between the two models is that the SQ-Am is motorized. The motor uses 6 AA batteries in the hand-grip to advance the film and cock the shutter; the maximum continuous firing rate is 3 frames every 2 seconds. This shooting speed is not as high as that of the Hasselblad 500ELX, but is equal to that of the Rollei 6006/6002.

The SQ-A and SQ-Am are both $2\frac{1}{4} \times 2\frac{1}{4}$in/6×6cm leaf-shutter cameras. The electronic between-the-lens shutter is linked to the shutter speed dial on the left-hand side of the camera body and is powered by a 6 volt battery. Battery failure causes the shutter to trip at $\frac{1}{500}$sec – not the most useful speed.

1 Viewing hood
2 Flash sync socket
3 Film winding crank
4 Focusing ring
5 Aperture ring
6 Lens release button
7 Depth of field preview
8 Shutter speed scale
9 Back cover release
10 Battery check button
11 Shutter speed dial
12 Dark slide slit
13 Film plane indicator
14 Camera strap stud
15 Film magazine
16 Film back release
17 Remote release socket
18 Motor-drive button
19 Mode selector switch (single/continuous/off)
20 Hot shoe
21 Shutter release button
22 Hand strap
23 Motorized hand grip

Bronica SQ-A with 80mm f2.8 Zenzanon PS lens

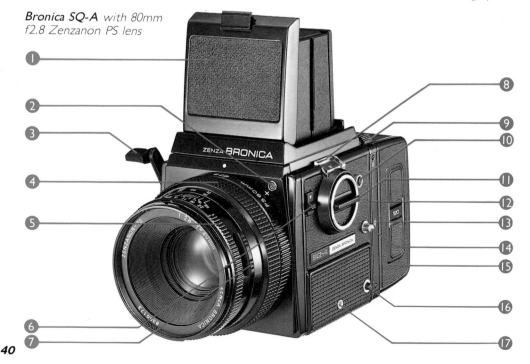

40

The metering system is an integral part of the camera body, but needs one of the prism heads to activate it. The latest prism finder is the AE model S, which gives a noticeably brighter screen image than the Hasselblad meter Prism Finder PME; it can operate either automatically or manually. It is an aperture-priority system with stepless speeds: hence the need for electronic control of the leaf shutters. The film speed dial on each film magazine automatically transmits its information to the AE finder. When the metering system is in manual mode, the recommended shutter speed is given by a blinking LED display – disappointingly, the actual shutter speed is not displayed.

The mirror lock-up selector lever on the right side of the camera body has three positions: "N" for normal shooting without mirror lock-up; "S" for locking the mirror for a single exposure; "C" which locks the mirror until the lever is returned to "N".

The film backs, which fit the camera body by hinging at the top, cover the basic range of 120 and 220 film (but not 70mm), $2\frac{1}{4}\times2\frac{1}{4}$in/6x6cm and $1\frac{3}{4}\times2\frac{1}{4}$in/4.5x6cm formats (but not vertical $2\frac{1}{4}\times1\frac{3}{4}$in/6x4.5cm), and Polaroid. In addition, there are two backs for 35mm film, one giving the standard $\frac{15}{16}\times1\frac{7}{16}$in/24x36mm format, the second giving an unusual $\frac{15}{16}\times2\frac{1}{8}$in/24x54mm panoramic frame.

Bronica SQ-Am with 80mm f2.8 lens

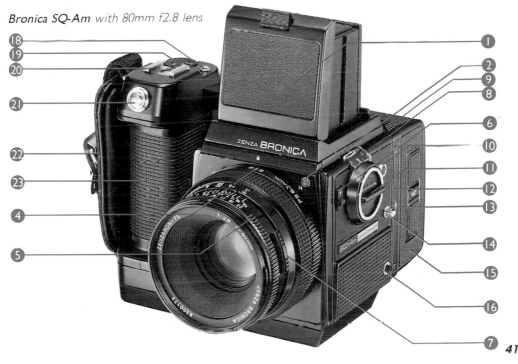

BRONICA SQ-A/SQ-Am SYSTEM

The accessory range for both cameras is modest but useful, including a choice of viewers, close-up bellows, extension tubes and supplementary lenses (for close-up work), lens shades, grips and remote battery packs.

The Zenzanon-PS lenses range from a 40mm wide-angle to a 500mm telephoto. The emphasis is on the middle of the focal length range – the 110mm, 150mm, 200mm and 250mm lenses are quite closely spaced. Other useful lenses include two Variogon zoom lenses (75–150mm and 140–280mm) and a wide-angle Super-Angulon shift lens with $\frac{15}{16}$in/24mm total travel from left to right and $\frac{7}{8}$in/22mm vertically.

THE SPEED GRIP
This right-hand, manual grip increases the handling speed of the SQ-A. It attaches to the base of the camera and incorporates a 35mm-style winding lever, which advances the film and cocks the shutter, as well as a shutter release button and flash hot shoe.

FOCUSING SCREENS
The standard screen has the usual split-image spot in the center, surrounded by a microprism ring. The two 35mm screens, which are masked horizontally to provide the correct frame width, have vertical guide lines defining the $\frac{15}{16} \times 1\frac{7}{16}$in/ 24x36mm and $\frac{15}{16} \times 2\frac{1}{8}$in/ 24x54mm format sizes.

Standard

Microprism Split-image

35mm

Matte Grid-lines Microprism/ Matte
 Split-image

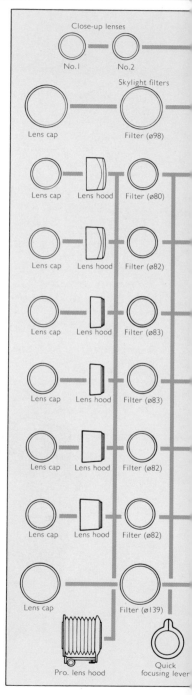

Close-up lenses
No.1 No.2

Skylight filters

Lens cap Filter (ø98)

Lens cap Lens hood Filter (ø80)

Lens cap Lens hood Filter (ø82)

Lens cap Lens hood Filter (ø83)

Lens cap Lens hood Filter (ø83)

Lens cap Lens hood Filter (ø82)

Lens cap Lens hood Filter (ø82)

Lens cap Filter (ø139)

Pro. lens hood Quick focusing lever

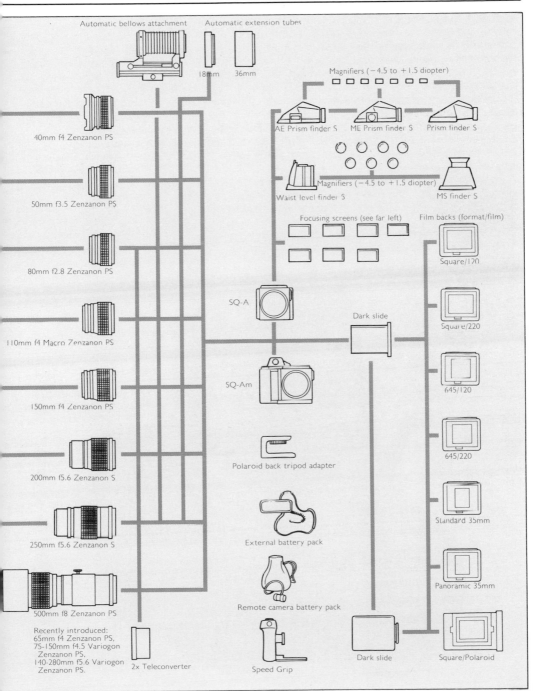

Automatic bellows attachment

Automatic extension tubes

18mm 36mm

Magnifiers (−4.5 to +1.5 diopter)

AE Prism finder S ME Prism finder S Prism finder S

40mm f4 Zenzanon PS

Magnifiers (−4.5 to +1.5 diopter)

Waist level finder S MS finder S

50mm f3.5 Zenzanon PS

Focusing screens (see far left) Film backs (format/film)

Square/120

80mm f2.8 Zenzanon PS

SQ-A

Dark slide

Square/220

110mm f4 Macro Zenzanon PS

645/120

150mm f4 Zenzanon PS

SQ-Am

645/220

200mm f5.6 Zenzanon S

Polaroid back tripod adapter

Standard 35mm

250mm f5.6 Zenzanon S

External battery pack

Panoramic 35mm

500mm f8 Zenzanon PS

Remote camera battery pack

Recently introduced:
65mm f4 Zenzanon PS,
75-150mm f4.5 Variogon
Zenzanon PS,
140-280mm f5.6 Variogon
Zenzanon PS.

2x Teleconverter Speed Grip Dark slide Square/Polaroid

BRONICA *GS-1*

In most respects, Bronica's GS-1 is a slightly larger version of the Bronica SQ-A, designed to compete with other $2\frac{1}{4}\times2\frac{3}{4}$in/ 6x7cm cameras, such as the Mamiya 67 models. This compact, lightweight Hasselblad-style camera (4lb/1.8kg in its basic configuration with the standard 100mm lens) is certainly easier to hand-hold than the 5lb 15oz/2.7kg Mamiya RB67.

Although the relative simplicity of the GS-1 is a good feature, it has been achieved at the cost of being able to change from a horizontal to a vertical picture frame. The GS-1 is designed for shooting horizontal $2\frac{1}{4}\times2\frac{3}{4}$in/6x7cm images. There is no revolving back, as there is in the Mamiya 67 models – not even a $2\frac{3}{4}\times2\frac{1}{4}$in/7x6cm interchangeable back. With a rotating eye-level prism finder, the camera can be turned on its side, but then holding and firing become awkward. With only a waist-level viewer, vertical shooting is almost impossible.

All the main features are comparable to those of the Bronica SQ-A. The electronic between-the-lens shutter

1 *Viewing hood*
2 *Film winding crank*
3 *Focusing ring*
4 *Aperture ring*
5 *Depth of field preview*
6 *Film magazine*
7 *Shutter speed indicator*
8 *Main switch*
9 *Shutter speed selector dial*
10 *Flash sync socket*
11 *Camera strap attachment*
12 *Lens release*
13 *Film magazine release*
14 *Mirror lock*

Bronica GS-1 *with 100mm f3.5 Zenzanon PG lens*

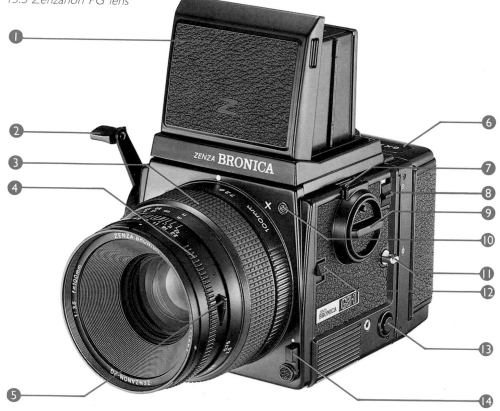

means that remote control is possible, by means of any switched cable ending in a $\frac{1}{8}$in/2.5mm miniature jack plug (there is no connection for an ordinary cable release). The remote release facility can be used to reduce camera vibration during shooting, and is most useful when the mirror is locked up (although the procedure for locking up the mirror is complicated and causes the loss of one frame). Shutter speeds (selected by a dial on the left side of the body) range from 16 seconds and "B" to $\frac{1}{500}$sec. There is a special "A" setting for automatic exposure with the AE Prism Finder.

The range of interchangeable backs is considerable: $2\frac{1}{4}$x$2\frac{3}{4}$in/6x7cm, $2\frac{1}{4}$x$2\frac{1}{4}$in/6x6cm, $1\frac{3}{4}$x$2\frac{1}{4}$in/4.5x6cm and $2\frac{1}{4}$x$1\frac{3}{4}$in/6x4.5cm for 120 and 220 roll-film, a standard $\frac{15}{16}$x$1\frac{7}{16}$in/24x36mm frame size for 35mm film, another for panoramic $\frac{15}{16}$x$2\frac{3}{4}$in/24x69mm images, and a Polaroid back. Film speed dials on each magazine link electronically with the AE metering head, and there is also an exposure compensation dial for manual override of the automatic exposure setting.

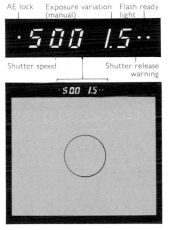

AE lock | Exposure variation (manual) | Flash ready light

Shutter speed | Shutter release warning

EXPOSURE METERING
The GS-1 has two metered viewfinders: the AE Prism Finder G and the AE Rotary Finder G. The Prism Finder has an aperture-priority metering system (manual or automatic) which takes average, center-weighted readings; these are displayed on a 7-segment LED display (above). In addition, the Rotary Finder has a spot meter which uses the center spot in the viewfinder.

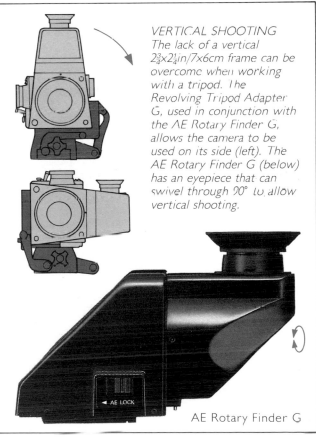

VERTICAL SHOOTING
The lack of a vertical $2\frac{3}{4}$x$2\frac{1}{4}$in/7x6cm frame can be overcome when working with a tripod. The Revolving Tripod Adapter G, used in conjunction with the AE Rotary Finder G, allows the camera to be used on its side (left). The AE Rotary Finder G (below) has an eyepiece that can swivel through 90° to allow vertical shooting.

AE Rotary Finder G

AE LOCK

45

BRONICA GS-1 SYSTEM

This system has a good selection of the basic elements (such as lenses, interchangeable film backs, and viewfinders), but few frills. The range of lenses stretches from 50mm up to 500mm, but lacks a zoom or shift lens. One noticeable omission is the lack of a motor drive. However, there is one non-motorized accessory that can be used to improve the GS-1's handling speed, namely the manual Speed Grip. When the Grip is combined with the Speed Light G-1 flash unit, an automatic off-the-film metering system comes into play. This measures the amount of light reflected off the surface of the film, and uses this information to control the discharge from the flash unit. The flash head can be swiveled in order to bounce the light off a ceiling or wall. For close-up work the Bellows attachment is useful.

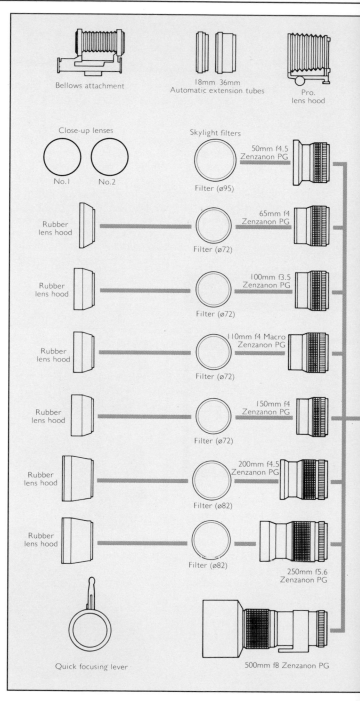

Bellows attachment

18mm 36mm
Automatic extension tubes

Pro.
lens hood

Close-up lenses

No.1 No.2

Skylight filters

Filter (ø95)

50mm f4.5
Zenzanon PG

Rubber
lens hood

Filter (ø72)

65mm f4
Zenzanon PG

Rubber
lens hood

Filter (ø72)

100mm f3.5
Zenzanon PG

Rubber
lens hood

Filter (ø72)

110mm f4 Macro
Zenzanon PG

Rubber
lens hood

Filter (ø72)

150mm f4
Zenzanon PG

Rubber
lens hood

Filter (ø82)

200mm f4.5
Zenzanon PG

Rubber
lens hood

Filter (ø82)

250mm f5.6
Zenzanon PG

Quick focusing lever

500mm f8 Zenzanon PG

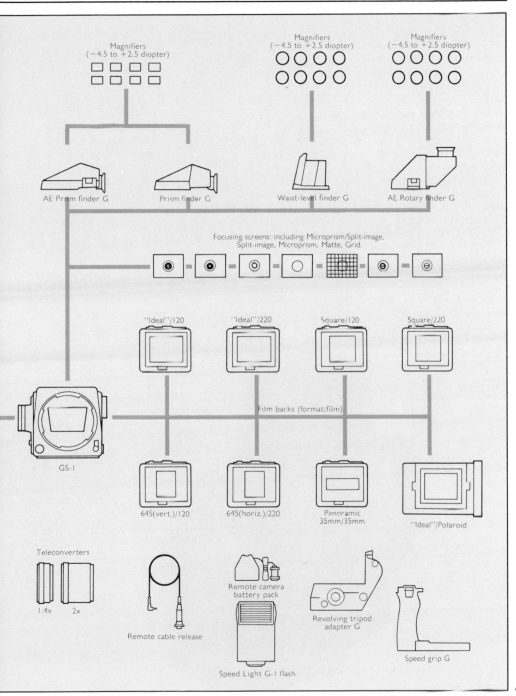

Magnifiers
(−4.5 to +2.5 diopter)

Magnifiers
(−4.5 to +2.5 diopter)

Magnifiers
(−4.5 to +2.5 diopter)

AE Prism finder G

Prism finder G

Waist-level finder G

AE Rotary finder G

Focusing screens: including Microprism/Split-image,
Split-image, Microprism, Matte, Grid.

"Ideal"/120

"Ideal"/220

Square/120

Square/220

Film backs (format/film)

GS-1

645(vert.)/120

645(horiz.)/220

Panoramic
35mm/35mm

"Ideal"/Polaroid

Teleconverters

1.4x 2x

Remote cable release

Remote camera
battery pack

Revolving tripod
adapter G

Speed grip G

Speed Light G-1 flash

FUJI *GX680*

This large, electronic reflex camera is designed to have the versatility of a professional studio view camera, with little attempt to make it easy to handle or quick to use. This lack of compromise – the GX680 weighs 10lb 2oz/4.6kg – has made it possible to produce a camera that has every lens movement (opposite page, left). The GX680 has a range of interchangeable lenses (far right) and two film backs; the backs offer a choice between a 120 and 220 version of the full $2\frac{1}{4} \times 3\frac{1}{8}$in/6x8cm frame, both rotating through 90° to give the option of vertical or horizontal shooting. The viewfinder is automatically masked when in horizontal mode.

A central microprocessor controls the lens shutter, exposure measurements and film winding (including continuous exposure of up to 1 frame per second). Automation even extends to loading the first frame without your having to match the start mark on the film leader (pages 98–99). The exposure system is unusual in that it has off-the-film metering and is used only to monitor rather than to control the exposure: it simply displays an under- or over-exposure warning in the viewfinder (there is an audible warning when you use remote control). The shutter and aperture have to be set manually. A TTL aperture-priority exposure meter is available in the Angle Finder accessory. Power is supplied by a rechargeable NiCad battery pack or DC supply.

1 *Waist-level finder*
2 *Film back*
3 *Exposure monitor display/battery check*
4 *Shutter speed dial*
5 *Motor-drive mode selector*
6 *Remote control socket*
7 *Mirror mode selector*
8 *Flash sync test button*
9 *Lens movement control knobs*
10 *Focusing knob*
11 *Bellows*
12 *Flash hot shoe*
13 *Aperture dial*
14 *Lens release*

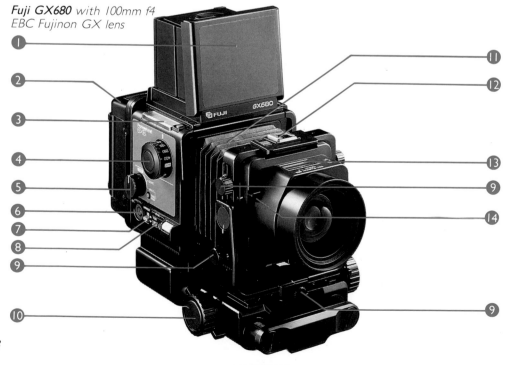

Fuji GX680 with 100mm f4 *EBC Fujinon GX lens*

LENS MOVEMENTS

The range of lens movements offered by the GX680 allows you to control depth of field to the maximum advantage and to alter the perspective of the image. (This is explained on page 89.) The range includes a $\frac{5}{8}$in/15mm rise, $\frac{1}{2}$in/13mm fall, $\frac{5}{8}$in/15mm shift (left/right), 12° tilt (up/down), and 12° swing (left/right) – the exact size of each movement depends on the lens and whether shift and tilt/swing movements are used together. Also shown here (right) is the viewfinder mask for the horizontal $2\frac{1}{4}$x$3\frac{1}{4}$in/6x7cm format.

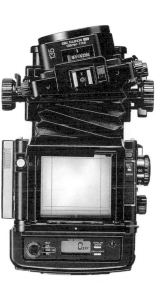

EBC FUJINON GX LENSES

In keeping with the GX680's intended studio use, the range of lens focal lengths is restricted and closely spaced. Apart from the 80mm lens which takes 95mm (screw) filters, all the lenses can be fitted with 82mm (screw) filters. A list of the GX680's interchangeable lenses is given below:

80mm f5.6 EBC Fujinon GX
100mm f4 EBC Fujinon GX
125mm f5.6 EBC Fujinon GX
135mm f5.6 EBC Fujinon GX
150mm f4.5 EBC Fujinon GX
180mm f5.6 EBC Fujinon GX
210mm f5.6 EBC Fujinon GX
250mm f5.6 EBC Fujinon GX
300mm f6.3 EBC Fujinon GX

FUJI GX680 ACCESSORIES

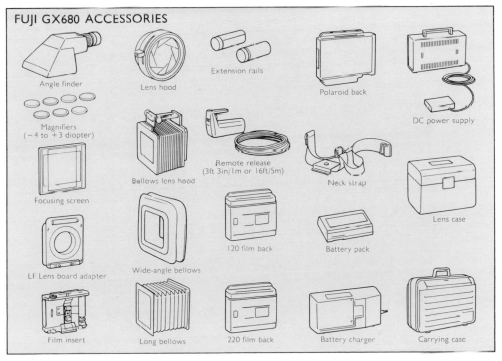

Angle finder

Lens hood

Extension rails

Polaroid back

Magnifiers (−4 to +3 diopter)

DC power supply

Focusing screen

Bellows lens hood

Remote release (3ft 3in/1m or 16ft/5m)

Neck strap

Lens case

LF Lens board adapter

Wide-angle bellows

120 film back

Battery pack

Film insert

Long bellows

220 film back

Battery charger

Carrying case

PENTAX 6x7

This camera has two great advantages. One is its range of lenses (pages 52–53). The other is that it can be used rapidly, hand-held, and in the kind of situations for which most people would choose 35mm equipment. What the Pentax 6x7 lacks in system versatility – there are, for example, no interchangeable backs – it gains in ease of handling.

The 6x7 is easy to hold and operate, but with one precaution: if you are in the habit of supporting a 35mm camera by gripping the sides, this technique does not transfer well to the larger, heavier Pentax 6x7. It is better to support most of the weight with the heel of the left hand, leaving the right hand free to manipulate the lens, winding lever and shutter release.

All the external components are the same as in a 35mm camera, from the eye-level pentaprism to the thumb-stroke winding lever. (The frame counter is situated on the top of the winding lever.) The Pentax also uses a 35mm-style film transport system, with the film wound directly from the film spool on the left to the take-up spool on the right. However, the size of roll-film means that you have to take extra care

1 TTL Pentaprism
2 Winding lever
3 Shutter release
4 Exposure counter
5 Shutter release lock
6 120/220 film selector
7 Camera strap lug
8 Mirror lock
9 Battery check lamp
10 Shutter speed dial
11 Shutter speed winder
12 Depth of field preview button
13 Aperture ring
14 Focusing ring

Pentax 6x7 with 105mm f2.4
SMC Takumar lens

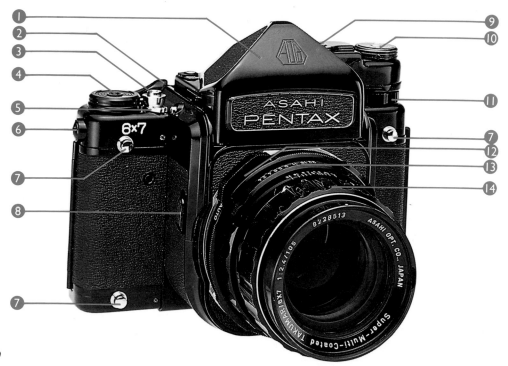

with the loading, as explained on pages 98–99. The lack of interchangeable backs means that the only way to change film in the middle of a shoot is to use a second body. The camera will accept both 120 and 220 film.

The focal-plane shutter has a range of speeds from 1 to $\frac{1}{1000}$ sec, with "B" and "X" settings as well. (For electronic flash, use either the "X" setting or $\frac{1}{30}$ sec or slower. For timed exposures, turn the shutter speed dial to "B" and lock the shutter release.) The shutter is electronically controlled and needs a 6 volt silver oxide or alkaline battery; power failure triggers a safety mechanism that halts the mirror part way, preventing any further shooting.

The instant-return mirror action is solid and heavy – not surprising for a camera of this size. This means that the vibration it produces can cause blurring at $\frac{1}{30}$ sec or slower, even when the camera is mounted on a tripod. At slower speeds it is therefore necessary not only to use a tripod but also to lock up the mirror (the lever is situated on the right-hand side of the mirror chamber). You should also do this when using the bellows or any of the longer lenses.

SLR EYE-LEVEL MODELS

ADVANTAGES
* Through-the-lens viewing
* No parallax problems
* Depth of field preview available on most lenses
* Easy handling, familiar to a 35mm user
* Lens movements available
* Suitable for action photography

DISADVANTAGES
* No Polaroid back
* Heavy: the lightest model is 4lb 3oz/1,900g
* No motor drive
* Bulky compared with the rangefinder design

FILM TRANSPORT
The usual "double-back" transport system, as used by Hasselblad, presents a flat film surface to the incoming light by tensioning the film over two rollers. In contrast, the "straight-path" system in the Pentax 6x7 uses a pressure plate to keep the film flat. This design allows the Pentax to be thinner, but also wider, than the Hasselblad.

"Double-back" system

"Straight-path" system

120/220 FILM
When changing from 120 to 220 film, proceed as follows.
1 Open the film back. Press down on the pressure plate and slide it to the right, until it clicks into place.
2 To verify that the plate is in the right position, check "220" appears in the window on the camera back.
3 Set the film type selector dial (situated at the right-hand end of the body) to "220"; this can be done with the edge of a coin. If you

forget, the selector can still be changed after the film has been loaded, provided that you have not exposed more than 9 frames. Finally, load the 220 film as shown on pages 98–99.

PENTAX 6x7 SYSTEM/1

The Pentax 6x7 system has the largest range of lenses of any full-size medium-format camera. Of special note are the long telephoto lenses which give the Pentax a strong edge in areas such as wildlife and sports photography.

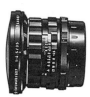

35mm f4.5 Fish-eye SMC Takumar

45mm f4 SMC Pentax

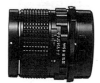

55mm f4 SMC Pentax

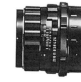

75mm f4.5 SMC Takumar

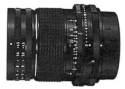

75mm f4.5 Shift SMC Pentax

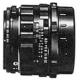

90mm f2.8 SMC Takumar

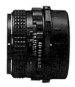

90mm f2.8 SMC Pentax

105mm f2.4 SMC Takumar

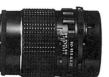

135mm f4 Macro SMC Takumar

165mm f2.8 SMC Pentax

200mm f4 SMC Takumar

2x Rear converter

600mm f4 SMC Takumar

800mm f4 SMC Takumar

300mm f4 SMC Takumar

400mm f4 SMC Takumar

500mm f5.6 SMC Pentax

800mm f4 ED(IF) SMC Pentax-M

1000mm f8 SMC Reflex-Takumar

1.4x Rear converter

PENTAX 6x7 SYSTEM/2

The strongest feature of this system is the large range of lenses (pages 52–53). To complement this range there is a moderate selection of extension tubes, lens hoods, glass filters, gelatin filter frames (which will accept the standard 3x3in/7½x7½cm square filters) and focusing screens. There is also a K-Mount Adapter which permits the 6x7's lenses to be used with bayonet-mounting 35mm cameras.

One accessory that is designed specifically for fieldwork is the Remote Battery Cord. In extremely cold conditions, the camera's battery may lose its voltage, causing the electronic shutter to malfunction. This can be avoided by removing the battery to a warm place, such as a pocket. The battery is then connected to the camera by the Remote Battery Cord.

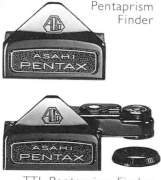

Pentaprism Finder

TTL Pentaprism Finder

PENTAPRISM FINDERS
The standard Pentaprism Finder is compact, light (16oz/460g) and offers a bright, laterally-corrected view. The manual, metered TTL Pentaprism Finder automatically couples to the shutter speed dial (situated on the left-hand end of the camera) and the aperture. The meter takes average readings, and has a simple over- or under-exposure display in the viewfinder.

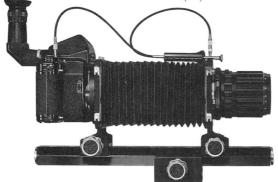

AUTO BELLOWS SET
This includes a bellows, adjustable monorail and double cable release. The set is designed for close-up photography (pages 196–197), offering a range of magnifications from 0.5x to 3.3x. It can be used with all the lenses from 90mm to 300mm. When the TTL Pentaprism Finder is fitted, the exposure meter automatically compensates for the reduced amount of light reaching the film.

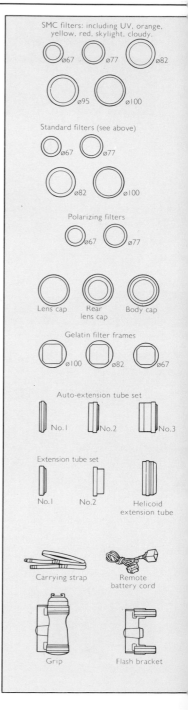

SMC filters: including UV, orange, yellow, red, skylight, cloudy.
ø67 ø77 ø82
ø95 ø100

Standard filters (see above)
ø67 ø77
ø82 ø100

Polarizing filters
ø67 ø77

Lens cap Rear lens cap Body cap

Gelatin filter frames
ø100 ø82 ø67

Auto-extension tube set
No.1 No.2 No.3

Extension tube set
No.1 No.2 Helicoid extension tube

Carrying strap Remote battery cord

Grip Flash bracket

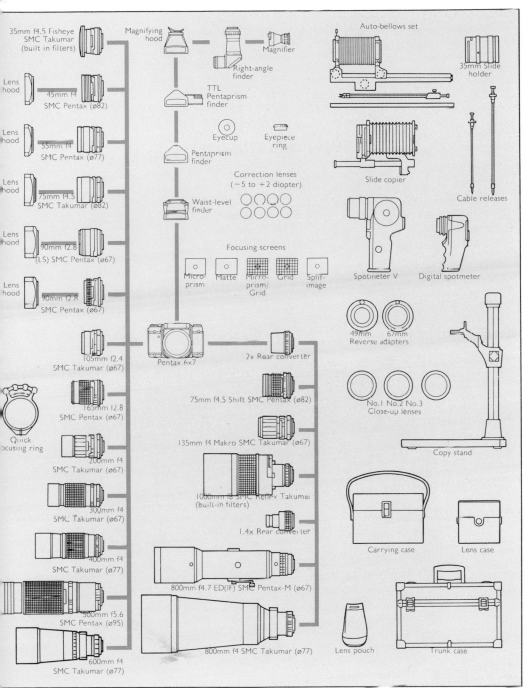

35mm f4.5 Fisheye
SMC Takumar
(built in filters)

Magnifying
hood

Magnifier

Right-angle
finder

Auto-bellows set

35mm Slide
holder

Lens
hood

45mm f4
SMC Pentax (ø82)

TTL
Pentaprism
finder

Lens
hood

55mm f4
SMC Pentax (ø77)

Eyecup

Eyepiece
ring

Slide copier

Cable releases

Lens
hood

75mm f4.5
SMC Takumar (ø82)

Pentaprism
finder

Lens
hood

90mm f2.8
(LS) SMC Pentax (ø67)

Correction lenses
(−5 to +2 diopter)

Waist-level
finder

Lens
hood

90mm f2.8
SMC Pentax (ø67)

Spotmeter V

Digital spotmeter

Focusing screens

Micro-
prism

Matte

Micro-
prism/
Grid

Grid

Split-
image

105mm f2.4
SMC Takumar (ø67)

Pentax 6x7

2x Rear converter

49mm 67mm
Reverse adapters

Quick
focusing ring

165mm f2.8
SMC Pentax (ø67)

75mm f4.5 Shift SMC Pentax (ø82)

No.1 No.2 No.3
Close-up lenses

200mm f4
SMC Takumar (ø67)

135mm f4 Makro SMC Takumar (ø67)

300mm f4
SMC Takumar (ø67)

1000mm f8 SMC Reflex Takumar
(built-in filters)

Copy stand

400mm f4
SMC Takumar (ø77)

1.4x Rear converter

Carrying case

Lens case

500mm f5.6
SMC Pentax (ø95)

800mm f4.7 ED(IF) SMC Pentax-M (ø67)

600mm f4
SMC Takumar (ø77)

800mm f4 SMC Takumar (ø77)

Lens pouch

Trunk case

EXACTA 66

There is a no-nonsense approach to every aspect of this solid, robust $2\frac{1}{4} \times 2\frac{1}{4}$ in/6x6cm camera. The Exacta 66 is essentially a scaled-up 35mm SLR, designed primarily as a field camera, for quite rapid handling. The rubber covering gives a good grip and the angled shutter release on the front is well-sited (the Exacta is a tall model, so the conventional top-plate position for the shutter release would be an awkward stretch for the forefinger). Just enough electronics have been incorporated to allow manual, through-the-lens (TTL) metering when the Prism Finder is fitted.

Like the Pentax 6x7, there is a 35mm-style film transport system (pages 50–51) which uses an adjustable pressure plate to keep the film flat. The winding lever is stubby, needing a full single stroke to advance the film which can be either 120 (12 exposures) or 220 (24 exposures).

The shutter speed selector dial is on the left-hand end of the top plate, and is large and easy to work. The mechanical focal-plane shutter has a range of speeds from "B" and 1 second to $\frac{1}{1000}$ sec; less satisfactory is the flash sync speed – only $\frac{1}{25}$ sec.

An original feature is the tripod-style support, which lets the camera sit perfectly level on a flat surface – achieved by enlarging the two film spool retainers and adding a third

1 *Prism release*
2 *Winding lever (incorporates exposure counter)*
3 *Shutter release*
4 *Self-timer*
5 *Cable socket*
6 *Tripod support*
7 *Prism*
8 *Aperture ring*
9 *Focusing ring*

Exacta 66 *with 80mm f2.8 Xenotar MF lens*

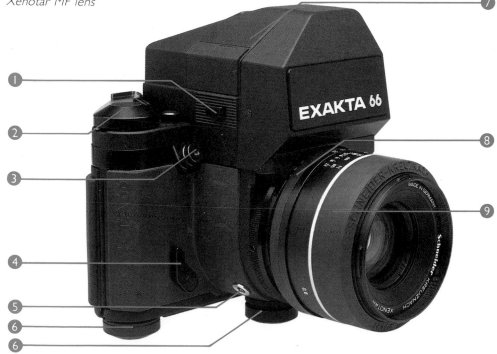

projection under the mirror box. This support makes it possible to do without a tripod for some time-exposures.

The mirror is not instant-return, which means that you have to wind the film on before it is possible to see the next image – a considerable inconvenience when rapid hand-held shooting is required.

The metering system, on the other hand, does help to make the camera competitive. Powered by a single 6 volt battery, the TTL Prism Finder takes center weighted readings for films rated between ISO 12 and ISO 3200. This is a semi-automatic system in which the shutter speed and/or aperture are adjusted manually to give a match-setting (right). This is displayed twice – inside the viewfinder, and on an LCD panel on top of the prism.

All the lenses are made by Schneider, and so of top quality. The standard lens is an 80mm f2.8 Xenotar MF. A Super Angulon shift lens, the 55mm PCS f4.5, allows $\frac{9}{32}$in/7mm movement in all directions for perspective control. The 2x Teleconverter can be used with all the lenses to double the focal length while retaining the automatic aperture function and metering; the bellows extension can be used with the 28mm, 50mm, 135mm and 180mm.

VIEWFINDER DISPLAY
When the through-the-lens prism finder is fitted, the aperture setting and exposure reading are displayed on the left-hand side of viewfinder (above): plus means over-exposed, zero means correct exposure, minus means under-exposed.

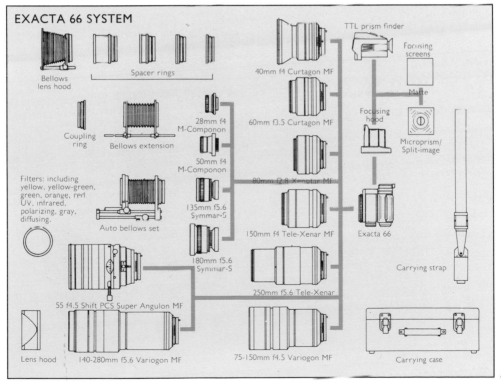

EXACTA 66 SYSTEM

Bellows lens hood

Spacer rings

40mm f4 Curtagon MF

TTL prism finder

Focusing screens

Matte

Coupling ring

Bellows extension

28mm f4 M-Componon

60mm f3.5 Curtagon MF

Focusing hood

Microprism/ Split-image

Filters: including yellow, yellow-green, green, orange, red, UV, infrared, polarizing, gray, diffusing.

50mm f4 M-Componon

80mm f2.8 Xenotar MF

Auto bellows set

135mm f5.6 Symmar-S

150mm f4 Tele-Xenar MF

Exacta 66

180mm f5.6 Symmar-S

Carrying strap

55 f4.5 Shift PCS Super Angulon MF

250mm f5.6 Tele-Xenar

Lens hood

140-280mm f5.6 Variogon MF

75-150mm f4.5 Variogon MF

Carrying case

MAMIYA *M645 1000S/SUPER*

In 1975, Mamiya launched the first camera in a new, small medium-format — $1\frac{3}{4}\times2\frac{1}{4}$in/4.5×6cm — which bridged the gap between 35mm and the full-sized $2\frac{1}{4}\times2\frac{1}{4}$in/6×6cm format. This miniature medium-format combines the advantages of interchangeable components with the ease of handling associated with a 35mm single-lens reflex camera. The M645 1000S is the older, more basic model. It has been superseded by the more expensive M645 SUPER, which has been designed along cleaner ergonomic lines, and has a more flexible system. The 645 format is certainly a popular way for many amateurs to enter roll-film photography.

The M645 SUPER camera, at 2lb/895gm, compares favorably with the full-sized Hasselblad 500C/M (3lb 5oz/1.5kg), but is slightly heavier than a typical 35mm camera such as the Pentax LX (1lb 13oz/820gm). However, combined with the eye-level AE Prism Finder and the right-hand Power Drive accessory, the M645 SUPER is considerably easier to use than a full-sized medium-format model.

The M645 SUPER is small and light enough to be comfortably held on its side for vertical shooting; this overcomes the lack of any interchangeable vertical-format

1 *AE Prism finder*
2 *Film speed dial*
3 *Finder release button*
4 *Film back*
5 *Exposure counter*
6 *Shutter speed dial*
7 *Power drive shutter release*
8 *Power drive selector dial*
9 *Power drive release*
10 *Hand grip*
11 *Exposure compensation dial*
12 *Exposure meter selector*
13 *Aperture ring*
14 *Focusing ring*
15 *Shutter release*
16 *Shutter release lock*

Mamiya M645 SUPER with 80mm f2.8 Mamiya-Sekor C lens

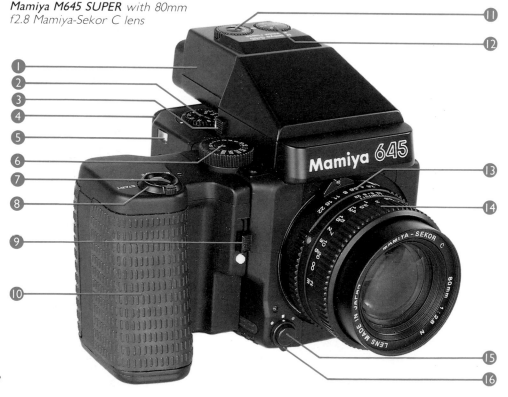

magazines or a revolving magazine system, as used by the larger Mamiya 67 models. All the film magazines take inserts which can be pre-loaded and used to speed up film changing in the middle of a shoot. Each magazine also has a speed dial that links it, through a strip of contacts, to the camera's electronics.

Apart from the 120 and 220 film magazines for the standard $1\frac{3}{4} \times 2\frac{1}{4}$in/4.5x6cm frame, there is a choice of a 35mm film magazine and a Polaroid back (although the image on an instant print is more difficult to judge than usual as the picture is that much smaller). It is possible to obtain 15 exposures on one roll of 120 film (compared with the usual 12), and 30 exposures on 220 film.

The focal-plane shutter speeds range from "B" and 4 seconds to $\frac{1}{1000}$sec, with a flash sync speed of $\frac{1}{60}$sec.

The M645 1000S is basically similar to the M645 SUPER, but lacks interchangeable film backs and a mechanical back-up speed for when the electronics fail (the M645 SUPER's back-up speed is $\frac{1}{60}$sec). Also, the 1000S's AE Prism Finder takes only average, center-weighted readings, unlike the SUPER's more sophisticated meter (below).

SLR 645 MODELS

ADVANTAGES
* TTL viewing
* No parallax problems
* Depth of field preview with most lenses
* Easy to handle, familiar to the 35mm user
* Eye-level viewing usual

DISADVANTAGES
* Relatively small negative size reduces the image quality available
* No alternative formats available (except 35mm with some models)
* Lens movements and Polaroid back available on some models

EXPOSURE CONTROL
When the AE Prism Finder is fitted to the M645 SUPER, the camera electronically links the finder to the film back, shutter and aperture ring to give aperture-priority exposure control. It offers a choice between average metering, spot metering and an automatic setting in which the finder chooses between average and spot metering, depending on the light.

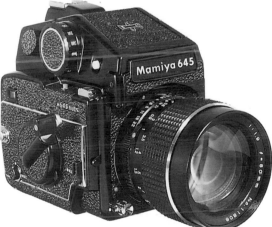

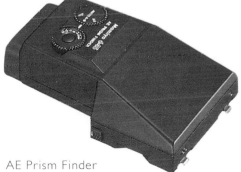

AE Prism Finder

Mamiya M645 1000S with 80mm f1.9 Mamiya-Sekor C lens. This is the only model still in production from the old M645/J/1000S series. Like the newer M645 SUPER, it has a focal-plane shutter, with a top speed of $\frac{1}{1000}$sec. Unlike the SUPER it has a fixed back, but can take inserts for 120 or 220 film. **59**

As the M645 1000S has been superseded by the SUPER, only the SUPER's system is shown here.

The M645 1000S system is very similar to that of the SUPER but the accessories are not interchangeable, with one important exception: all the lenses can be used with either camera. The strongest feature of the SUPER's system is the large range of lenses. All are shutterless (except for a 70mm leaf-shutter lens which allows flash synchronization up to $\frac{1}{500}$sec). The range includes a 24mm fisheye, 50mm shift, 80mm macro and 145mm soft focus lens. The three extension rings can be used with the standard 80mm lens to give up to life-size images. When the Power Drive accessory is fitted, the electronic shutter can be remotely triggered from a distance of 65yds/60m using the infrared remote control transmitter/receiver.

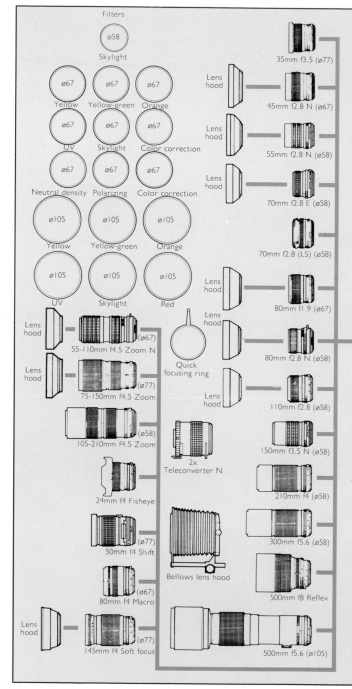

Filters
ø58 Skylight
ø67 Yellow
ø67 Yellow-green
ø67 Orange
ø67 UV
ø67 Skylight
ø67 Color correction
ø67 Neutral density
ø67 Polarizing
ø67 Color correction
ø105 Yellow
ø105 Yellow-green
ø105 Orange
ø105 UV
ø105 Skylight
ø105 Red

Lens hood — 35mm f3.5 (ø77)
Lens hood — 45mm f2.8 N (ø67)
Lens hood — 55mm f2.8 N (ø58)
Lens hood — 70mm f2.8 E (ø58)
70mm f2.8 (LS) (ø58)
Lens hood — 80mm f1.9 (ø67)
Lens hood — 80mm f2.8 N (ø58)
Lens hood — 110mm f2.8 (ø58)
150mm f3.5 N (ø58)
210mm f4 (ø58)
300mm f5.6 (ø58)
500mm f8 Reflex
500mm f5.6 (ø105)

Lens hood — 55-110mm f4.5 Zoom N (ø67)
Lens hood — 75-150mm f4.5 Zoom (ø77)
105-210mm f4.5 Zoom (ø58)
24mm f4 Fisheye
50mm f4 Shift (ø77)
80mm f4 Macro (ø67)
Lens hood — 145mm f4 Soft focus (ø77)

Quick focusing ring
2x Teleconverter N
Bellows lens hood

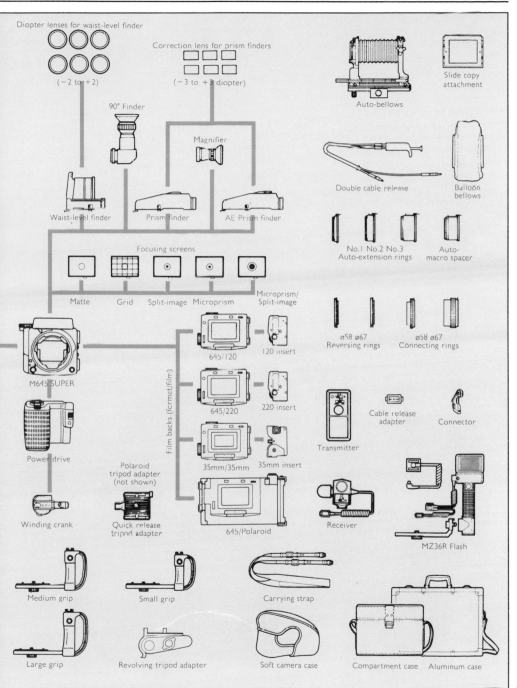

Diopter lenses for waist-level finder
(−2 to +2)

Correction lens for prism finders
(−3 to +3 diopter)

90° Finder

Magnifier

Waist-level finder

Prism finder

AE Prism finder

Focusing screens

Matte Grid Split-image Microprism Microprism/Split-image

M645 SUPER

Power drive

Winding crank

Polaroid tripod adapter (not shown)

Quick release tripod adapter

Film backs (format/film)

645/120 120 insert

645/220 220 insert

35mm/35mm 35mm insert

645/Polaroid

Slide copy attachment

Auto-bellows

Double cable release

Balloon bellows

No.1 No.2 No.3
Auto-extension rings

Auto-macro spacer

ø58 ø67
Reversing rings

ø58 ø67
Connecting rings

Transmitter

Cable release adapter

Connector

Receiver

MZ36R Flash

Medium grip

Small grip

Carrying strap

Large grip

Revolving tripod adapter

Soft camera case

Compartment case Aluminum case

61

PENTAX 645

With this camera, Pentax have gone wholeheartedly for automation, multi-mode exposure control and all the high-tech electronic trappings usually associated with 35mm SLRs. They have also abandoned the conventional interchangeability of viewfinders — instead, there is a fixed, low-profile pentaprism. This camera is aimed at the 35mm mass market.

The box-like construction with right-mounted handgrip superficially resembles that of the Mamiya 645 and Bronica ETRS, but a closer look at the back reveals major differences. The film chamber is built right into the main body, and while 120, 220 and 70mm film can all be used by means of different inserts that slide into the back, these inserts can't be changed in mid-roll. The film spacing is extremely accurate, unlike on most other medium-format cameras, allowing 15 exposures on a roll of 120 film, 30 on 220, and 90 on 70mm. The spacing is adjusted automatically, and a pair of electrical contacts on the pressure plate senses the end of the film, so that the winding automatically stops after the last frame has been exposed. Film advance is motorized, as is shutter tensioning and the resetting of the mirror. The motor is relatively small, but

1 *Diopter adjusting ring*
2 *Eyepiece*
3 *LCD display*
4 *Exposure mode selector buttons*
5 *Shutter release*
6 *Main switch*
7 *Depth of field preview lever*
8 *Hand grip*
9 *Hot shoe*
10 *Viewing prism*
11 *Aperture ring*
12 *Focusing ring*
13 *Lens release button*

Pentax 645 *with 75mm f2.8 SMC Pentax-A lens*

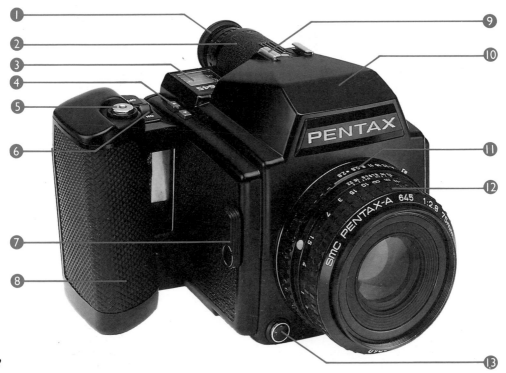

powerful; the power is supplied by 6 alkaline 1.5 volt batteries, which last for 250 rolls of 120, 170 of 220 film, or 50 of 70mm film.

The fixed finder is designed purely for eye-level viewing. The pentaprism is of a unique design which allows the finder to be especially compact. Nine coated lens elements in the viewfinder eyepiece give a good view even from a slight angle. The eyepiece also has a diopter adjusting ring that allows diopter correction from -5 to +2. Because the prism is fixed, the focusing screens have to be changed from inside the mirror box, with access through the lens mount.

The mirror is set at an angle of greater than 45° to match the unusual angles in the prism. In order to reduce the vibrations caused by the mirror each time it moves out of the light path for an exposure, there is a motorized flywheel that acts as a brake. The Pentax 645 is consequently one of the quietest of medium-format SLR cameras.

In the event of battery failure the shutter will operate only at $\frac{1}{50}$sec. It is possible to advance the film by using the manual film winding knob on the base of the camera.

CONTROL PANEL

1 Exposure compensation button: manual override of exposure setting by up to +/-3 f-stops.
2 Film speed button
3 Mode button: used to select control modes
4 Viewfinder LED on/off
5 Control panel LED display illumination button
6 Control panel LED display
7 Selecting buttons: used with other control buttons to adjust exposure mode, shutter speed, aperture, film speed and exposure compensation
8 Main switch
9 Shutter release

EXPOSURE MODES
Programmed AE Mode Both shutter speed and aperture are automatically selected according to the brightness and film speed. In low light, the bias is toward the shutter speed, switching toward aperture as the light increases.
Shutter-Priority AE Mode The speed is entered by using the selecting buttons.
Aperture-Priority AE Mode 1 Aperture is selected by using the selecting buttons.
Aperture-Priority AE Mode 2 Same as above but designed to be used with compatible lenses from the Pentax 6x7 system.
Metered Manual Mode Allows both settings to be selected manually (by using the selecting buttons), with the viewfinder display screen showing over- or under-exposure within a 6-stop range, and an "OK" when the correct exposure is selected.
TTL Auto Flash Mode The shutter speed is automatically set to $\frac{1}{60}$sec and the aperture setting is left to the operater.
Programmed Auto Flash Mode Both the aperture and the shutter speed are set automatically (the latter to $\frac{1}{60}$sec).
Manual Flash Mode Used with non-dedicated flash units.
Bulb Mode For time exposures.
LS Mode (LS stands for leaf shutter) For use with the special 75mm and 135mm leaf-shutter lenses for flash synchronization up to $\frac{1}{500}$sec. **63**

PENTAX 645 SYSTEM

Without interchangeable viewfinders and with the fixed 1¾×2¼in/4.5×6cm format, this system is fairly simple. However, there is an attractive range of lenses. There are 12 lenses made specifically for the 645 (a selection of which are shown below), including 2 leaf-shutter designs (75mm, 135mm) for fast flash synchronization speeds, a macro and a zoom lens. In addition, there is an adapter that allows the 645 access to the complete range of lenses in the Pentax 6×7 system. These 6×7 lenses can be used in Aperture-Priority AE Mode 2, Metered Manual Mode, and TTL Auto Flash Mode.

45mm f2.8 SMC Pentax-A

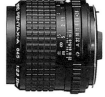
55mm f2.8 SMC Pentax-A

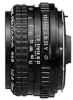
75mm f2.8
SMC Pentax-A

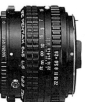
75mm f2.8 (LS)
SMC Pentax-A

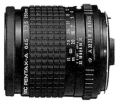
150mm f3.5
SMC Pentax-A

80mm–160mm f4.5 zoom SMC
Pentax-A

1.4x Rear Converter
for 300mm lens

64 300mm f4 ED(1F) SMC Pentax-A

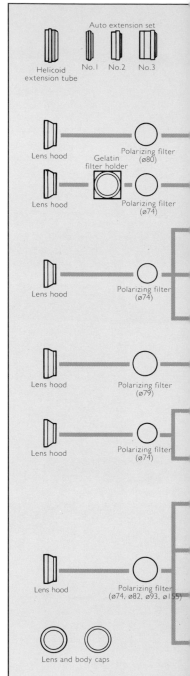

Auto extension set

Helicoid extension tube No.1 No.2 No.3

Lens hood Gelatin filter holder Polarizing filter (ø80)

Lens hood Polarizing filter (ø74)

Lens hood Polarizing filter (ø74)

Lens hood Polarizing filter (ø79)

Lens hood Polarizing filter (ø74)

Lens hood Polarizing filter (ø74, ø82, ø93, ø155)

Lens and body caps

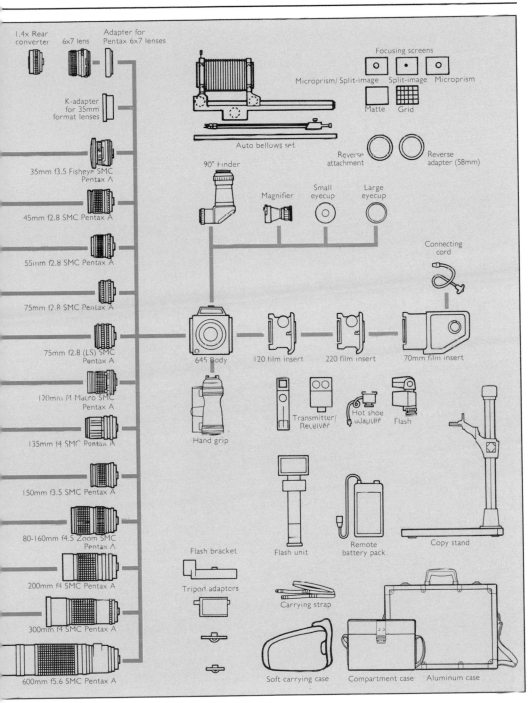

1.4x Rear converter

6x7 lens

Adapter for Pentax 6x7 lenses

K-adapter for 35mm format lenses

35mm f3.5 Fisheye SMC Pentax A

45mm f2.8 SMC Pentax A

55mm f2.8 SMC Pentax A

75mm f2.8 SMC Pentax A

75mm f2.8 (LS) SMC Pentax A

120mm f4 Macro SMC Pentax A

135mm f4 SMC Pentax A

150mm f3.5 SMC Pentax A

80-160mm f4.5 Zoom SMC Pentax A

200mm f4 SMC Pentax A

300mm f4 SMC Pentax A

600mm f5.6 SMC Pentax A

Auto bellows set

90° Finder

645 Body

120 film insert

220 film insert

70mm film insert

Hand grip

Focusing screens

Microprism/Split-image Split-image Microprism

Matte Grid

Reverse attachment

Reverse adapter (58mm)

Magnifier Small eyecup Large eyecup

Connecting cord

Transmitter/ Receiver

Hot shoe adapter Flash

Flash bracket

Tripod adapters

Flash unit

Remote battery pack

Copy stand

Carrying strap

Soft carrying case Compartment case Aluminum case

65

BRONICA *ETRS*

Of the three 645 cameras on the market, the Bronica ETRS is the least sophisticated, with a limited range of accessories and lenses. It is also the least expensive model. Unlike its competitors, it has a between-the-lens shutter, electronically controlled from the camera body. The shutter operates at speeds from 8 seconds to $\frac{1}{500}$sec, with two mechanical back-up speeds – "T" (for time exposures) and $\frac{1}{500}$sec: flash synchronization is possible at all speeds.

The film can be wound on with an ordinary, Hasselblad-style crank, but the standard mechanism promoted by Bronica is a winding lever (the Speed Grip), similar to that used with the Bronica SQ-A and GS-1. This attaches to the right-hand side of the camera, and has a lateral film-advance lever at the top that takes two strokes for a full wind. An alternative to this is a simple, modular motor-drive attachment; this gives the choice of single or continuous operation up to one frame per second.

The interchangeable film magazines are basically similar to those of the Hasselblad (page 20), but with one difference: they swing upward, rather than downward, for attachment and removal. There is a metal slide that protects the film when the back is removed. This slide also acts as a double safety mechanism: it prevents the back from being removed if the slide is not inserted, and it disables the shutter release

1 *Viewing hood*
2 *Film magazine*
3 *Magazine release*
4 *Exposure counter*
5 *Multiple exposure lever*
6 *Winding crank*
7 *Manual film winder*
8 *Shutter release*
9 *Flash sync socket*
10 *Focusing ring*
11 *Aperture ring*

*Bronica **ETRS** with 75mm
f2.8 Zenzanon E lens*

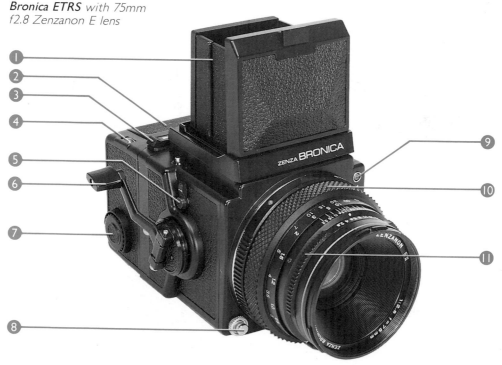

when the back is attached until the slide is removed. The choice of film magazines is similar to that of the Mamiya M645 SUPER — $1\frac{3}{4} \times 2\frac{1}{4}$in/4.5×6cm format in 120, 220, 35mm and Polaroid film, with the addition of a $\frac{15}{16} \times 2\frac{1}{8}$in/24×54cm panoramic 35mm magazine.

Metering is an option rather than an integral part of the camera body, and works through the fully automatic AE-II Prism Finder. This eye-level finder lacks a spot metering capability but has the other features of the Mamiya M645 SUPER meter — stepless aperture-priority automatic operation and a display of shutter speeds. The viewfinder display also gives a simple under- or over-exposure warning by means of red LED arrows. Slight pressure on the shutter release, or on the LED display button, shows the shutter speed selected. The viewing screen is noticeably bright and contrasty. On the right-hand side of the finder there is the automatic/manual exposure selector dial; on the left the film speed dial.

Of special interest is the Rotary Viewfinder accessory. This is a prism finder with an eyepiece that rotates through 90° to the left or right, giving look-down viewing for both horizontal and vertical picture frames. The camera is turned on its side for vertical shooting and the prism rotated (below, 3). A drawback is that the Rotary Viewfinder is not metered.

ETRS PERMUTATIONS
The ETRS can be configured in a number of ways, each suited to a different task. Some of the possible combinations are shown on this page. A list of the main accessories used in each case is given below.
1 Motorized AE Set-Up: with the Motor drive, and AE-II Finder.
2 Standard AE Set-Up: with the Speed Grip, and AE-II Finder.
3 Low-Angle Set-Up: with the Rotary Viewfinder, and a lens hood.
4 Polaroid Set-Up: with the Polaroid back, Speed Grip, and bellows lens hood.
5 Macro Set-Up: with automatic Bellows, AE-II Finder, and Speed Grip.

BRONICA *ETRS SYSTEM*

This system contains all the basic accessories. In addition to the lenses shown here (bottom, and system chart) Bronica have recently introduced four lenses: a 55mm f4.5 Zenzanon PE PCS Super Angulon, a 100mm f4 Macro Zenzanon E, a 70–140mm f4.5 Zoom Zenzanon PE Variogon, and a 125–250mm f5.6 Zoom Zenzanon PE Variogon.

CLOSE-UP ACCESSORIES
There are a number of ETRS accessories designed for close-up work. The two close-up lenses allow magnifications from 0.15x to 0.65x (when both lenses are used together). The three extension tubes (E-14, E-28, E-42) give from 0.18x to 0.73x magnification when used with the standard lens. A variable extension is possible with the automatic bellows, from 0.71x to 2.18x with the same lens.

ZENZANON E LENSES
The range of leaf-shutter lenses is modest, in comparison with the competition, but adequate for most kinds of shooting. The 2x tele-converter extends the effective focal length range to 40mm–1000mm, and can be used with all the prime lenses (75mm–500mm). The fact that the lens shutter opens fully, even for the fastest speed of $\frac{1}{500}$sec, means that flash synchronization is possible at all speeds.

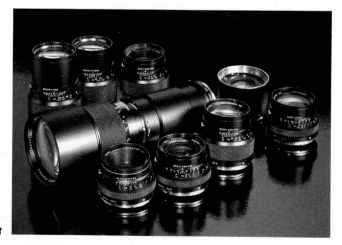

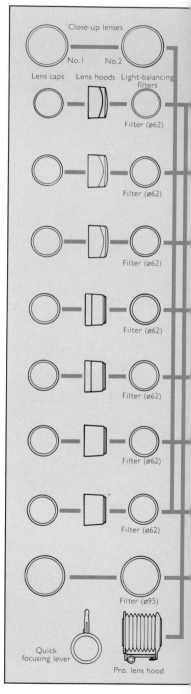

Close-up lenses

No.1 No.2

Lens caps Lens hoods Light-balancing filters

Filter (ø62)

Filter (ø62)

Filter (ø62)

Filter (ø62)

Filter (ø62)

Filter (ø62)

Filter (ø62)

Filter (ø95)

Quick focusing lever

Pro. lens hood

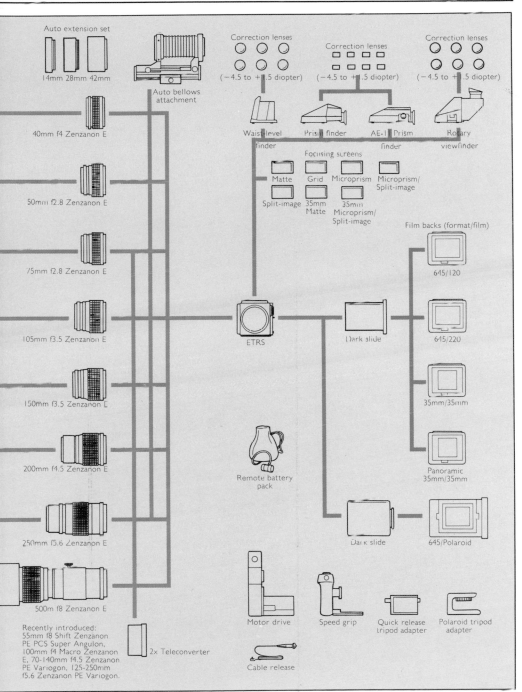

Auto extension set

14mm 28mm 42mm

Auto bellows attachment

Correction lenses

(−4.5 to +1.5 diopter)

Correction lenses

(−4.5 to +1.5 diopter)

Correction lenses

(−4.5 to +1.5 diopter)

Waist-level finder

Prism finder

AE-1 Prism finder

Rotary viewfinder

40mm f4 Zenzanon E

50mm f2.8 Zenzanon E

75mm f2.8 Zenzanon E

105mm f3.5 Zenzanon E

150mm f3.5 Zenzanon E

200mm f4.5 Zenzanon E

250mm f5.6 Zenzanon E

500m f8 Zenzanon E

Focusing screens

Matte Grid Microprism Microprism/Split-image

Split-image 35mm Matte 35mm Microprism/Split-image

ETRS

Dark slide

Film backs (format/film)

645/120

645/220

35mm/35mm

Panoramic 35mm/35mm

Remote battery pack

Dark slide

645/Polaroid

Recently introduced:
55mm f8 Shift Zenzanon
PE PCS Super Angulon,
100mm f4 Macro Zenzanon
E, 70-140mm f4.5 Zenzanon
PE Variogon, 125-250mm
f5.6 Zenzanon PE Variogon.

2x Teleconverter

Motor drive

Speed grip

Quick release tripod adapter

Polaroid tripod adapter

Cable release

FUJI *GW690II/GSW690II/GW670II*

The rangefinder design, with its small, separate, optical viewing system, is still the simplest construction for a basic camera. The two Fuji $2\frac{1}{4}\times3\frac{1}{4}$/6×9cm models – the wide-angle GW690II and super-wide GSW690II – have been made with professional photographers in mind, and take full advantage of the inherent simplicity of design: they are light (3lb 3oz/1,440g and 3lb 4oz/1,480g respectively), compact and quick to use.

The viewfinder image is brighter than in a single-lens reflex camera, as the image doesn't first have to pass through a prism and focusing screen. Also, rangefinder focusing, once learned, is faster than SLR focusing. One drawback, which emphasizes the professional nature of these cameras, is the lack of an exposure meter. It is unlikely that in the candid situations for which these cameras have been designed there will be enough time to use a hand-held meter, so the ability to anticipate exposure levels is essential. The responsibility is placed on the photographer to have the knowledge and experience to be able to use this design of camera well. The lack of through-the-lens viewing can produce parallax problems at close range.

GW690II with fixed 90mm
f3.5 EBC Fujinon lens

1 *120/220 film selector dial*
2 *Film winding lever*
3 *Self-cocking mechanism*
4 *Top shutter release*
5 *Camera strap attachment*
6 *Front shutter release*
7 *Shutter release lock*
8 *Hot shoe*
9 *Rangefinder window*
10 *Rangefinder illumination window*
11 *Viewfinder window*
12 *Focusing ring*
13 *Aperture ring*
14 *Collapsible lens hood*

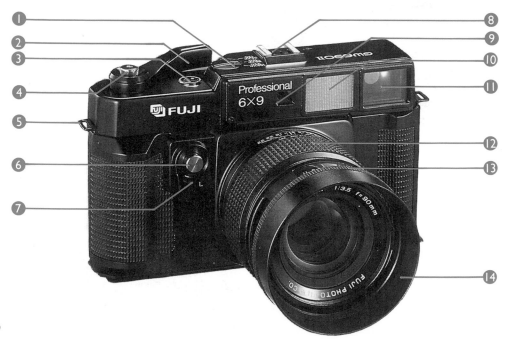

Both these models accept 120 and 220 film. A switch on top of the body selects between 4 exposures on a half-roll of 120 film, 8 exposures on a complete roll of 120 and 16 exposures on 220. The winding lever requires two strokes to cock the shutter and move the film onto the next frame. The first stroke moves through 138°, while the second is of variable length, automatically adjusting to the film size. There is an exposure counter next to the winding lever, which automatically resets itself when a new film is loaded.

Following the success of the 690 models, Fuji launched a $2\frac{1}{4} \times 2\frac{3}{4}$in/6x7cm model, the GW670II, which in all essential features and appearance is part of the same series. There is, however, one important difference: the GW670II has an automatic parallax compensation system, which adjusts the viewfinder frame depending on the focusing distance.

All three models have two shutter release buttons – one on the front, one on the top of the winding lever – which facilitates the switch between horizontal and vertical shooting. The shutter is mechanical with speeds ranging from 1 second (and "T") to $\frac{1}{500}$sec. There is a hot-shoe and flash sync socket for use with any type of flash.

RANGEFINDER MODELS

ADVANTAGES
* Lightweight and quiet
* No mirror to obscure finder image during shooting
* Fast focusing
* Easy handling, familiar to the 35mm user
* Compact: many models have collapsible lenses

DISADVANTAGES
* Parallax problems: but some models have compensating viewfinders
* No motorized models
* Fixed lens (except for Mamiya Universal Press)
* Polaroid back is available for one model only

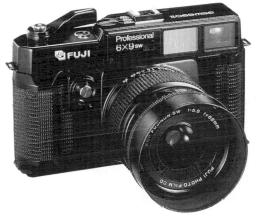

GW670II (below) with a fixed 90mm f3.5 EBC Fujinon lens (equivalent to a 44mm lens on a 35mm camera). The smaller frame size allows 10 exposures on a roll of 120 film, and 20 on 220 film.

GSW690II (above) with fixed 65mm f5.6 EBC Fujinon SW lens (equivalent to a 28mm lens on a 35mm camera). This lens has a 76° angle of view compared with the 58° view of the GW690II's 90mm lens.

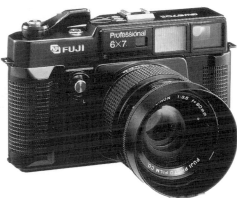

FUJICA GS645/GS645S/GS645W

Having applied the compactness and design simplicity of rangefinders to full-size medium-format cameras (pages 70–71), Fuji have turned their attention to the small 645 format and produced the smallest and lightest available roll-film cameras. The GS645 series of fixed-lens cameras – the standard GS645 (1lb 13oz/820g), wide-angle GS645S (1lb 10oz/750g) and super wide-angle GS645W (1lb 8oz/680g) – are as compact as some 35mm cameras while still producing images nearly three times larger.

The GS645 revives an old method of camera construction: a collapsing lens attached to the body by a short bellows. A hard cover swings out when the opening bar is pressed, and is locked firmly in place by a brace. The bellows extends to a fixed distance and plays no part in the focusing; the lens has a normal helical focusing ring, turned by a large protruding button. When the cover is closed and the lens retracts, the camera measures only $2\frac{3}{16}$in/56cm front-to-back, slim enough to fit easily into a jacket pocket.

On both the wide-angle models, the lenses are sited so close to the film plane that a collapsing mechanism is impracticable–but also unnecessary, as the GS645S measures $3\frac{9}{16}$in/90mm front-to-back, and the GS645W only 3in/76mm.

Unlike the larger Fuji 690 and 670 rangefinder cameras, all three of the 645 models have only one shutter release button,

1 *Film winder lever*
2 *Shutter release*
3 *Camera strap attachment*
4 *Shutter release lock*
5 *Exposure counter*
6 *Back cover opening switch*
7 *Front cover opening lever*
8 *Hot shoe*
9 *Rangefinder window*
10 *Viewfinder window*
11 *Bellows*
12 *Shutter speed/aperture index*
13 *Focusing ring*
14 *Aperture ring*
15 *Shutter speed ring*
16 *Flash sync socket*

Fujica GS645 with 75mm f3.4 EBC Fujinon S lens

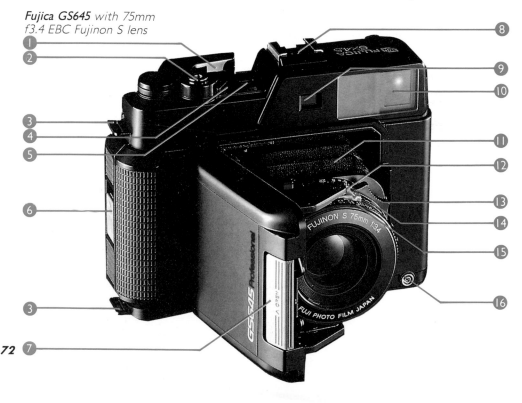

situated on the top plate. There is a shutter release lock to prevent accidental exposure.

The viewfinder image, as is usual with rangefinder cameras, shows considerably more than the picture frame, which is outlined with a broken rectangle. This helps to show what is about to enter the frame – a useful compositional aid with active subjects and when the camera is being panned. In addition there is an automatic parallax correction system.

A very straightforward exposure measurement system meters the entire frame (slightly center-weighted) and displays the results in a simple plus-zero-minus panel of LEDs (right). The metering is accurate under most lighting conditions; the exceptions are direct back-lighting and bright top-lighting, when it is necessary to shade the meter window.

The exposure is set manually. All the exposure controls are located on the lens: the thin film speed ring is situated between the shutter speed and aperture rings. The mechanical lens shutter has speeds ranging from 1 second to $\frac{1}{500}$sec, and synchronizes with flash at all speeds.

As with the larger 690 Fuji cameras, a selector switch on the top plate can be switched between 120 (15 exposures) and 220 film (30 exposures). The pressure plate must also be adjusted. Film loading is simpler than usual because of the two small red buttons on the base plate that release the film spool lugs.

EXPOSURE METERING
The exposure display is activated by pressure on the shutter release. Through various plus-zero-minus combinations, it shows whether the exposure is correct, or out by $\frac{1}{3}$, 1, or more than 1 stop.

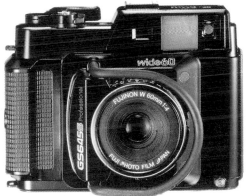

Fuji GS645S with fixed 60mm f4 EBC Fujinon W lens. Situated between the GS645 and the GS645W in terms of lens focal length, this camera, with its 60° angle of view, is equivalent to a 35mm camera with 38mm lens.

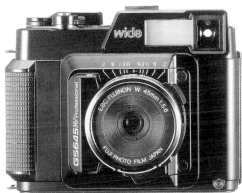

Fujica GS645W with fixed 45mm f5.6 EBC Fujinon lens. The lens has a 76° angle of view and will focus from 3ft 3in/1m to infinity, with click stops at 6ft 6in/2m and 16ft/5m.

PLAUBEL MAKINA 670/67W

Plaubel's original Makina 67 made its name on the compactness of its design. The current 670 and 67W are the updated versions, the first with a near-standard lens, the second with a wide-angle. At 3lb 1oz/1.4kg and 2lb 13oz/1.3kg, they are, just, the lightest and most compact $2\frac{1}{4}\times2\frac{3}{4}$in/6x7cm cameras on the market. In addition, they have an automatic parallax compensation system in the viewfinder and electronic exposure metering (far right).

Plaubel for decades have had an expertise in sliding tongs and bellows as a method for moving the lens. This system is used to collapse the camera when not in use to a slim package ($2\frac{1}{4}$in/56.5mm for the 670, $2\frac{1}{8}$in/54mm for the 67W), and as the basis for a unique focusing system. A release button on the left-hand side of the camera, below the lens, extends the lens panel for shooting. This extension can then be varied for focusing, which is controlled by the rubberized focusing ring that surrounds the shutter release, on the top plate. This ring, which has a distance scale marked on it from infinity to the minimum focusing distances (3ft 3in/1m for the 670, 2ft 8in/80cm for the 67W) operates two sliding horizontal bars by means of a rack and pinion; the bars then work the tongs which focus the lens. Connected to the focusing mechanism is

1 *Film winding lever*
2 *Exposure counter*
3 *Shutter release*
4 *Focusing ring*
5 *Camera strap attachment*
6 *120/220 film selector lever*
7 *Bellows*
8 *Camera back double lock*
9 *Flash sync socket*
10 *Hot shoe*
11 *Rangefinder window*
12 *Viewfinder window*
13 *Tong*
14 *Aperture ring*

Plaubel Makina 670 with 80mm f2.8 Nikkor lens

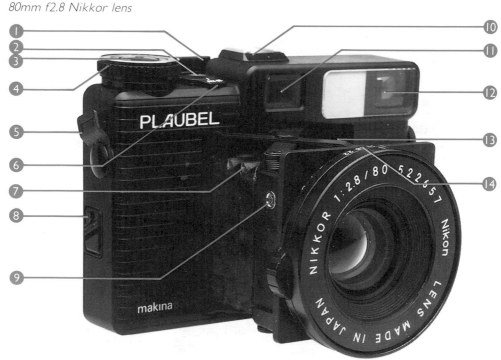

a parallax compensation system which appears in the viewfinder as a moving frame.

Plaubel have worked hard to make the 670 and 67W easy to handle. The split-image rangefinder focusing method, the shutter release (with its large button) and the two-stroke film advance lever are all clustered together and can be operated by the thumb and forefinger of the right hand. On the other side, the heel of the left hand is best used to support the camera, while the thumb and forefinger are used to operate the aperture ring and shutter speed ring on the lens.

The lenses, specially made by Nikon to a slim design, are an 80mm f2.8 for the 670 (equivalent to a 40mm lens on a 35mm camera) and a wide-angle 55mm f4.5. The 80mm's angle of view is 58°, the 55mm's 77°. The minimum aperture for both lenses is f22, and each houses a mechanical leaf shutter with speeds from "B" and 1 second to $\frac{1}{500}$ sec. Flash synchronization is possible at all speeds.

Film loading is straightforward, with spool release catches on either side that can be operated with one finger. Both 120 and 220 film can be used; when changing from one to the other, a film selection lever has to be switched, and the pressure plate reversed.

VIEWFINDER DISPLAY
As the lens is focused, the size of the frame automatically changes to compensate for parallax. At the right-hand edge of the frame is the exposure meter display, which is activated by pressing a button on the back of the camera, below the film transport lever. Exposure readings are taken from the center of the screen, within a 10° angle of measurement. The meter is accurate to within a third of a stop. The complete range of exposure readings is shown below.

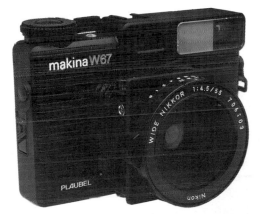

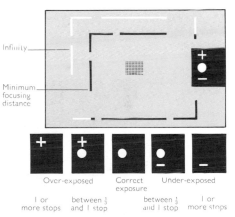

Infinity

Minimum focusing distance

Over-exposed		Correct exposure	Under-exposed	
1 or more stops	between $\frac{1}{3}$ and 1 stop		between $\frac{1}{3}$ and 1 stop	1 or more stops

Plaubel Makina 67W (above) with 55mm f4.5 Nikkor lens. This wide-angle model is slightly smaller and lighter than the Makina 670. It uses the same focusing system, and has a similar viewfinder display with parallax compensation. However, unlike the 670, the 67W will only accept 120 film (10 exposures).

TONGS AND BELLOWS FOCUSING (left)
This detail shows the X-shaped tongs that are used to focus the lens. As the lens panel is extended, the curved arm (situated beneath the left-hand tong) transmits the movement to the moving viewfinder frame (diagram above) that compensates for parallax.

MAMIYA UNIVERSAL PRESS

This camera is descended from the old "press" cameras. It is the most unsophisticated roll-film camera still being manufactured. However, because it is so basic there is little that can go wrong, and it is one of the least expensive cameras in the 6x9cm format. Also, it accepts an enviable number of accessories, including a range of Mamiya-Sekor lenses of excellent quality.

A range of interchangeable viewfinder masks are used to compensate for parallax with the 100mm, 150mm and 250mm lenses. There is also a choice between the $2\frac{1}{4} \times 3\frac{1}{4}$in/6x9cm and $2\frac{1}{4} \times 2\frac{3}{4}$in/6x7 formats. Focusing can be performed either by using the rangefinder or, for finer focusing, there is a ground-glass focusing back.

Nominally a $2\frac{1}{4} \times 3\frac{1}{4}$in/6x9cm camera, the Universal Press accepts frame sizes all the way down to $1\frac{3}{4} \times 2\frac{1}{4}$in/4.5x6cm. Apart from roll-film, it can be used with cut sheet film, dry plates and Polaroid 100 and 600 series instant emulsions – the coverage of the 127mm lens is sufficient to fill the complete Polaroid print. There are two types of roll-film magazine: a curved-end design (also used with the Plaubel 69W proshift: pages 80–81) which is good for ensuring maximum film flatness, and the Mamiya RB67 magazine (pages 28–29).

All the settings and shutter cocking are operated manually. The range of shutter speeds is from "B" and 1 second to $\frac{1}{500}$ sec.

1 *Eye piece*
2 *Viewfinder window*
3 *Camera strap attachment*
4 *Film winding lever*
5 *Shutter release*
6 *Hand grip*
7 *Shutter release cable*
8 *Hot shoe*
9 *Rangefinder illumination window*
10 *Rangefinder window*
11 *Alternative shutter release*
12 *Focusing ring*
13 *Aperture and shutter speed rings*
14 *Hand grip*

Mamiya Universal Press with 100mm f3.5E Mamiya-Sekor lens

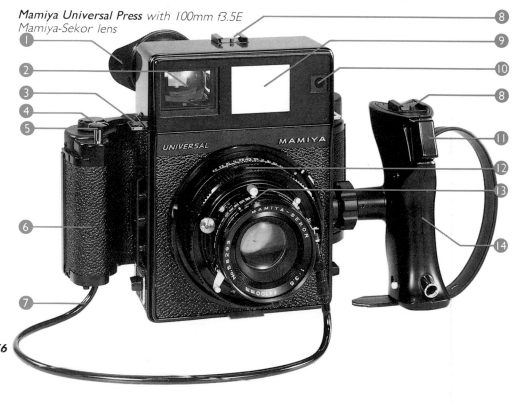

MAMIYA UNIVERSAL PRESS SYSTEM

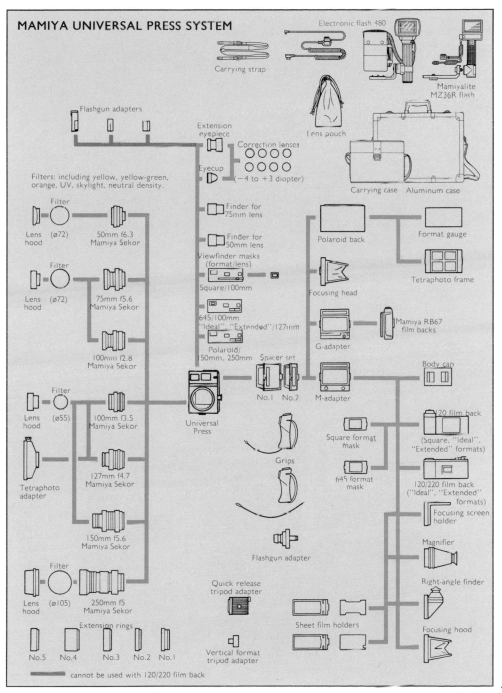

Carrying strap

Electronic flash 480

Mamiyalite MZ36R flash

Flashgun adapters

Lens pouch

Extension eyepiece

Correction lenses

Carrying case Aluminum case

Filters: including yellow, yellow-green, orange, UV, skylight, neutral density.

Eyecup
(−4 to +3 diopter)

Filter

Lens hood (ø72) 50mm f6.3 Mamiya Sekor

Finder for 75mm lens

Finder for 50mm lens

Polaroid back

Format gauge

Filter

Lens hood (ø72) 75mm f5.6 Mamiya Sekor

Viewfinder masks (format/lens)

Square/100mm

Tetraphoto frame

Focusing head

100mm f2.8 Mamiya Sekor

645/100mm

"Ideal", "Extended"/127mm

Polaroid/ 150mm, 250mm Spacer set

G-adapter

Mamiya RB67 film backs

Filter

Lens hood (ø55) 100mm f3.5 Mamiya Sekor

Universal Press

No.1 No.2 M-adapter

Body cap

120 film back

Square format mask

(Square, "Ideal", "Extended" formats)

Tetraphoto adapter

127mm f4.7 Mamiya Sekor

Grips

645 format mask

120/220 film back ("Ideal", "Extended" formats)

Focusing screen holder

150mm f5.6 Mamiya Sekor

Magnifier

Flashgun adapter

Right-angle finder

Filter

Lens hood (ø105) 250mm f5 Mamiya Sekor

Quick release tripod adapter

Sheet film holders

Focusing hood

Extension rings

No.5 No.4 No.3 No.2 No.1

Vertical format tripod adapter

━━━ cannot be used with 120/220 film back

HASSELBLAD SWC/M

This 2¼×2¼in/6×6cm camera is designed entirely around a classic lens, the Zeiss 35mm f4.5 Biogon CF, which gives an exceptionally sharp image, a 90° angle of view and extremely good distortion correction. The Biogon lens, because it must be positioned very close to the film in order to focus at infinity, doesn't allow any space for a focal-plane shutter or a mirror; this means that it is impracticable for single-lens reflex cameras.

Hasselblad chose to use this excellent lens in the only possible way, by building a permanent camera body around it, and using a separate viewfinder for composition. Focusing, as you might expect with an extreme wide-angle lens, is not critical in most situations because of the extensive depth of field, so the lack of a rangefinder is not serious.

The optical viewfinder sits on top of the camera. This displacement can cause parallax problems with close subjects (far right). A more accurate viewing alternative, but one that is slower to use, is the focusing screen adapter. This ground-glass viewing screen attaches to the back of the camera in place of the film magazine. Once the viewing screen is in place,

1 *Viewfinder*
2 *Shutter release*
3 *Film magazine*
4 *Winding crank*
5 *Frame counter window*
6 *Film winding crank*
7 *Shutter status indicator*
8 *Focusing ring*
9 *Cross-coupling button*
10 *Shutter speed ring*
11 *Aperture ring*
12 *Tripod attachment*

Hasselblad SWC/M with 38mm f4.5 Biogon lens

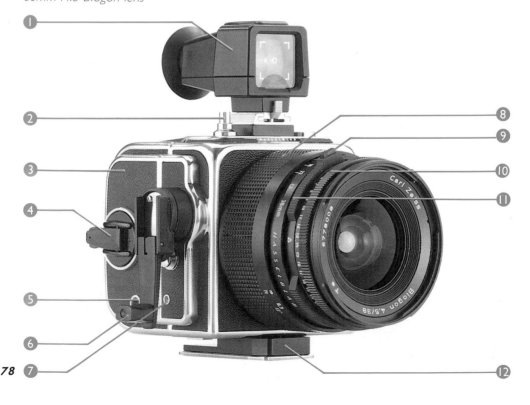

the shutter speed ring has to be set to "B", and the shutter locked open by turning the small lever on the shutter release from its normal "O" setting to "T". Then the release has to be pressed so that the image can be viewed on the screen. Returning the lever to "O" closes the shutter again. Any of the viewfinder attachments—hood, magnifier or prisms—can be used with the screen to give a clearer image.

As one of the SWC/M's most popular uses is in architectural photography (interiors in particular), it is often important to level the camera in order to avoid converging verticals; accordingly, the viewfinder has a built-in spirit level. Masking frames, which clip onto the front of the viewfinder, are available to crop the view down to the $1\frac{5}{8}\times2\frac{1}{4}$in/4.5x6cm and $1\frac{5}{8}\times1\frac{5}{8}$in/4.5x4.5cm picture frames.

All the Hasselblad film magazines can be used with the SWC/M, with the single exception of the Polaroid 80 magazine. The Polaroid 100 magazine, which accepts types 665, 667, 668 and 669, can be used, but then the crank cannot be turned in a complete circle: instead, you have to pump it up and down in short strokes.

THE FIXED LENS DESIGN
This side view shows just how thin the camera body has to be to bring the Biogon lens close enough to the film plane to focus on infinity. One drawback with this design is that it doesn't allow for any lens movements, which would have been useful for photographing buildings (pages 178–189).

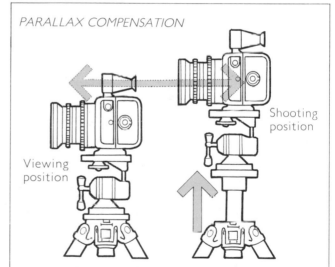

PARALLAX COMPENSATION

Viewing position

Shooting position

Parallax is a problem with any camera that doesn't have through-the-lens viewing, because the vertical distance between the viewfinder/viewing lens and the taking lens means that the field of view of the former does not match that of the latter. At normal shooting distances this isn't a problem, but in close-up the top of the picture will be lost if no allowance is made when viewing. One way to overcome this, when using a tripod, is to raise the camera between viewing and shooting to match the displacement.

PLAUBEL 69W proshift

At the heart of the 69W proshift are two components, each in its own way a classic piece of design: a Schneider 47mm f5.6 Super Angulon lens and a Mamiya curved-end film magazine. The Schneider lens, with its multi-coated eight elements in four groups, has a 105° angle of coverage that projects a $4\frac{13}{16}$in/123mm image circle.

The $2\frac{1}{4}\times3\frac{1}{4}$in/6×9cm format sits comfortably well inside the image circle of the lens (the angle of coverage is only 93° across the diagonal). This has left the Plaubel designers with enough room for a $\frac{5}{8}$in/15mm vertical movement (up and down) and a $\frac{1}{2}$in/13mm sideways shift (left and right). The 69W uses only two of these movements, upward and left: for a front fall or right shift you could invert the camera but, surprisingly, unlike the Linhof Technorama 612PC (pages 86–87), the 69W lacks a tripod bush on the top plate to facilitate this inversion. The shift mechanism has clearly been designed for architectural use and straightening of converging verticals; for this, two shift movements are enough.

The viewfinder is connected to the front plate of the camera so that it automatically follows any shift movements;

1 Viewfinder
2 Parallax compensation dial
3 Film winding lever
4 Shutter release
5 Viewing frame
6 Hand grip
7 Shift grip
8 Flash sync socket
9 Shutter release cable
10 Film speed dial
11 Spirit level
12 Shift guide
13 Shift locking lever
14 Focusing ring
15 Aperture ring
16 Shutter speed dial
17 Shutter lever (open/close)

Plaubel 69W proshift with 47mm f5.6 Super Angulon lens

in addition, it includes a parallax compensation system (far right). For really quick shooting, you remove the ordinary viewfinder and swing a pop-up ring into place. A metal bar frame then slides up from the lens panel, to serve as an action finder. Because the metal bar is actually on the lens panel, it shows the effect of shift movements without any need for adjustment.

The mechanical leaf shutter operates between f5.6 and f32 and from "B" and 1 second to $\frac{1}{500}$ sec. Like any large-format lens, it is manually operated; even cocking the shutter from the mount is done by hand. Focusing is helical. The shutter release is a short cable connected to a plunger on the top of the camera.

A common problem with wide-angle lenses is vignetting, when the image becomes progressively darker toward the edges. One way to compensate for this is to fit a centrally graduated filter; the only other way of keeping the illumination even across the photograph is to shoot on negative film and at the printing stage set the condensers in the enlarger to give the same amount of vignetting.

ADJUSTABLE VIEWFINDER
One potential problem with this design is that when the lens is shifted, the viewfinder's field of view no longer matches that of the lens. Plaubel's solution to this problem is an elegent one: they have mechanically linked the finder to the rising front so that the finder rotates left when the side shift is used, and upward with the vertical shift (left). The same principle is used to correct parallax. A dial at the right of the finder's base, engraved with a distance scale, can be used to tilt the finder downward for close views.

CURVED-END DESIGN
The body of the 69W is built around the excellent Mamiya Roll Film Holder Model 3, which uses the distinctive curved-end design that gives the film a slight curve against its natural curl in order to keep it flat. The film, either 120 or 220, is wound on with a conventional thumb-operated lever on the right-hand end of the film magazine.

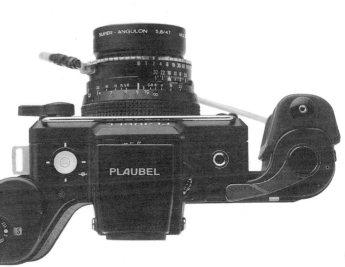

ROLLEIFLEX 2.8GX

The twin-lens reflex (TLR) design (first introduced in 1929 by Rollei), with its separate viewing and taking lenses and rack-and-pinion focusing system, was superseded by the single-lens-reflex camera with its through-the-lens viewing. However, despite its shortcomings, the simplicity and reliability of the TLR design, combined with the fact that TLR cameras are inexpensive, ensures its survival.

Rollei's reputation in this field is such that the company continues to update its classic $2\frac{1}{4}\times2\frac{1}{4}$in/6x6cm design. The latest model is the 2.8GX. The fixed, 80mm Planar lens has a very small curvature of field and excellent color correction. There are no interchangeable backs (the 2.8GX will accept only 120 film – 12 exposures). However, compared with one of the least expensive SLR models, the Bronica SQ-A, the Rollei 2.8GX is usually about a third of the price.

Compared with earlier Rollei models, the major improvement in the 2.8GX is in the metering: there is a through-the-

1 *Viewing hood*
2 *Viewing lens*
3 *Shutter speed wheel*
4 *Aperture wheel*
5 *Taking lens*
6 *Shutter release*
7 *Shutter release lock*
8 *Viewfinder release*
9 *Camera strap attachment*
10 *Battery check light*
11 *Film spool button*
12 *Focusing knob*
13 *Film speed setting dial*
14 *Hot shoe*
15 *Supply spool button*
16 *Flash sync socket*

Rolleiflex 2.8GX with fixed 80mm Planar lens

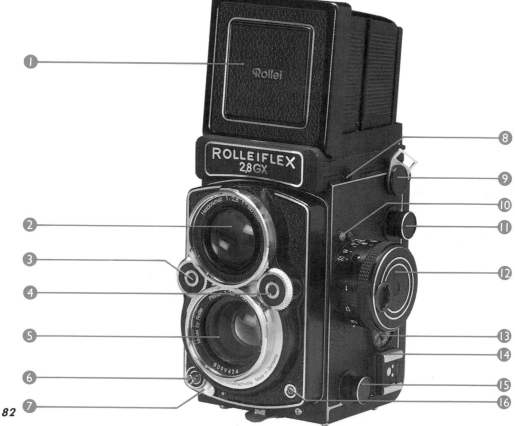

lens exposure meter and an off-the-film (OTF) flash meter. The manual TTL metering system is built into the body and can be either aperture or speed priority. It takes center-weighted readings that are displayed at the top of the viewfinder frame by means of colored LED indicators: green for correct exposure; yellow for over- or under-exposure by half a stop; red for a deviation from the correct exposure by more than half a stop. The metering range covers 16 stops, from EV3 to EV18 with ISO 100 film.

The OTF flash metering system is similar to that of the Hasselblad ELX and Rollei's other medium-format single-lens reflex models. An adapter – the SCA356 – is needed to link the camera's system to any automatic flash unit that conforms to the SCA300 system. Flash synchronization is possible from 1 second to $\frac{1}{500}$sec.

The aperture and shutter speed controls are on either side of the lenses. The settings can be inspected by means of the window conveniently placed on the top of the viewing lens. The TLR design excludes the possibility of depth of field preview, but there is a depth of field scale on the focusing knob. Eye-level viewing is possible with the addition of one of the prism viewfinders and the Pistol Handgrip. There is a range of five focusing screens.

TLR MODELS

ADVANTAGES
* Quiet
* Inexpensive
* Reliable
* Look-down viewing gives a 2-dimensional image which aids composition
* No interruption to viewfinder image during exposure

DISADVANTAGES
* No Polaroid backs
* No depth of field preview (except with 105mm Mamiya lens)
* Lack of through-the-lens viewing can cause parallax problems
* No lens movements available
* No motorized models

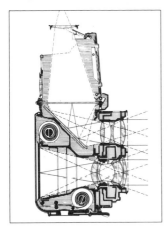

TLR DESIGN
The light path to the film is straight (above), while the viewing light path is turned through 90° by the mirror to form a laterally-reversed image on the focusing screen. The only difference between the 2 lenses is the vertical displacement.

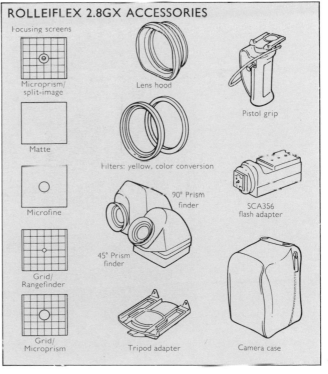

ROLLEIFLEX 2.8GX ACCESSORIES

Focusing screens

Microprism/split-image

Matte

Microfine

Grid/Rangefinder

Grid/Microprism

Lens hood

Filters: yellow, color conversion

90° Prism finder

45° Prism finder

Tripod adapter

Pistol grip

SCA356 flash adapter

Camera case

MAMIYA *C220f/C330s*

Traditionally, twin-lens reflexes were made with fixed lenses, but Mamiya took the basic design an important step further: both the C220f and C330s accept interchangeable lenses. The 80mm f2.8 is the standard lens, but the 105mm f3.5 DS is especially useful because it has an aperture diaphragm in the viewing lens which can be used to give an accurate depth of field preview. It is important, of course, not to forget to set the aperture on the taking lens after viewing.

The difference between the two models is that the C220f has simpler features. For example, there is one shutter release instead of two, and the film is advanced by a ratchet knob rather than a crank. However, the basic operation is the same, and all the lenses and viewfinders fit both models.

The focusing mechanism is a rack and pinion, shifting the entire lens assembly forward (the amount of travel depending on the focal length of lens): lightproofing is maintained by a bellows. In order to calculate the amount of exposure

1 *Viewing hood*
2 *Camera strap attachment*
3 *Exposure counter*
4 *Multiple exposure dial*
5 *Upper shutter release*
6 *Film winding crank*
7 *Aperture control lever*
8 *Focusing knob*
9 *Lens clamp bracket*
10 *Viewing lens*
11 *Taking lens*
12 *Shutter cocking lever*
13 *Lower shutter release*

Mamiya C330s with 80mm f2.8 Mamiya-Sekor lens

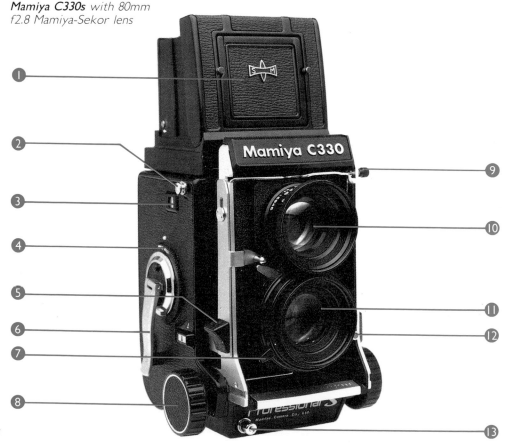

compensation required for a shot there is a focusing distance/exposure compensation scale. In the C220f a single engraved chart covers all the lenses, while the C330s has a system of rods that display the distance in a window. Neither method is particularly convenient.

The distance between the viewing and taking lenses causes parallax problems with subjects close to the camera. With the C330s, there is a parallax correcting dial, adjustable for each lens. This displays a pointer on the focusing screen to show the top limit of the image. With the C220f, the upper picture limit is marked by lines engraved on the screen. The "1.5" line is used when the focusing is close enough to need a 1.5x increase in exposure, the "2" line when 2x the exposure is needed: these values must first be read off the focusing distance/ exposure compensation scale.

Simple metering is provided by optional viewing heads, but the exposure settings must then be made manually.

Mamiya C220f with 80mm lens

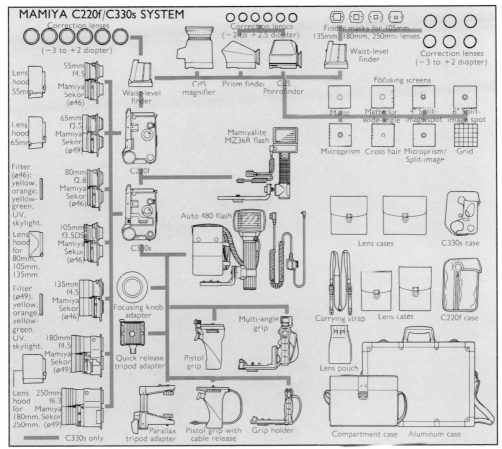

MAMIYA C220f/C330s SYSTEM

Correction lenses (−3 to +2 diopter)

Correction lenses (−2 to +2.5 diopter)

Finder masks for 105mm, 135mm, 180mm, 250mm lenses.

Correction lenses (−3 to +2 diopter)

Lens hood 55mm

55mm f4.5 Mamiya Sekor (ø46)

Waist-level finder

CdS magnifier

Prism finder

CdS Porrofinder

Waist-level finder

Focusing screens

Lens hood 65mm

65mm f3.5 Mamiya Sekor (ø49)

C220f

Mamiyalite MZ36R flash

Matte Matte for 4° Split- 6° Split-
wide-angle image spot image spot

Microprism Cross hair Microprism/ Grid
Split-image

Filter (ø46): yellow, orange, yellow-green, UV, skylight.

80mm f2.8 Mamiya Sekor (ø46)

Lens hood for 80mm, 105mm, 135mm

105mm f3.5DS Mamiya Sekor (ø46)

C330s

Auto 480 flash

Lens cases

C330s case

Filter (ø49): yellow, orange, yellow-green, UV, skylight.

135mm f4.5 Mamiya Sekor (ø46)

Focusing knob adapter

Multi-angle grip

Carrying strap Lens cases C220f case

180mm f4.5 Mamiya Sekor (ø49)

Quick release tripod adapter

Pistol grip

Lens pouch

Lens 250mm hood f6.3 for Mamiya 180mm, Sekor 250mm. (ø49)

Parallax tripod adapter

Pistol grip with cable release

Grip holder

Compartment case Aluminum case

C330s only

C220f

PANORAMIC CAMERAS

A panoramic roll-film camera is one that has a frame size of $2\frac{1}{4}\times4\frac{1}{2}$in/6×12cm or longer and/or an angle of view of greater than 90°. Faced with the problem of projecting an image onto such a long frame, the manufacturers have come up with two main designs: the wide-angle fixed-lens camera, and the motorized rotation model. Linhof and Fuji have used the wide-angle design to cover the $2\frac{1}{4}\times4\frac{1}{2}$in/6×12cm and $2\frac{1}{4}\times6\frac{11}{16}$in/6×17cm formats respectively. The Widelux 1500 and Panoscope 65/70 are both motorized.

The first design simply uses an extreme wide-angle lens to cover the long format. One drawback with this method is the problem of vignetting. To compensate for vignetting you can fit a centrally graduated filter, but this will reduce the effective speed of the lens by one f-stop. Alternatively, if you

*Linhof Technorama 612PC
(left) with a 65mm f5.6
Super Angulon lens (91°
angle of view). The
alternative 135mm lens
avoids vignetting, but the
reduced angle of view
means that it is no longer
panoramic.) There is a rising
front which has a maximum
vertical shift of $\frac{5}{16}$in/8mm.
For a falling front, simply
invert the camera; to facilite
this there is a second tripod
bush on the top plate. 120
or 220 film can be used.*

*Fuji Panorama G617 (right)
with a fixed 105mm f8
Fujinon-SW lens. This lens
has a 75° angle of view. The
contoured grips on the
body, and the front-
mounted shutter release
make the G617 easier to
handle than the Technorama
612PC. Shutter speeds range
from "B" and 1 second to
$\frac{1}{500}$ sec. This camera can be
used with either 120 or 220
film.*

are using negative film you can compensate when printing.

There are two variations on the rotation design: either the lens (as with the Widelux) or the whole camera (as with the Panoscope) is rotated. The Widelux's lens rotates through a fixed angle of view to fill its $2\frac{1}{4} \times 4\frac{1}{2}$in/6x12cm frame. With the Panoscope, the body of the camera (containing the lens and film) rotates on its own axis as the film is being wound on; thus the angle of view is variable, dependent upon the angle of rotation. If you set the Panoscope to rotate continuously, you can produce an image that fills a complete 120 roll. The camera has an interesting effect on perspective: the further a straight horizontal line is from the middle of the picture, the more it will be curved, converging toward vanishing points at either side of the frame.

Widelux 1500 (120 version) with 50mm f2.8 varifocus lens. The rotating lens gives the camera a 150° angle of view. Through the viewfinder it is possible to see the entire field of view. There is a range of 3 shutter speeds: $\frac{1}{8}$sec, $\frac{1}{60}$sec, $\frac{1}{250}$sec. On the base of the camera is a 3-point support which allows the camera to sit perfectly level on a flat surface. It can take up to 5 exposures on a roll of 120 film.

Panoscope 65/70 with 65mm f4.5 Grandagon lens. The angle of view is variable from 90° to continuous rotation. The motor is powered by a rechargeable 12 volt battery. The trigger knob, rotation indicator, reset switch and angle of rotation preselection switch are all on a remote handset. The range of effective shutter speeds is from 4 seconds to $\frac{1}{250}$sec.

ROLL-FILM BACKS

A 4x5in/10x12.5cm view camera with roll-film back may seem a cumbersome alternative to a purpose-built roll-film camera, yet for certain kinds of photography the combination is hard to beat. Some medium-format equipment manufacturers acknowledge the value of the lens movements offered by view cameras by including restricted movement in their camera designs – the Rollei SL66 and Fuji GX680 are notable examples. However, for complete image control, nothing is better than a monorail view camera. (The basic ways in which an image can be altered by moving the lens are explained in the box on the opposite page.) The addition of a roll-film back to a view camera offers the possibility of taking a number of shots in a continuous sequence without reloading. In addition, there is a larger range of emulsions on roll-film than is available on sheet film (pages 92-97.)

The most common design of 4x5in/10x12.5cm roll-film back, used by Horseman, Graflex and Linhof among others, is similar in principle to the normal film transport system adopted by Hasselblad. In another design, made by Sinar (right) and Calumet, the film is not bent significantly until after it has been exposed, and the supply and take-up spools are both at one end of a relatively long holder. Available frame sizes include $2\frac{1}{4}$x$2\frac{1}{4}$in/6x6cm, $2\frac{1}{4}$x$2\frac{3}{4}$in/6x7cm, $2\frac{1}{4}$x$3\frac{1}{4}$in/6x9cm and $2\frac{1}{4}$x$4\frac{1}{2}$in/6x12cm; the last is the largest possible for a 4x5in/10x12.5cm camera.

Because the standard design of back is bulky compared with the usual sheet film holder, you have to remove the ground glass focusing screen before clipping the back on in its place. To facilitate this the camera must have what is known as a universal back. Once the roll-film back has been clipped into place, and the lens diaphragm closed, the metal slide can be removed and the exposure made. As there are no safety interlocks in this kind of operation, double-exposure and

FLAT ROLL-FILM BACKS
The Sinar back (shown below in profile and cross-section) is designed to work in the same way as a sheet film holder. It slides into place, in front of the focusing screen for shooting and is withdrawn for viewing. This is a much quicker way of shooting roll-film on a view camera than the clip-on type of holder, but not as quick as a clip-on back with Rapid Adapter. A pressure plate is used to keep the film flat.

RAPID ADAPTER
One drawback with Horseman roll-film backs is the need to remove the focusing screen to fit the back; this slows down the whole shooting operation. With a Horseman Rapid Adapter, both the back and the screen are attached to a revolving plate, which is itself fitted to the back of the camera. The holder is simply swung out of the way for viewing (right), and swung back for shooting.

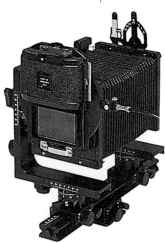

fogging mistakes are not uncommon. Most photographers who use these backs regularly have a set procedure to avoid making the the following errors: forgetting to close the lens diaphragm before withdrawing the metal slide; omitting to withdraw the slide before pressing the shutter; and forgetting to wind on the film before taking the next shot.

The main advantage of the alternative design used by Sinar and Calumet is that it can be inserted directly into the standard sprung back, just like a sheet film holder. The Sinar holders are particularly sophisticated, taking cartridges that can be pre-loaded before you start shooting; the film gate also has two long, thin cut-outs that will expose customized information, such as the photographer's name and copyright notice on the film rebates.

Finally, a third way to use roll-film with a view camera is to buy a back panel that will accept a medium-format camera body, making use of the view camera lens and movements.

IMAGE CIRCLE
The image circle of the lens has to be larger than the frame, otherwise its edge would intrude into the picture. Rise(above)/fall/shift movements can be used to bring the outer part of the image into the frame.

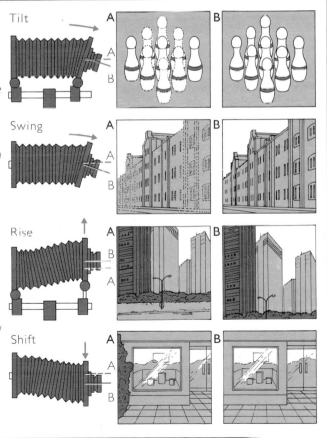

LENS MOVEMENTS
These can be divided into 2 groups: those that involve the lens moving parallel to the film, and those that angle the lens relative to the film. In the first group are the rise (upward), fall (downward), and shift (left/right) movements: in the second, the tilt (vertical) and the swing (horizontal). By tilting/swinging the lens you can angle the plane of sharp focus so that it matches the orientation of the subject. The rise/fall/shift movements simply move the lens' image circle relative to the picture frame. Rise can be used to take in the top of, for example, a building without having to point the camera upward which would cause the verticals to converge. The advantage of the view camera over the medium-format camera with lens movements is that not only the lens, but also the film plane can be moved.

Tilt

Swing

Rise

Shift

FILM

Unlike 35mm film, which has been highly standardized by mass marketing, medium-format films (or roll-films) offer a choice of frame size. The basic width of the film – 2¼in/6cm – remains constant; what changes is the division of the film into a fixed number of square or rectangular areas (from 2¼x2¼in/6x6cm square to 2¼x6¹¹⁄₁₆/6x17cm panoramic), each of which constitutes a single frame. Most camera makes offer a choice of formats. Obviously, the larger the frame size, the fewer pictures you can take on a roll.

Roll-film, like 35mm film, also offers a choice of lengths. The standard length is 120 film, which is paper-backed and rolled on spools. However, photographers can also choose double-length 220 film, also on spools but tightly wound, and without the paper backing, to accommodate extra frames. (A 120 roll will take twelve frames at 2¼x2¼in/6x6cm, ten at 2¼x3¼in/6x7cm, and eight at 2¼x3¼in/6x9cm.) Other options are sprocketed 70mm film, cut-down pieces of sheet film and Polaroid instant emulsions.

Such versatility is roll-film's great strength. However, it does, in a sense, require the photographer to work harder. Each equipment manufacturer has designed a particular way of loading and transporting the film. Further mechanical variations are made necessary by the choice between 120, 220 and 70mm film. Manufacturers have had to coordinate their film magazines with the other, fundamental features of the camera – features that vary from model to model, such as Mamiya's revolving back system or the Pentax 6x7's mimicry of the 35mm single lens reflex design. Other variations in film loading and transport mechanisms are the result of attempts to make the handling of roll-film easier and more efficient.

Roll-film could certainly benefit from further improvements in this direction. The standard 120 form is an old design that has undergone little change over the years. Loading and unloading calls for some dexterity, and it is easy to spoil a frame or two through carelessness or inexperience. On the face of it, 70mm film seems the answer to the problem – essentially, it is a scaled-up version of 35mm cassette film. Unfortunately, it has received too little support from equipment manufacturers or from processing laboratories to have made any real impact.

BLACK-AND-WHITE FILMS

Medium-format black-and-white films are not made in quite the same range of emulsions as 35mm film, but the selection available from the three main manufacturers – Kodak, Agfa and Ilford – is adequate for most photographic situations.

All these companies produce slow, fine-grained emulsions (ISO 25-50) for maximum definition, medium-speed, medium-grain emulsions (ISO 100 and 125) for all-purpose use, and fast, grainy emulsions (ISO 400) for shooting in low light or to freeze rapid action. In addition, Ilford produce a dye-image film that combines almost imperceptible grain with very wide exposure latitude.

The relation of film speed to graininess is a phenomenon that will be familiar to users of 35mm film. Graininess in a negative or print is the clumping together of many tiny grains of silver, which individually are too small to be seen with the naked eye. The ideal for the highest image quality is a film with very small, evenly spread grains, but the penalty for this is loss of speed – that is, lower sensitivity to light. Modern film chemistry has seen a number of improvements, but you still have to make a basic choice: whether to opt for maximum speed or maximum freedom from grain. Certain subjects actually benefit from graininess – for example, those where you want to achieve a documentary feel.

The grains in a medium-format film are the same size as those in a 35mm film with the same ISO rating. However, you also need to take into account the enlargement factor. A 4x5in/10x12.5cm print from, say, Tri-X roll-film will be less grainy that one taken from Tri-X 35mm film. For moderate enlargements, a fast roll-film can be used as a standard emulsion. Aspects of the printing process also play a part in

Brand name	Type	Speed (ISO)	Availability
Agfapan 25	Fine-grain	25	120
Technical Pan 6415 (Kodak)	Fine-grain	25	120
Panatomic-X (Kodak)	Fine-grain	32	120
Pan F (Ilford)	Fine-grain	50	120
Agfapan 100	Medium	100	120
T-Max 100 (Kodak)	Medium	100	120
FP4 (Ilford)	Medium	125	120, 220
Plus-X (Kodak)	Medium	125	120, 220
Agfapan 400	Fast	400	120
HP5 (Ilford)	Fast	400	120, 220
Tri-X (Kodak)	Fast	400	120
Tri-X Professional (Kodak)	Fast	400	220
T-Max 400 (Kodak)	Fast	400	120
XP1 (Ilford)	Dye-image	200-1,600	120
Agfa-ortho 25	Lith	25	120

the equation. For example, you can limit the effects of grain by using a special fine-grain developer. Also, there is little point in using a high quality camera lens if the enlarging lens is not of a comparable quality.

Ilford's dye-image film, XPI, is developed in colour negative chemicals to form a fine-grain image in dye rather than in silver grains. The exposure latitude is such that the film can be rated at between ISO 125 and ISO 800 (even ISO 1600 in some instances) without altering the development time. The disadvantages of XPI are that it is more expensive than conventional black-and-white films, and that prints made from the dye-image negative are likely to show deterioration sooner.

Polaroid produce a number of black-and-white instant emulsions: these are discussed on pages 96-97.

Matching film to subject
The slowest roll-films in normal use – ISO 25 to 50 – have very fine grain and excellent definition. They are thus suitable for close rendering of detail – for example, in a subject where texture is important, such as a landscape or architectural view (below) – or when you intend to make considerable enlargements. If you use a tripod, the loss of light sensitivity is not a problem.

COLOR FILMS

As with black-and-white films, there is more choice in 35mm than in medium-format, but the main sacrifice is in the more exotic emulsions. There is no infra-red Ektachrome, and the fastest color transparency films are ISO 400. The lack of very fast films (with the single exception of Agfa's ISO 1000 color negative emulsion) is because medium-format cameras are not normally used for hand-held shooting in low light.

Color film consists of a 3-layered sandwich of emulsion, each layer sensitive to a different part of the spectrum. Dyes are built into these layers, so that one layer records blue light, another green, and the third red. These three primary colors, when mixed, can produce any other color in the spectrum. The way in which these dyes are translated into the colors that you see in the final print or transparency is described on pages 124-125.

Brand name	Type	Speed (ISO)	Availability
COLOR NEGATIVE FILM			
Agfacolor XRS100	Fine-grain	100	120
Fujicolor HR100	Fine-grain	100	120
Kodacolor VR100	Fine-grain	100	120
3M Color Print 100	Fine-grain	100	120
Vericolor HC (Kodak)	High-contrast	100	120
Fujicolor 160S	Medium-grain	160	120, 220
Vericolor IIIS (Kodak)	Medium-grain	160	120, 220, 70mm
Agfacolor XRS200	Medium-grain	200	120
Kodacolor VR200	Medium-grain	200	120
Agfacolor XRS400	Fast	400	120
Fujicolor HR400	Fast	400	120
Kodacolor VR400	Fast	400	120
Agfacolor XRS1000	Ultra-fast	1,000	120
Vericolor IIL (Kodak)	Tungsten	100	120
Fujicolor 160L	Tungsten	160	120
COLOR TRANSPARENCY FILM			
Agfachrome 50RS	Fine-grain	50	120, 70mm
Fujichrome 50D	Fine-grain	50	120
Ektachrome 64	Fine-grain	64	120, 220, 70mm
Kodachrome 64	Fine-grain	64	120
Agfachrome 100RS	Fine-grain	100	120
Ektachrome 100	Fine-grain	100	120, 220
Fujichrome 100D	Fine-grain	100	120, 220
Agfachrome 200RS	Medium-grain	200	120
Ektachrome 200	Medium-grain	200	120
Ektachrome 400	Fast	400	120
Fujichrome 400D	Fast	400	120
Agfachrome 50L	Tungsten	50	120
Ektachrome 50	Tungsten	50	120
Fujichrome 64T	Tungsten	64	120

The same relationship between film sensitivity and grain exists in color films as in black-and-white. However, the grain in a color film is different in appearance from that in a black-and-white negative or print. In monochrome film, the grains of black silver are dense enough to give a distinct, even sharp, texture: in a color film, the silver grain is replaced by transparent patches of dye, called "dye-clouds", which make the grain less obvious.

Color has subjective qualities that make comparisons between makes of film a matter of personal taste. This applies in particular to color transparency films, which carry the final, positive image as soon as they are processed. With color negative film, the printing stage itself introduces so many variables that only a precise laboratory test can reveal any differences between the makes.

COMPARING FILMS
The best way to compare the different makes of color film is by a side-by-side comparison. The Khmer temple complex shown below has been shot on both Kodachrome (top) and Fujichrome (bottom). Fujichrome is noted for its intense blues.

POLAROID FILMS

One notable feature of medium-format equipment is that for every model that accepts interchangeable backs there is a special holder for Polaroid instant film. Polaroid films have long been used by professional photographers as a means of checking the image before shooting on regular film – with regard to the exposure, color balance, lighting (particularly with flash) or any other aspect of uncertainty.

The films used for this kind of testing are constructed on the peel-apart principle, patented by Polaroid. In this, each frame is exposed and processed individually. The negative emulsion uses conventional silver halide grains, and is exposed normally. Next to it is a separate sheet, known as the positive receiving layer, and at one end of the packet is a sealed pod of viscous chemicals. Processing begins when the packet is pulled out of the holder between two metal rollers.

Brand name	Print size	Speed (ISO)	Dev. time (75°F/24°C)
COLOR PRINT			
Type 668 Polacolor (High contrast, 4 stops latitude)	$3\frac{1}{4}$×$4\frac{1}{4}$in/8.3×10.8cm	80	1 min
Type 668H (Paper based for use with Polapress)	$3\frac{1}{4}$×$4\frac{1}{4}$in/8.3×10.8cm	80	1 min
Type 669 Polacolor ER (Extended brightness range, $5\frac{1}{2}$ stops lat.)	$3\frac{1}{4}$×$4\frac{1}{4}$in/8.3×10.8cm	80	1 min
Type 669S (Silk finish)	$3\frac{1}{4}$×$4\frac{1}{4}$in/8.3×10.8cm	80	1 min
Type 88 Polacolor	$3\frac{1}{4}$×$3\frac{3}{8}$in/8.3×8.6cm	80	1 min
OVERHEAD COLOR TRANSPARENCY			
Type 691	$3\frac{1}{4}$×$4\frac{1}{4}$in/8.3×10.8cm	80	4 min
HIGH-SPEED BLACK-AND-WHITE PRINT			
Type 667	$3\frac{1}{4}$×$4\frac{1}{4}$in/8.3×10.8cm	3,000	30 sec
Type 87	$3\frac{1}{4}$×$3\frac{3}{8}$in/8.3×8.6cm	3,000	30 sec
POSITIVE/NEGATIVE BLACK-AND-WHITE PRINT			
Type 665	$3\frac{1}{4}$×$4\frac{1}{4}$in/8.3×10.8cm	75	30 sec (70°F/21°C)
LOW-CONTRAST BLACK-AND-WHITE PRINT			
Type 611	$3\frac{1}{4}$×$4\frac{1}{4}$in/8.3×10.8cm	200	45 sec (65°-75°F/ 18.5°-24°C)
MEDIUM-CONTRAST BLACK-AND-WHITE PRINT			
Type 664	$3\frac{1}{4}$×$4\frac{1}{4}$in/8.3×10.8cm	100	30 sec
HIGH-CONTRAST BLACK-AND-WHITE PRINT			
Type 612	$3\frac{1}{4}$×$4\frac{1}{4}$in/8.3×10.8cm	20,000	30 sec

These rollers break the pod and squeeze the contents evenly between the negative emulsion and the receiving layer. The exposed crystals are developed, while the remainder, which are used to make the positive final image, pass to the positive receiving layer, where they precipitate as black silver grains. This is the finished print. Apart from Type 665 (below), all the films have a built-in protective coating on the surface of the print, and need no further treatment once processed.

The complete range of Polaroid films is extensive, but complicated by a confusing system of descriptions. Those that can be used with medium-format cameras are all available in packs and come in two sizes: $3\frac{1}{4} \times 4\frac{1}{4}$ in/8.3×10.8cm and $3\frac{1}{4} \times 3\frac{3}{8}$ in/8.3×8.6cm (this is the outer dimension of the print: the actual image sizes are slightly smaller, as shown right). From the numbered designations these films are often referred to as the "80" series and "600" series.

As these films are normally used in medium-format photography as a way of testing, it is important to be aware of some differences in performance between the Polaroid emulsions and regular films. For example, the color accuracy of a Polacolor print depends on the exposure time. At shutter speeds slower than $\frac{1}{30}$ sec, there is a noticeable loss of sensitivity, and a strong shift toward blue-green. This is the result of reciprocity failure, in which one or more of the emulsion layers responds increasingly sluggishly as exposure time is extended. Of course, when using the test exposure as a basis for the actual shot you have to compensate for any difference in film speeds.

Type 665 is unique among medium-format Polaroid films in that it produces both a fine-grained print and a high resolution negative. Used for its negative, this film is a valid alternative to shooting on normal black-and-white film. One precaution, however: if the print looks well exposed, the negative is likely to be too thin. So when shooting for the negative, I prefer to rate the film at ISO 50 instead of the recommended ISO 75.

IMAGE SIZE
The medium-format frame sizes are smaller, in at least one direction, than the image area of the Polaroid print. The result is that an exposed instant print carries the image on just part of the print. The illustration above (not actual size) shows a standard $2\frac{1}{4} \times 2\frac{1}{4}$ in/6x6cm image on a $3\frac{1}{4} \times 4\frac{1}{4}$ in/ 8.3x10.8cm print.

PROCESSING TYPE 665
This film has to be treated with a coating fluid supplied with the pack. The coating neutralizes any trace of processing fluid and gives a hardened surface. It should be applied soon after processing. If the coating is delayed, the highlights in the print will tend to lighten. Once the negative has been washed and dried it can be used for printing.

FILM LOADING

In use, 120 and 220 roll-films are wound from film spool to take-up spool: they are not rewound as 35mm film is. (70mm roll-film is the exception: it comes loaded in cassettes into which the film is rewound after exposure.) The most common film transport system is the "double-back" type, used by Hasselblad and others. The other main system has a straight film path and is used in 35mm-style cameras, such as the Pentax 6x7. The loading sequences for the Hasselblad and the Pentax are shown here in some detail. The unloading sequence (opposite page) applies to both systems. It is advisable to refer to the manufacturer's instructions before attempting to load any medium-format film.

"DOUBLE-BACK"
LOADING
The Hasselblad loading sequence shown here is typical of all the cameras with a "double-back" loading system. With this system, the film is bent against its natural curve, doubling-back around 2 rollers: tension between the rollers keeps the film flat.

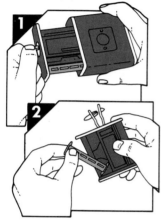

1 Pull up the locking key on the left-hand side of the magazine, and turn it counter-clockwise. Use the key to pull out the insert.

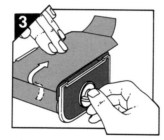

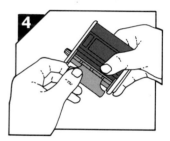

2 Place the empty spool in the top chamber. Insert the film into the other chamber, having removed its paper strip.

3 Twist the locking key clockwise to raise the film clamp. Pull the leader out and around the roller and slide it under the clamp.

4 Slide the leader over the second roller, and inset the tapered end into the socket of the take-up spool. Hold in place with your finger.

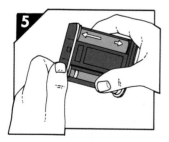

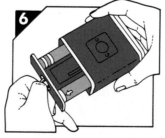

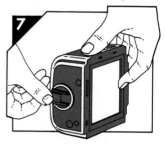

5 Wind on the film by turning the ribbed knob clockwise until the arrow is opposite the triangular mark on the end of the chamber.

6 Turn locking key counter-clockwise to secure the paper under the clamp. Push the insert into the magazine, and lock it in place by turning the key clockwise.

7 Holding the magazine firmly in one hand, turn the crank handle clockwise until it locks. The number "1" should appear in the counter window.

"STRAIGHT-PATH" LOADING

The Pentax 6x7 camera and similar models have a straight film path. This allows the film chamber, and therefore the camera, to be slim in comparison with the "double-back" design. A pressure plate attached to the inside of the camera back keeps the film flat.

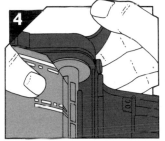

1 Open the camera back, turn and pull down the right retaining knob. Insert an empty spool. Push back the knob and turn to lock.

2 Turn the winding lever until the slot in the empty take-up spool faces outward. Never turn the spool in the opposite direction.

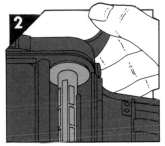

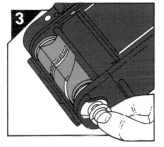

3 Turn and pull out the left-hand retaining knob. Insert a roll of film, having removed the paper strip that seals it. Once the film is in place, push in the knob.

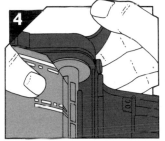

4 Pull the leader across the back and thread it into the slot in the take-up spool. Hold in place and turn the winding lever, until the leader is tightly wound.

5 Continue winding until the arrow on the backing paper lines up with either the 120 or 220 mark. Close the back, and wind on until the counter reads "1".

REMOVING THE FILM

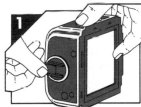

1 When the whole film has been exposed, the shutter automatically disengages. Turn the winding lever until you feel the film go slack.

2 In subdued light, turn and pull down the retainer knob, while pressing down on the upper rim of the spool. Gently extract film.

3 Once the film is free check that it is tightly wound. Lick the gummed paper tape and seal the roll. Store in a clean, dry place.

FORMAT OPTIONS

Roll-film's generous width allows a choice of image size and shape—a unique feature of medium-format photography. The *frame* width is $2\frac{3}{16}$in/55mm, more than twice that of a frame on 35mm film. A $2\frac{1}{4}\times3\frac{1}{4}$in/6x9cm image on roll-film has the same proportions as the standard $\frac{15}{16}\times1\frac{7}{16}$in/24x36mm frame on 35mm film, yet covers more than six times the area. Arranging the pictures vertically on the roll creates a smaller image ($2\frac{1}{4}\times1\frac{3}{4}$in/6x4.5cm), yet even this can be printed at a moderate enlargement without noticeable graininess.

Most of the available roll-film picture formats are relatively recent. The traditional frame size, $2\frac{1}{4}\times2\frac{1}{4}$/6x6cm, dominated until the 1960s. From the compositional point of view, this square shape is an odd choice. The reason for it, however, was not aesthetic, but mechanical.

The first reflex camera designs for roll-film had to be used at waist-level, looking down into the viewfinder — at right angles to the camera's lens axis. There would have been no difficulty in making the frame rectangular, but the only way of changing the picture from horizontal to vertical would have been to rotate the camera. Given the simple look-down construction, viewing this way is almost impossible. Hence, a square format made mechanical sense: the photographer could *imagine* a horizontal or vertical format within the square and crop the picture later, after processing. The film size, of course, was large enough to stand this cropping.

Two later developments made it practicable to use a rectangular film frame, both horizontally and vertically: eye-level viewing and rotating film backs. The former was always a simple matter for non-reflex cameras, as the viewfinder had

Roll-film's versatility
*Superimposed on this view of a snow-bound New England barn are the various format options (shown actual size) available on roll-film (both 120 and 220). Because the $1\frac{3}{4}\times2\frac{1}{4}$in/4.5x6cm frame (**1**) is arranged across, instead of along, the roll, it is referred to as the 645 format (rather than 456). The proportions of this miniature medium-format are halfway between those of the "ideal" ($2\frac{1}{4}\times2\frac{3}{4}$in/6x7cm) (**3**) and "extended" ($2\frac{1}{4}\times3\frac{1}{4}$in/6x9cm) (**4**) formats. It has an area of $3\frac{2}{5}$sq in/22sq cm, $2\frac{1}{2}$x that of the 35mm frame (bottom left). The square ($2\frac{1}{4}\times2\frac{1}{4}$in/6x6cm) (**2**), "ideal" and "extended" formats have areas of $4\frac{7}{10}$, 6, $7\frac{2}{5}$sq in/30, 38.5, 47.6sq cm respectively. Also shown are two panoramic formats: $2\frac{1}{4}\times4\frac{1}{2}$in/6x12cm (**5**) and $2\frac{1}{4}\times6\frac{1}{4}$in/6x17cm (**6**).*

The 35mm alternative
The image below is a 35mm frame shown actual size ($\frac{15}{16}\times1\frac{7}{16}$in/24x36mm, occupying $1\frac{7}{8}$sq in/8.6sq cm). Juxtaposition with the various roll-film formats (right) makes a telling point about the superior image quality of roll-film.

its own separate axis along which the eye was placed for viewing. However, in a reflex camera eye-level viewing needed a pentaprism of the type developed for 35mm single-lens reflexes. All modern medium-format single-lens reflexes now accept pentaprisms or include them as an integral part of the body assembly. Rotating backs were first developed by Mamiya. While they add to the complexity of the camera, they use roll-film to its maximum advantage.

Once a variety of frame shapes and sizes became a practicable proposition, most camera manufacturers expanded their systems to take advantage of the opportunities that they offered. Interchangeable backs add an extra dimension to photography. In the 35mm format, your equipment choice is mainly that of lens focal length. With most medium-format cameras you can also decide on the suitable picture dimensions.

The range of formats also adds an extra element to picture composition. The 35mm user will have grown used to adapting the $\frac{15}{16} \times 1\frac{7}{16}$in/24x36mm frame to every shot; to the medium-format photographer this would be like being forced to use only the "extended" format (which has the same proportions as the standard 35mm frame) – but, as the name suggests, these proportions are definitely on the long side. The greater freedom in roll-film photography means that the most suitable format can be selected for the shot.

At the other end of the range, the square format may at first appear rather unnatural, as it is very different from our own field of vision; but once the initial apprehension has been overcome it can be a most interesting and flexible choice.

70mm film

A variant type rather than a format, 70mm film has sprocket holes along each edge enabling it to be used in the same way as 35mm film – packed in metal cassettes and transported by sprocketed rollers in a special magazine. The range of emulsions available on 70mm film is very limited (pages 92–95).

SQUARE FORMAT/1

Photographers who are accustomed to a $2\frac{1}{4}\times2\frac{1}{4}$in/6x6cm camera usually see nothing peculiar in this square format. Through familiarity, they find the format, and the special working methods that go with it, perfectly natural. However, to anyone else such as a convert from 35mm photography, a square picture frame seems ill-suited to most image designs.

Psychologically, most people are attuned to rectangular proportions. When a square frame is used, the composition often looks strained, as if forced into place. The secret of using a square format successfully is to know the kinds of subject that lend themselves to it, and not to try too hard to make the picture work otherwise.

There are two distinct ways of composing within a square viewfinder: one is to make the composition fit the frame, the other is to imagine a horizontal or vertical shape within the finder, and compose inside that. There is a third method – not to make any decision at all until the negative is ready for printing – but this is essentially design by default, and not recommended.

There is a price to pay for cropping into the square format. The size advantage that roll-film has over 35mm is considerable, but a $2\frac{1}{4}\times2\frac{1}{4}$in/6x6cm camera gives $3\frac{1}{2}\times$ the picture area *only* if the full square frame is used. A cropped-in rectangle of the same proportions as a 35mm frame is just $2\frac{3}{4}\times$ larger – yielding an image quality that is good, but not spectacular.

When you compose a picture, it helps to be aware of the influence of the frame on the dynamics of the shot: a square format undoubtedly has a static effect. No one side is longer than another, so the picture has no built-in direction. The center of the frame is emphasized, directing the eye inward. There may even be a sense of confinement. All in all, a square frame tends to be better suited to still, well-organized images than to those with a strong element of motion.

From this account, it is easy to see that there are two kinds of image that are served particularly well by a square format: any subject organized around a central point, and any picture

Movement within a square
The dynamic lines of an Art Deco factory facade (the Firestone factory, London, now demolished) are reinforced by the formality of the square format. The slightly off-center framing is part of the reason for its success.
250mm Sonnar, ISO 64 Ektachrome, $2\frac{1}{4}\times2\frac{1}{4}$in/6x6cm, $\frac{1}{125}$sec, f11.

SQUARE FORMAT/2

that is essentially an overall pattern. To take a subject that is already formally structured and then organize it within an even more formal frame goes against the usual principles of design: the resulting balance will be static rather than dynamic, and leave little for the viewer to explore. For this highly formal approach to succeed so much depends on whether the subject holds other kinds of graphic interest. Also, the design must be *really* exact: anything slightly askew will be evidence of sloppiness.

A square format also suits pattern photographs. The advantage of square sides to this kind of image is that no direction is implied, so the pattern appears to spread equally in all directions, and without limit.

Framing a pattern
This market on the banks of the Rio Negro, in Brazil, appears almost as a pattern, filling the frame from edge to edge. The neutrality of a square format suits this kind of composition, in which the only focus of attention is that lent by perspective.
38mm Biogon, ISO 64
Ektachrome, 2¼×2¼in/6x6cm,
$\frac{1}{15}$sec, f8.

Perfect symmetry
The precision of the roof of the chapter house vault in Westminster Abbey, London, is reinforced here by the square frame. The main column was centered exactly so that the format would emphasize the symmetry of the radiating lines.
38mm Biogon, ISO 200 Ektachrome, 2¼×2¼in/6×6cm, 1sec, f8.

An effect of balance
Even with subjects that do not obviously lend themselves to square design, a successful composition can often be made by counter-balancing different blocks of tone or color. It helps when the blocks are divided simply, with clean breaks – as here in a telephoto shot of a small iceflow in Iceberg Lake, Glacier National Park, Montana.
500mm Tele-Tessar, ISO 64 Ektachrome, 2¼×2¼in/6×6cm, $\frac{1}{125}$sec, f11.

SQUARE FORMAT/3

Leaving aside centered images and patterns, designing within a 2¼x2¼in/6x6cm border is often a matter of making full use of the space. This is not necessarily the same thing as *filling* the space, which is a poor principle to follow for any format. What is important is to balance the different parts of the image so that the eye is led across and around the frame.

The square resists our natural inclination to see in terms of either a horizontal or vertical image. Thus, an ill-composed image in this format tends to appear heavy in one part of the frame, often the upper. One way of countering this is to use shapes, tones or colors in a way that opposes large against small. A warning, however: once you have made a tight composition in the viewfinder, it may be impossible to re-crop it in any other way at a later stage.

Given the undoubted awkwardness of most square compositions, and the fact that medium-format cameras are widely used by professionals who are shooting to rectangular formats imposed by their clients, the usual way of working with the 2¼x2¼in/6x6cm frame is to crop the image mentally at the time of shooting. This wastes some of the film but, if the final proportions have been set, there is no alternative.

With experience, it is possible to imagine a horizontal or vertical shape within the viewfinder, without artificial aids. However, for beginners there is often a tendency to drift back to the square. If you notice this happening, and you find that you cannot crop your square negative successfully during

The abstract approach
Abstracted images are more adaptable than almost any other kind to different formats. A close, backlit view of these caladium leaves after a rain shower, with the aperture almost fully open, has emphasized color and tone at the expense of detail. The curving umbrella of lines at the top deliberately fits the top of the frame.
80mm Planar (+ 21mm extension), ISO 64 Ektachrome, 2¼x2¼in/6x6cm, ¹⁄₃₀sec, f4.

enlargement, consider inserting some kind of frame marker inside the viewing head. It is simple enough to make your own marker by drawing a set of lines, in waterproof draughting ink, on a piece of clear celluloid cut to shape. Alternatively, some manufacturers produce drop-in screens for use with $2\frac{1}{4}\times1\frac{3}{4}$in/6x4.5cm and $1\frac{3}{4}\times2\frac{1}{4}$in/4.5x6cm magazines, and these will do the same job. The difficulty some people experience with mental cropping partly explains the popularity of the 645 camera and of Hasselblad, Rollei and Bronica accessory magazines for the same format. However, most $2\frac{1}{4}\times2\frac{1}{4}$in/6x6cm adherents would argue that the open square frame gives a faster and more flexible choice.

A frame within a frame
You can often set a dynamically angled window frame within the confines of the square. This stone arch, in a monastery in Cartagena, Colombia, has been shot to complement the $2\frac{1}{4}\times2\frac{1}{4}$in/6x6cm format. 38mm Biogon, ISO 64 Ektachrome, $2\frac{1}{4}\times2\frac{1}{4}$in/6x6cm, $\frac{1}{2}$sec, f16.

"IDEAL" FORMAT/1

The term "ideal" is often used for the $2\frac{1}{4}\times2\frac{3}{4}$in/6x7cm format. While it is easy to challenge the assumption that any proportions are inherently better than others, this rectangular frame does have some natural advantages. It corresponds closely to the standard printing paper sizes – 8x10in/20.5x-25.5cm, 10x12in/25.5x30.5cm, 16x20in/40.5x51cm. Moreover, it is close to what most people would consider to be the eye's normal field of view (even though this has blurred edges and is vaguely horizontal rather than being a precise rectangle). Mostly, photographers compose by intuition, and this process seems to go more smoothly if the proportions of the picture frame are themselves not strained or unusual. The $2\frac{1}{4}\times2\frac{3}{4}$in/6x7cm frame is unobtrusive, both for the photographer making the composition and for someone else looking at the result. Whereas a panorama, for example, draws attention to the shape of the picture by being a little out of the ordinary, an "ideal" border usually goes unremarked.

Some of the most common arrangements of elements inside the frame use the same proportions as the frame itself. If you look at a wide variety of images in this format, and pay

Central division

In this picture, taken in the old Indian city of Fatehpur-Sikri, the dividing line has been placed deliberately in the exact center to emphasize the near-perfect reflection of the marble palace in the lake. This encourages the eye to flip from the top half to the bottom without finding a natural place to rest the attention.

50mm, ISO 50 Agfachrome (70mm film), $2\frac{1}{4}\times2\frac{3}{4}$in/6x7cm, $\frac{1}{60}$sec, f16.

attention to the ways in which the frame is divided, you will see one feature that recurs time and again – a slight off-centeredness. Most people who have a natural eye for composition tend to compose in this way.

One of the most common dividing lines in nature – and in photography – is the horizon. Obviously, there are countless positions for the skyline in a picture; however, they fall into three distinct groups (centered, off-centered, high/low), each with its own characteristic effect on composition. A centered horizon tends to create a certain amount of unresolved tension, because neither the land nor sky has priority. A very high or very low horizon has a dramatic effect, making an instant impact. A horizon line that is just slightly above or below the middle seems natural: it is sufficiently off-center to create an active balance and catch the attention, but not so extreme as to make you wonder why.

The same innate tendency toward off-centered composition comes into play when you are considering other aspects of composition. If the picture is divided, both horizontally and vertically, in the same proportions as the frame itself, the

High horizon
Aiming the camera slightly down, so that the horizon lies at the top of the frame, concentrates attention on these rock pools and seaweed-covered boulders on the Maine coast, while still keeping these close details firmly in their setting. A revolving back was used.
90mm, ISO 64 Ektachrome, 2¼×2¾in/6×7cm, ½sec, f32.

"IDEAL" FORMAT/2

point of intersection is one of the most satisfying positions for the main subject: this could be an isolated object, such as a boat on a lake, or a natural focus of attention, such as a face.

This is composition at a fairly primitive level: it would be a mistake to think that it embodies a high order of aesthetics. However, it is possible to treat these proportions mathematically. A strictly mathematical approach is not usually practicable when using a camera, but it has played an important part in the history of art. The most famous proportions are those of the Golden Section (right), known to the Greeks and used by artists since the Renaissance. The principle of the Golden Section is that the proportions of the division are related to each other; the smaller section is in the same proportion to the larger section as the larger section is to the whole. The theory behind this is that because the proportions bear a strict relationship to each other, there is an underlying natural elegance that makes for a satisfying image. Whether this is true or not can only be a matter of opinion; it remains, however, a conventionally acceptable method of composition. The simple fractions that come

Golden Section
The proportions of the Golden Section (above) have been used in the composition of the picture of a pumping engine (below).
90mm, ISO 50 Ektachrome (tungsten-balanced), 2¼×2¾in/6x7cm, 60sec, f32.

closest to describing the Golden Section division are $\frac{5}{8}$ and $\frac{3}{8}$. While no current camera format has exactly these proportions, $2\frac{1}{4}\times2\frac{3}{4}$in/6x7cm is not far off.

The rectangular picture shape, of course, creates another choice: whether to shoot horizontally or vertically. A number of factors influence this decision, not the least being the camera design. The Pentax 6x7, which is modeled on the typical 35mm single-lens reflex camera, is made to be held horizontally; like a 35mm camera it has a kind of built-in ergonomic resistance to being used for vertical shots. The Mamiya RB67/RZ67 with its revolving back has no such bias and so exerts no influence of its own.

Camera handling considerations apart, the main influence on whether to shoot horizontally or vertically is the subject itself. Many scenes have a strong directional component which naturally suggests the most suitable orientation to use. Even so, it is nearly always possible to make a successful picture design whatever the alignment of the frame, because the difference between vertical and horizontal within these "ideal" proportions is never pronounced.

Quartering the frame
In this wide-angle view, the placement of the urn in the exact center of the picture contrasts with the more conventional horizontal division of the frame. This crosswise arrangement helps to separate the two elements of the image, increasing the sense of depth.
50mm, ISO 64 Ektachrome, $2\frac{1}{4}\times2\frac{3}{4}$in/6x7cm, $\frac{1}{2}$sec, f32.

"EXTENDED" FORMAT

Compared with the normal range of roll-film picture formats, the $2\frac{1}{4}\times3\frac{1}{4}$in/6x9cm frame, used in some Fuji rangefinder cameras, the Plaubel 69 proshift and in some roll-film backs, is distinctly elongated. Photographers familiar with the $2\frac{1}{4}\times2\frac{1}{4}$in/6x6cm format will have to rethink their approach to composition. However, 35mm users will be completely at home – the "extended" proportions are exactly the same as those of the standard 35mm frame.

In this format, a horizontal picture is psychologically easier to look at than a vertical one. This is due to the slight reluctance of the eyes to scan up and down. Vertical images tend to succeed only if they make full use of the height of the frame. This is particularly true of large images.

In landscape photography, most vertical images are details of wider views – for example, a cliff-face or sharp peak, rather

Low horizon
A $2\frac{1}{4}\times3\frac{1}{4}$in/6x9cm roll-film back on a 4x5in/10x12.5cm view camera was used to photograph this "Blackbird" SR71 jet fighter. A wide-angle lens takes in a broad horizon, its position low in the frame makes full use of the long format.
65mm Super Angulon (on a Sinar Handy camera), ISO 100 Fujichrome, $2\frac{1}{4}\times3\frac{1}{4}$in/6x9cm, $\frac{1}{125}$sec, f11.

than a full mountain range. Such shots are usually the province of telephoto lenses, which are naturally selective. Wide-angle lenses, on the other hand, are easier to use horizontally. A vertical shot taken with a wide-angle lens usually calls for an interesting foreground – excess sky is a common design problem, unless there are attractive clouds.

Dividing the frame into thirds is a useful compositional guide when working with the "extended" format, because the $2\frac{1}{4} \times 3\frac{1}{4}$in/6x9cm proportions are themselves built on thirds – the shorter side is two-thirds of the longer. You can follow the same rule of thumb when placing subjects in the frame. In a vertical composition the main subject, if isolated, is often placed in the lower third, to give extra weight to the base: otherwise, the height of the frame in relation to its width may look uncomfortably exaggerated.

Vertical composition
The narrow opening of a door in a deserted croft in northern Scotland is a natural subject for a longer format. Even if photographed on $2\frac{1}{4} \times 2\frac{1}{4}$in/ 6x6cm, this image would have benefited from cropping during enlargement.
65mm Super Angulon, ISO 64 Ektachrome, $2\frac{1}{4} \times 3\frac{1}{4}$in/6x9cm, $\frac{1}{60}$sec, f16.

PANORAMIC FORMATS

When the proportions of a picture frame are at least twice as long as they are high, the photograph takes on the special characteristics of a panorama.

The visual principle is that of the broad, sweeping view. The most typical panoramic photographs are of landscapes that already have a strong horizontal element: the effect is similar to that of standing on a high viewpoint and scanning the horizon. With such scenes, composition virtually takes care of itself. The long edges at top and bottom seem to closely confine the image, making it doubly important to keep the horizon level. Usually, the main concern is the horizontal arrangement of the scene. We view the print by scanning rather than taking it in at a single glance. If the visual interest tails off to the left or right, the eye is less likely to take in the whole picture, and the full effect will be wasted.

With rather more care, a panoramic format can be used for closer and more confined views. Clearly, any long, shallow subject is suitable, but the chief difficulty is usually the vertical edges: truncated into sections by the shallow frame, tree trunks, pillars, door frames and the like may appear misplaced, dividing the panorama into separate pictures.

To produce a $6\frac{1}{2}$x$8\frac{1}{2}$in/16.5x21.5cm print a $2\frac{1}{4}$x$2\frac{3}{4}$in/6x7cm negative requires a 3x enlargement; in the $2\frac{1}{4}$x$6\frac{3}{4}$in/6x17cm format the same magnification will yield a 20in/51cm long panorama. At this level, there is no graininess in the final image, and the grading of tones is extremely fine. The only waste will be in the paper, which is less costly than film.

2¼x4¾in/6x12cm (above)
This is the least extreme of panoramic formats. In this picture of a Colonial church in the Philippines, the clouds have been used to unify the image.
65mm Super Angulon (on a Sinar Handy camera), ISO 100 Fujichrome, 2¼x4¾in/6x12cm, 1/15 sec, f16.

2¼x6¾in/6x17cm
In this photograph of an old town hall in Massachusetts, the horizontal lines of the snowbank and hills make good use of the format.
90mm Super Angulon (on a Linhof Technorama), ISO 64 Ektachrome 2¼x6¾in/6x17cm, 1/60 sec, f16.

BLACK-AND-WHITE PROCESSING

Now that most photography is in color, there is very little commercial processing of black-and-white film. Most photographers who work in black-and-white do their own processing. This can be, and should be a pleasure – a natural link between making the exposure and the printing. If you perform all the stages yourself, you have control over the photographic process, and can make adjustments at any point.

Black-and-white processing is a straightforward procedure, with considerable latitude in working temperature and times. All that is really necessary is to handle the film with care and follow the procedures meticulously. A variety of developing solutions is available from different manufacturers, and over time you will acquire your own preferences. At the start, however, it is a good idea to use one of the solutions recommended by the film manufacturer in the instruction sheet packed with the film. If you want to experiment, do a controlled test between different developers, using each on rolls of the same film that have been exposed identically. All modern developers give fine-grain results, but some special solutions are sold to give extra-fine-grain, while others enhance the effective film speed.

The basic equipment for black-and-white processing is shown below. The only stage that must be carried out in the dark is the loading of the film into the processing tank (right). The basic steps in the developing process are shown opposite; for more details, consult the manufacturer's instructions.

LOADING THE FILM

There are two basic designs of processing tank: one with a plastic reel, the other with a metal reel. Plastic reels are rim-loaded: the film, with the emulsion on the inside, is fed into the spiral groove of the reel (below), and the two sides are turned in opposite directions, in a ratchet motion, to wind the film on. Metal reels are center-loaded: the film is clipped to the reel's core and, with the film bowed, the whole reel is rotated.

EQUIPMENT
1 *Processing tank (plastic design)*
2 *Film reel (plastic design)*
3 *Timer*
4 *Rubber gloves*
5 *Thermometer*
6 *Stirring paddle*
7 *Hose*
8 *Film clips*
9 *Wetting agent*
10 *Funnel*
11 *Water bath (for warming the solutions)*
12 *Graduates (for mixing the chemicals)*
13 *Film developer*
14 *Stop bath*
15 *Fixer*

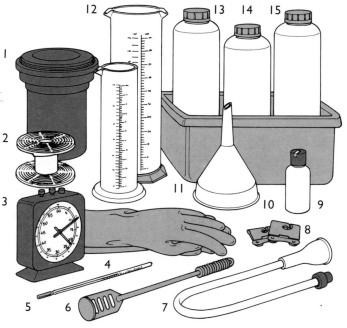

*STEP-BY-STEP
PROCESSING*
First, prepare the chemicals,
following the manufacturer's
instructions. Measure the
quantities in the graduates,
making sure that there is
enough of each solution to
fill the tank. Bring the
solutions to the correct
temperature by standing the
graduates in a warm water
bath. Check the
temperature of the solutions
with the thermometer:
68° F/20° C is normal. Then
follow the steps below:

1 In darkness, remove the
adhesive paper from the film
and pull the film off its
backing. Holding the film by
its edges, load it on to the
reel

2 In darkness, slot the reel
into the tank. Be sure to
seal the lid securely, but
leave off the small central
cap. The remaining steps can
be done in daylight.

3 Pour the developer into
the tank, and seal with the
central cap. Start the timer
as soon as the tank is full.
Rap the tank smartly to
dislodge air bubbles.

4 Agitate the tank, by gently
inverting it, for 15 seconds,
stop for 30 seconds, and
agitate again for 5 seconds.
Repeat until the end of the
development time.

5 Start draining the tank
before the development
time is complete, so that it
is empty when the timer
stops. Drain developer and
discard or retain for re-use.

6 Pour in the stop bath and
agitate for 30 seconds.
Drain. Pour in the fixer,
setting the timer for the
recommended period.
Agitate and drain.

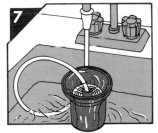

7 Remove the lid of the
tank and run water through
a hose into the center of the
reel for 30 minutes. Add a
few drops of wetting agent,
leaving for 30 seconds.

8 Remove the reel and hang
up the film to dry. Draw a
sponge or your fingers,
wetted in the water from
the tank, down the film to
remove drops.

COLOR PROCESSING

Although the processes for developing color negative and color transparency film are more involved and less tolerant of error than those for black-and-white film (pages 116-117), the basic techniques are the same. Film loading, agitation and tank handling remain unchanged.

Standardization in film chemistry has resulted in two major processes, both supplied by Kodak. C-41 is the process for color negatives, E-6 for color transparencies. These can be applied to most other makes of film, such as Fujichrome and Agfachrome, but first check the instructions packed with the film. There are now so many commercial laboratories processing color films rapidly and efficiently that the easiest course is to leave this stage of photography to them, but neither the C-41 nor the E-6 process is difficult. Most medium-format photographers use this size of camera and film because of the image quality that it can deliver, and one way to make sure that this quality is maintained is to undertake every process yourself. (There is one exception, Kodachrome must be processed by Kodak.)

EQUIPMENT
The equipment is essentially the same as for black-and-white processing (page 116), with the following exceptions. There are more solutions for color, requiring more graduates for mixing. As accurate temperature control is crucial, it is worth considering a thermostatically controlled water bath. The thermometer must be accurate to 0.25°F/0.15°C. Rubber gloves are essential, because some solutions are harmful to the skin.

C-41 COLOR NEGATIVE PROCESSING

1 The following process uses Kodak's Flexicolor Kit. First, mix the solutions according to the instructions.

2 In darkness, carefully load the film onto the reel, as described for black-and-white processing (page 116).

3 Warm the solutions to the working temperature given in the instructions. (It is also a good idea to warm the processing tank). The developer must be kept at 100°F/37.8°C, with no more than 0.25°F/0.15°C variation on either side. The other solutions can be kept between 75°F/24°C and 104°F/40.5°C. It is usually easiest to bring them all to the temperature of the developer.

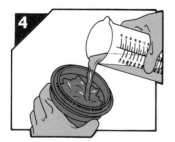

4 Pour in the developer and start the timer. (In steps 5-10, the processing time is given in brackets, with 10 secs for draining.)

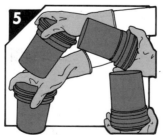

5 Agitate the developer, by gently inverting the tank, according to the instructions given by the manufacturer, then drain (3¼ minutes).

6 Pour off the developer. Add the bleach solution and reset the timer. Agitate, then drain (6½ minutes).

7 Wash the film by using the hose to run water through the center of the reel. Drain the tank (3¼ minutes).

8 Pour in the fixer and reset the timer. Fix for at least the time specified. Agitate, then drain (6½ minutes).

9 Wash the film for a second time, then drain. All the washing stages can be carried out with the lid off the tank (3¼ minutes).

10 Pour in the stabilizer for the required time, then drain (1½ minutes).

11 Hang the film up to dry at room temperature. To stop the film from curling add a clip to the bottom end. (20-30 minutes)

TRANSPARENCY PROCESSING

The main difference between processing color negatives and color transparencies is that the transparency process (E-6) has more steps and chemical solutions. This is because it contains two developing stages, with a reversal bath in between. The first development produces a negative. The reversal bath then causes silver to be deposited on previously unexposed areas of the film. The second color developer then works on this to produce the final transparency. The chart (right) shows the steps required in the E-6 process. As with color negative film, the temperatures are critical: the tolerances are only ½°F/0.3°C for the first developer, and 2°F/1.1°C for the second.

Process step	Minutes	°F	°C
1 First dev.	7	100±0.5	37.8±0.3
2 Wash	1	92-102	33.5-39
3 Wash	1	92-102	33.5-39
Or (2,3) wash for 2 minutes in running water			
4 Reversal bath	2	92-102	33.5-39
Steps 5-11 can be done in normal room light			
5 Color dev.	6	100±2	37.8±1.1
6 Conditioner	2	92-102	33.5-39
7 Bleach	7	92-102	33.5-39
8 Fixer	4	92-102	33.5-39
9 Wash	6	92-102	33.5-39
10 Stabilizer	1	92-102	33.5-39
11 Drying	10-20	Room temperature	

PRINTING/1

Much of the equipment used for printing is the same as that for film processing (pages 116–119). The basic equipment required for enlarging is shown below, and the print processing equipment is shown opposite. Although there is a process for printing from transparencies (page 124), they are often shot for themselves. In particular, professional photographers whose work is intended for publication use color transparency film because that is what printers prefer for photomechanical reproduction. This section of the book therefore concentrates on the printing of negatives, rather than of transparencies.

The most important piece of equipment is the enlarger. Those that have been specifically designed for color work will have either a color head (with built-in adjustable filters – yellow, magenta and cyan), or a filter drawer for loose color

EQUIPMENT
1 *Enlarger (suited to both color and black-and-white)*
2 *Color head*
3 *Enlarging lens*
4 *Voltage stabilizer*
5 *Easel*
6 *Contact sheet frame*
7 *Printing paper*
8 *Timer*
9 *Compressed air and anti-static brush*
10 *Safelight*
11 *Black cardboard*

filters (below). The focal length of the enlarging lens should be no less than the diagonal measurement of the film frame – for $2\frac{1}{4}\times2\frac{1}{4}$in/6x6cm negatives an 80mm lens is suitable. An improvement on the basic timer is the exposure timer which is electronically linked to the enlarger, automatically controlling the length of each exposure. A voltage stabilizer is useful to remove any fluctuations in the voltage, which may cause a color change.

On the print processing side, color printing requires more graduates than does black-and-white because there are more chemicals involved in the process. Color prints can be developed in open trays as is the case with black-and-white, but a print drum has the advantage of making temperature control easier, and of allowing the whole process to take place in daylight in a sealed container.

PRINT WASHING
After processing, it is necessary to wash each print in running water. To ensure a continuous flow in a deep sink, the outlet should be at the surface of the water, rather than at the bottom of the tank. You can easily adapt a sink by attaching a length of hose to the tap, and a plastic pipe in the outlet, as shown below.

PROCESSING EQUIPMENT
1 *Processing chemicals: print developer, stop bath, fixer.*
2 *Graduates*
3 *Printing trays*
4 *Funnel*
5 *Print tongs*
6 *Timer*
7 *Stirring paddle*
8 *Thermometer*
9 *Rubber gloves*
10 *Water bath(s) – large enough to hold a printing tray(s)*

ADDITIONAL EQUIPMENT FOR COLOR
11 *Color processing kit*
12 *Print drum*
13 *Additional graduates*

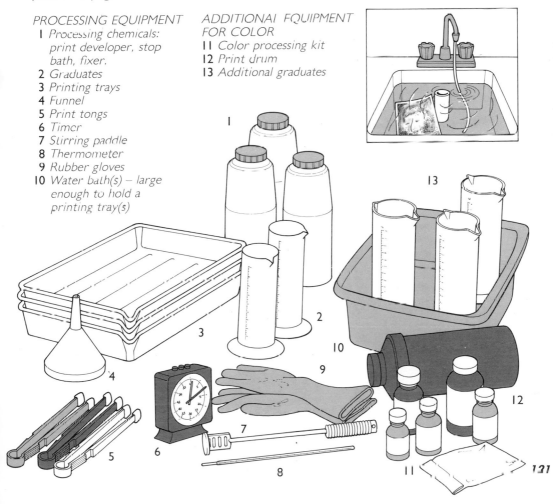

PRINTING/2

The basic printing process is very similar for black-and-white, color negative and color transparency. The first stage is to make a contact sheet from the roll of film. This simply gives a same-size positive image of each frame, without which you cannot easily judge which frames you want to print. The sheet can also carry printing notes (and, in the case of color, filtration notes). The second stage is the making of a test print from the chosen negative (or transparency): this is used to judge the exposure. (A test for filtration is also made when working with color.) The third stage is the final print.

With black-and-white printing (shown here), there is a choice between fixed contrast and variable contrast papers. Fixed contrast papers come in a range of grades, usually from 1 to 7: grade 2 is normal, with the higher numbers denoting higher contrast. Variable contrast paper achieves the same effect with a single type of paper and a set of blue and yellow filters. By changing the filter you change the contrast.

THE CONTACT SHEET
When making a contact print, accurate exposure is not as important as with the final print. As each negative is likely to have been exposed differently in the camera, the exposure chosen for the print has to be an average. Nevertheless, the highlights should be white and the dark areas a rich black. Usually the enlarger is used with its negative carrier empty, and the negatives arranged in a special contact frame.

1 Under safelight, place a sheet of printing paper in the contact frame. Then lay the negatives on the sheet and lower the glass.

2 Set the lens aperture to f11, and expose the paper for about 15 seconds. Return the negatives to their sleeves.

3 Still in safelight, place the paper in the developer and agitate by gently rocking the tray for the recommended time (about 90 seconds).

4 Place in the stop bath and agitate continuously for about 30 seconds. Then transfer the paper to the fixer.

5 Place the paper in the fixer tray and agitate continuously for the first 30 seconds, then occasionally for another 1½ minutes.

6 Wash the print in running water (70°F/21°C–75°F/24°C) for about 4 minutes. Remove and dry.

MAKING A PRINT

Once you have selected the negatives that you want to print from the contact sheet, the next step is to individually expose each negative. To assess the exposure first make a test print on grade 2 paper, which will give you a range of exposures to choose from. When you have selected the optimum exposure and the most suitable grade of paper, you are in a position to expose and develop the final print.

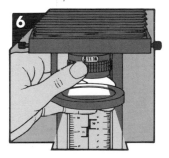

1 In safelight, swing the red filter in front of the lens. Place a strip of printing paper on the easel and switch on the enlarger lamp.

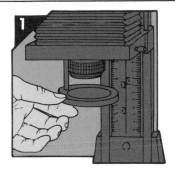

2 Position the paper so that it covers both dark and light areas of the image. Turn off the enlarger lamp and swing the filter out of the way.

3 Check that the ends of the strip are firmly held by the frame on the easel. Turn on the enlarger and expose the whole strip for 4 seconds.

4 Use black cardboard to cover first a $\frac{1}{4}$ then a $\frac{1}{2}$ then $\frac{3}{4}$ of the strip, exposing the sections for 4, 8, and 16 seconds respectively.

5 Process the test print steps 3-6 (opposite page). Choose the zone that gives the best tones and note its exposure time.

6 Swing the filter in front of the lens, and switch on the enlarger lamp. Check the aperture setting is correct, then switch off the lamp.

7 Place a sheet of printing paper on the easel and swing the red filter out of the way. Expose the paper for the chosen time.

8 Process the print (steps 3-6, opposite page). Make sure that the development temperature is the same as that for the test print

PRINTING/3

Apart from the fact that you have to work in total darkness, that there are more steps and the temperature has to be controlled more tightly, the basic procedure for printing from a color negative is similar to that described for black-and-white printing on pages 122-123. However, it is often necessary to make a second test print: the first, as with black-and-white, is used to judge the exposure; the second, to assess the color filtration. Color filters are used to control the color of the final print. (The same set of filters can be used for printing from a transparency.) The principles behind the use of these filters are described in the box below.

While making the exposure test print, set the filtration to an initial setting, such as 50Y (yellow), 90M (magenta) and 0C (cyan). Once you have chosen the correct exposure, you can then use the exposure test print as the basis for a color filtration test. One way of doing this, is described in the step-by-step on the opposite page.

ADJUSTING FILTRATION
Color printing uses the 3 primary colors: green, red and blue. Each of these has a complementary color: magenta, cyan and yellow. To adjust the color of the final print, magenta, cyan and yellow filters are used to control the amount of colored light reaching the paper. Each filter absorbs light of its complementary color: for example, a magenta filter absorbs green light, but allows red and blue light to pass through. To adjust the color in a print taken from a negative, first look at the exposure test to assess whether the

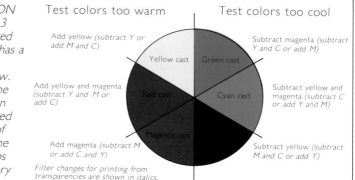

Test colors too warm — Test colors too cool

Add yellow (subtract Y or add M and C) — Yellow cast — Green cast — Subtract magenta (subtract Y and C or add M)

Add yellow and magenta (subtract Y and M or add C) — Red cast — Cyan cast — Subtract yellow and magenta (subtract C or add Y and M)

Add magenta (subtract M or add C and Y) — Magenta cast — Subtract yellow (subtract M and C or add Y)

Filter changes for printing from transparencies are shown in italics.

colors are too warm or too cool. Then adjust the filtration according to the color cast diagram (above). For example, if the exposure test filtration was set at 50Y (yellow), 90M

(magenta) and 0C (cyan) and the colors are too warm, then try the changes suggested in the table (below, left). The fourth quadrant can be used for a variation on one of the first three changes. Most filter packs contain only magenta and yellow: to remove a cyan cast simply reduce the amount of the other two colors. When printing from color transparencies the process is exactly the same but reversed: simply add where before you subtracted.

	First quarter	Second quarter	Third quarter
Starting filtration	50Y 90M 0C	50Y 90M 0C	50Y 90M 0C
Change	+10Y	+10Y +10M	+10M
New filtration	60Y 90M 0C	60Y 100M 0C	50Y 100M 0C

There is a basic difference between printing from a color negative and printing from a transparency. With a negative you compensate for any color bias by adding filters of the same color or subtracting filters of the other two colors. With a transparency, you subtract the same color or add the other two colors. (A 10-unit change in filtration is usually sufficient to remove a pale color cast.) With a transparency increasing the exposure gives a lighter print, while decreasing it makes the print darker; the opposite is true of negatives.

With color transparency film, there are two processing systems: reversal processing, such as Kodak's Ektachrome R-3+, and silver dye-bleach processing, such as Cibachrome. The latter needs fewer processing steps and a lower temperature, but the chemicals are more corrosive and need more care in handling. The full details of the steps involved in each process are supplied with the chemicals.

MAKING A FILTRATION TEST PRINT
The step-by-step below shows the basic procedure for adjusting the color filtration when printing from a negative. Depending on the design of the enlarger, changing the value of one of the color filters is either a matter of changing the filters in the filter tray, or of adjusting the built-in filters in the color head, as shown in step 1 (below).

1 Set the filtration to the starting settings determined from the test strip. Turn off the lights.

2 In total darkness, place the photographic paper on the easel and cover with a mask, which leaves one quadrant uncovered.

3 Using the time chosen from the test strip, expose the first quadrant. Return the paper to its box. Switch on the lights.

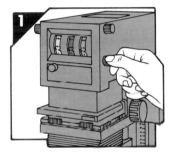

4 Adjust the mask and easel so that the same section of the image falls on a different quadrant of the paper. Reset the filtration.

5 In darkness, expose the second quadrant. Repeat steps 4 and 5 for the other quadrants, adjusting the filtration each time.

6 Place the paper in the processing tank and develop. Before evaluating the colors, make sure that the print is dry.

APPLICATIONS

The wide range of medium-format equipment available today means that roll-film is suitable for most applications – even subjects traditionally associated with 35mm film, such as street life. The following section of the book looks at five classic subject areas in which the format offers particularly exciting possibilities. Some of the strategies described are special to medium-format equipment: others will already be familiar to those who have taken an informed approach to 35mm work. One theme that unites all these different fields is the need for meticulous care in all aspects of picture-taking – from film and lens choice to the finer points of lighting and composition. As you gradually gain more experience, the procedures you need to go through will become almost instinctive, and your success rate will improve noticeably. The rewards of patient devotion to the craft of roll-film photography are eloquently and imaginatively demonstrated by the special portfolios for each topic.

LANDSCAPE

WILDLIFE

PEOPLE

ARCHITECTURE

STILL-LIFE

LANDSCAPE

Landscape offers an inexhaustible wealth of subject matter and accordingly it has inspired an enormous variety of photographic styles. This is a field that imposes few technical restrictions on the photographer. The freedom and simplicity of approach help to explain landscape's appeal.

At one end of the spectrum, you can go for maximum drama, choosing the viewpoint, lens, framing or time of day to create a picture that will make an immediate impact on the viewer. At the opposite extreme is a quieter, more subtle representational style. Both approaches benefit from the image quality obtainable on roll-film.

Away from roads, when photography has to be combined with walking, weight is an important consideration. If you leave behind a lens or tripod for the sake of greater comfort, you might miss a good shot. But the same is likely to happen if you are overloaded: too heavy a kit limits mobility. However, if you have to choose between a third lens or a tripod, my advice would be to take the tripod, as many of the most evocative pictures are captured when the light begins to fail.

Black-and-white film has its adherents among landscape photographers. The essence of monochrome landscapes is tonal control — by careful composition, choice of lighting conditions and subtlety of printing. Many photographers use color filters (especially yellow, orange or red) to darken tones and deepen textures. Technical excellence is a key feature of the monochrome landscapes studies in the Ansel Adams Portfolio on pages 136–139.

Olympic sunset
On 35mm film, the smooth gradation of the sky in this evening view of Second Beach on the coast of Washington's Olympic Peninsula would probably have been less striking, because of graininess in the enlargement. To aid exposure calculation in the changing light, a Polaroid test was shot first.
65mm Super Angulon (on a Sinar Handy camera), ISO 64 Ektachrome, $2\frac{1}{4} \times 2\frac{3}{4}$in/6x7cm, 1sec, f22.

TECHNIQUE

Landscape photography demands no additional lighting, and the scale of the subject is usually within the range of ordinary lenses. Thus, the equipment you need can be straightforward and limited (right). Of the accessories, the most useful are a tripod and cable release.

Certain aspects of a landscape picture benefit more than others from roll-film's high resolution and freedom from graininess. A crucial ingredient is the level of small detail that is visible – vegetation in the distance, grains of sand in the foreground, the texture of a rock or tree bark. In a large print, one of the criteria of enhanced realism is that there should appear to be more detail than the eye can see – just as there would be in the actual scene. Such image quality, of course, is only partly dependent on film size. It must be sustained with exemplary camera technique. Even slightly incorrect focusing can invalidate the effort involved in using a medium-format camera. Focus, depth-of-field management (page 12), exposure and camera movements (if you have the facility for them) all need to be controlled with great care.

Most landscape photographs include the horizon, which makes it tempting to focus on infinity. However, this is poor technique, because it wastes almost half the depth of field. It is possible to focus on a point much closer than the horizon and still have everything sharp up to infinity. The smaller the

EQUIPMENT CHECKLIST

Camera

Wide-angle lens

Standard lens

Telephoto lens

Lens hood(s)

Filters – ultra-violet

　　　 – polarizing

　　　 – mild straw-tinted

　　　 – neutral graduated

　　　 – red, orange and

　　 yellow (for b/w film)

Film backs (2)

Tripod

Cable release

Camera bag

aperture you select, the closer this point – located at what is known as the hyperfocal distance – to the camera position. Critical focusing, making use of the hyperfocal distance, has a special importance in landscape photography, where overall sharpness is a key element in capturing the detail of the scene.

Front-to-back sharpness can also be increased by using a camera with a lens tilt facility, as explained on page 89. This can be an effective approach with scenes that are fairly flat.

The uses of wide-angle and telephoto lenses for broad and distant views are described over the following pages. However, there is often plenty of scope for relatively close-up shots. Be sure not to miss such chances: it is easy to do so when your eyes are attuned to the far or middle distance. For nearby details, such as patterns of leaves or arrangements of roots on a woodland floor, the standard lens is eminently desirable. This lens is often overlooked, in preference for a wide-angle or telephoto, as it doesn't add any visual drama to the image. This, however, is the very reason why it can be most effective for close details. In close-up landscape photography you have some control over the actual components of the scene, rather than merely the viewpoint, viewing angle and choice of lens. For such shots – still-lifes on locations, as it were – there might even be some opportunity for using flash to fill in shadows.

A panorama

Panoramic cameras capture a broad view in superb detail. This photograph of a geothermal outflow at the foot of Puracé Volcano in Colombia was taken on a Linhof Technorama. The illustration here is a mere 60% enlargement of the original transparency.
90mm Super Angulon (on a Linhof Technorama), ISO 64 Ektachrome, $2\frac{1}{4} \times 6\frac{11}{16}$in/ 6×17cm, $\frac{1}{30}$sec, f19.

WIDE-ANGLE LENSES

A wide-angle lens has two important effects on the final appearance of a landscape photograph. First, when the view embraces a broad section of the horizon, the resulting picture tends to look open and panoramic. This is a natural treatment for wide, open spaces, such as prairies and deserts. The second effect is the exaggeration of the foreground – or, to put it another way, the exaggeration of perspective. How much foreground detail appears in a shot depends partly on the photographer's choice of viewpoint and camera angle, and partly on the film format. The deeper the frame in relation to its width, the more reason there is to include the foreground in the picture to balance the composition. Because of the exaggerated perspective, a small alteration to the camera position will make a major change to the image, especially when the camera is moved vertically.

Most landscapes are cluttered with untidy details. Although the eye will not be disturbed by such details while casually looking at a view, the same clutter, when locked into the formal square or rectangle of a photograph, will often look merely disorganized. Composing a broad view as a coherent image, with the sense of place we look for in landscape pictures, requires a skill that can only be learned by experience.

The best wide-angle views are often those that have a distinct flow between foreground and background – a route that the eye can follow as it scans the image. The link may take

A sweeping panorama
Dense vegetation in a South American rainforest presents a situation similar to that of an architectural interior – the problem of achieving a wide enough coverage to offer an informative view. For this image a panoramic camera was used – the type that uses a wide-angle lens to project the image onto a long strip of film (pages 86–87).
90mm Super Angulon (on a Linhof Technorama), ISO 64 Ektachrome, $2\frac{1}{4}\times6\frac{11}{16}$in/ 6x17cm.

the form of a similarity of shape or tone. Beware of any arrangement in which there is a detailed foreground, an interesting background and nothing in between. Such sharply divided images are usually disconcerting.

An interesting foreground is especially important in vertical and square images. Rather than a dull stretch of grasses, shrubs or rocks, it is usually desirable to include a distinct and prominent foreground element. This might be a gate, a tree stump or a deeply fissured rock. However, bear in mind that the texture of, say, a grassy mound can be captured in vivid detail in a print from roll-film, and may be enough in itself to balance the more distant parts of the image. On black-and-white film a yellow filter will emphasize the texture of grasses. The same filter will also darken blue skies, heightening the contrast with white clouds. A red filter creates the most dramatic effect, absorbing almost all the blue light.

The assumption is often made by beginners that wide-angle lenses obviate the need to worry about depth of field. Certainly, depth of field increases as the focal length decreases. However, an out-of-focus area in the near foreground of a picture will look disconcertingly obvious, and ruin the effect. You may be able to crop off the offending section during enlargement, but this is likely to weaken the composition. The best approach is to concentrate on technique, stopping down the aperture as much as you are able to insure that every part of the photograph is sharp.

A low viewpoint
Altering the size relationship between the foreground and background, the wide-angle lens used for this glacial landscape in Montana, USA, has recorded the sun as a distant flare and the ice-scoured rock as a dynamic sculptural form. The texture of the rock surface bridges the gap between foreground and background holding the interest of the viewer.
38mm Biogon, ISO 64 Ektachrome, 2¼x2¼in/6x6cm.

TELEPHOTO LENSES

By concentrating attention on one small part of the scene, telephoto lenses multiply your picture options. From one good viewpoint you should be able to take a variety of different telephoto images. If you are working with medium-format equipment in rough terrain, a telephoto (despite its weight) is clearly a desirable item, as it allows you to build up a portfolio of details with a minimum of arduous walking.

Users of 35mm equipment will be familiar with the compressed perspective effect that can make telephoto pictures look so striking. The view is foreshortened, and backgrounds appear more dominant. Landscapes that have distinct relief – for example, ranges of hills – are split into a series of planes, stacked one in front of the other. In 35mm photography, you would need a lens with a focal length of at least 135mm for this compression effect to be noticeable. In medium-format photography, you would need a lens of 250mm for the square format, 300mm for the "ideal" format.

Telephoto lenses need to be hand-held with special care to obtain high-quality results. As well as being heavy and bulky, they magnify faults. Focusing errors will be painfully obvious, and blur due to camera shake is a real danger: even a slight breeze may be enough to cause movement.

The drama of mountains
In this image of a mountain range emerging from clouds, a 250mm lens from a suitably elevated viewpoint produces the compressed effect typical of telephoto lenses. The series of ridges appears to be stacked more closely than they are in reality. Each ridge also seems foreshortened.
250mm Sonnar, ISO 64
Ektachrome, $2\frac{1}{4}\times2\frac{1}{4}$in/6x6cm.

A tripod is essential for serious long-focus work. Lenses of 180mm or longer cannot reliably be hand-held. In wind, shoot from a sheltered position, or lower the camera by setting up the tripod at its shortest extension. A cable release (or, with an electronic camera, a remote extension) helps to reduce vibration, as does locking up the mirror.

An ultraviolet or polarizing filter can help in cutting haze, but you should balance the merits of using one of these filters against the slight loss of image quality that the extra glass surface may cause. Lens flare tends to degrade the picture even more with a telephoto lens than a wide-angle. If direct sunlight strikes the front element, the effect is similar to fogging. The cure is to shade the lens and keep it clean: grease and dirt enhance flare.

The telling detail
Telephoto lenses can be used to select from a landscape. This shot of wind-whipped spray above the lip of a glacial outflow lake (in Glacier National Park, Montana) takes the scene out of context and makes it a little puzzling at first.
250mm Sonnar, ISO 50 Agfachrome (70mm film), $2\frac{1}{4} \times 2\frac{1}{4}$in/6×6cm, $\frac{1}{250}$sec, f11.

ANSEL ADAMS

Although Ansel Adams – indisputably the most famous of all landscape photographers – is mostly identified with large-format view cameras, an important body of his work was on $2\frac{1}{4} \times 2\frac{1}{4}$in/6x6cm. He used Hasselblads for many years, increasingly so in later life when 4x5in/10x12.5cm and 8x10in/20x25cm view cameras became too heavy for him to carry around. It is a testament to the image quality possible with medium-format film that Adams, who was fiercely concerned with craftsmanship in both picture taking and printing, used the medium extensively.

Born in 1902 in San Francisco, Adams began photography at the age of fourteen in the Yosemite Valley, California – the area which shaped his career. He initially trained as a concert pianist, but after meeting the documentary photographer Paul Strand in 1930 he decided to devote his life to photography. As a young man, he hiked and climbed over the Sierra Nevada with large-format cameras, developing his distinctive style of clearly perceived, confidently executed images of the landscape of western America.

In 1932 he was involved in the founding of Group f 64, a collection of photographers dedicated to a new approach to photography. As the name suggests, they were concerned with the use of small apertures to capture the detail in a scene, concentrating on light and texture. This was in contrast to the then popular pictorialist approach, which imitated Impressionist painting by producing soft-focus, misty prints.

The photographic philosophy that Adams evolved combined visual imagination and craft. He placed great emphasis on being able to visualize the final print while standing in front of the subject. The tonal range of a print and the detailed execution of its smallest areas were inseparable from the initial interpretation of the scene. Adams often compared the negative with a music score: it contained the basic template which the photographer then interpreted through the printing process. Later in his life, he began to reprint many of his earlier images, reinterpreting them in a more striking style.

The importance that Adams placed on the imaginative link between the photographer's initial assessment of the scene and the final print resulting from it, led him to develop the Zone system of judging exposure. This is a method for predetermining precisely the tone in the final print that a particular area of the scene would be represented by.

Adams was always generous in explaining his approach: most of the quotations here are from *Examples: The Making of 40 Photographs*, a book in which he annotated selected images from his *oeuvre*.

The photograph of Half Dome (opposite) was made when Adams, in his own words, was still in the process of "becoming fluent with the Hasselblad." He felt that, quite apart from the question of technical specifications, each make

Moon and Half Dome, 1960
This mountain is one of the star attractions of Yosemite, one of the United States' most visited National Parks. Adams was driving towards his hotel on a winter afternoon when he saw the moon rising to the left of the mountain. By his own admission, he loved photographing the moon. Instantly he saw the picture he wanted. For a view clear of trees, he had to walk several hundred feet, then set up his Hasselblad on a tripod. Unlike his view cameras, the medium-format camera allowed him to work quickly, which was necessary in the failing light. "I visualized the image in vertical format, the cropping closely determined from the start." He made a couple of exposures with a 150mm Sonnar, but then switched to the 250mm Sonnar.
250mm Sonnar, ISO 32 Kodak Panatomic-X, $2\frac{1}{4} \times 2\frac{1}{4}$in/6x6cm, $\frac{1}{4}$sec, f11.

of camera has a special "feel" to it, and that photographers develop an "emotional empathy" to particular types.

"I sometimes sense that the camera itself may encourage the photographer to relate to particular subjects favourable to the camera's format and other characteristics."

Looking back to photographing this Half Dome image in 1960, Adams claimed that "many of my best images since have been made with that most excellent camera [the Hasselblad]."

Adams was a supreme technician. However, he felt that the sheer range of equipment that had long been available could have a detrimental effect. For many people, the overwhelming choice could interfere with the more important visual and mental processes in making an image. He prefered simplicity of means. As he stated in *Camera and Lens* in 1970:

"There is a great illusion among photographers that creative work depends upon equipment. On the contrary, equipment is something to be selected for a specific purpose."

Dunes, Oceano, California, 1963

The Oceano dunes are on the coast of California, south-west of San Luis Obispo. They were often shrouded in fog but on one of Adams' frequent visits he was able to catch this clear image. As in many of Paul Strand's early photographs, the perspective has been compressed by the use of a long lens creating an effect of semi-abstraction. The texture of the sand is beautifully captured through the technical excellence of the processing and printing. The diagonal edge of the near dune dramatically separates the foreground from the background, keeping the eye on the move as it constantly searches for more detail.

WILDLIFE

One of the reasons why Victor Hasselblad designed his famous 2¼×2¼in/6x6cm camera was that he enjoyed photographing animals but found that the medium-format cameras then available were unsuitable for the purpose; neither the twin-lens reflex models nor the rangefinder cameras would accept telephoto lenses. The Hasselblad, with a reflex viewing system that allows accurate focusing and framing with long-focus lenses, is thus a landmark in wildlife photography.

Most animals, naturally enough, keep their distance from likely predators. Success in wildlife photography depends as much on experience of animal behavior and fieldcraft as on more technical factors.

There are two quite different methods, each perfectly valid. One is what most people immediately think of as wildlife photography: working in the field, either stalking an animal or building a hide close to a spot that animals frequent. The second method, often better suited to smaller wildlife, is captive photography: catching the animal and then constructing a set for it in the studio or at home. Medium-format cameras are suitable for both these approaches, but for captive photography they cannot be bettered.

In the field, medium-format cameras must be seen as specialized tools for particular kinds of shooting rather than all-purpose equipment. For high-power telephoto photography in low light 35mm would be the format of choice. However, for subjects that allow a reasonably close approach a roll-film camera is unsurpassed, allowing every hair, scale or feather to be rendered minutely.

Hand-held shooting
Even with a medium telephoto lens, these Bighorn sheep on a ridge in Glacier National Park, Montana, had to be approached within 40ft/13m. Photographing with a hand-held camera on rough terrain is difficult with long focal length lenses because of their weight and bulk. Here, a pistol grip was used. 250mm Sonnar, ISO 64 Ektachrome, 2¼×2¼in/6x6cm (cropped), ¹⁄₂₅₀sec, f8.

CAPTIVE SETS

Some animals, such as fish, burrowers and nocturnal mammals, are almost impossible to photograph, or even to see, in their own habitat without special equipment. Others present problems to the photographer simply because they are small and live in inaccessible places. The solution may be to catch the subject first and photograph it in controlled conditions – a form of studio photography. So long as you meticulously reproduce the habitat and treat the animals well, the results of this approach can be as valid as those of field photography.

The actual shooting may not be too difficult. Often more demanding is the need to preserve realism. This means knowing not only how the setting should look but also how the subject should behave: in captivity, most creatures act quite differently from the way they do in the wild, as can easily be observed in many zoos. Obviously, thorough research into the subject's natural behavior and habitat is necessary, combined with commonsense. It is best, at least to begin with, to choose animals that are commonly available from pet shops or those that are clearly not endangered, such as common insects. Always take good care of your subjects – after photography, as well as before and during.

Photographing insects
Slow-moving insects, like this mantis, do not need elaborate preparations to confine them and are relatively easy to work with. Providing food – in this case, a moth – has two advantages. It helps to keep the creature in one position, making focusing and framing easier; and it encourages natural activity. A ringflash, which fits like a collar around the lens, was used for this shot, its frontal lighting eliminating shadows. 80mm Planar (+ 21mm extension), ISO 50 Agfachrome, $2\frac{1}{4}$x$2\frac{1}{4}$in/6x6cm (cropped), $\frac{1}{250}$sec, f14.

The principal techniques are akin to those of still-life photography, particularly in the lighting. A reflex camera is essential to ensure that focusing and framing are accurate at the close subject distances often required. Close-up equipment will be useful (pages 196–197).

An aquarium is one of the most adaptable pieces of equipment, useful not only for aquatic creatures but also for insects, reptiles and small mammals. The thick glass will cause a slight loss of image quality. This is unavoidable if the tank has to be filled with water; but for a dry set it might be worth taking out a panel of glass and substituting a sheet of flexible material in which a hole can be cut for the lens. One drawback with this device is that it can make it a little awkward to get at the lens in order to focus; in some cases this problem can be overcome by the use of a lens focusing grip. The most efficient design for a custom-built set is one that takes into account the lens's angle of view, so that the sides funnel in toward the camera.

If you are photographing through glass, a sheet of black fabric or paper placed just in front of the camera, with a window for the lens, will prevent reflections off the shiny parts of the camera from intruding into the picture.

Choosing a background
The setting deserves thought in a captive set. This Phelsuma lizard from Mauritius was borrowed from a dealer in England, and there was little chance of acquiring plants from its native habitat. As a compromise, a palm with broad, ribbed leaves was chosen, and the photograph cropped tightly during enlargement. This had the added advantage of a graphic design. A studio flash unit was used with a diffuser. 120mm Sonnar, ISO 64 Ektachrome, $2\frac{1}{4} \times 2\frac{1}{4}$in/6×6cm (cropped), $\frac{1}{250}$sec, f22.

CONFINING THE SUBJECT
It is often possible to design a set in such a way that it keeps the subject continuously within the depth of field of the lens. In the case of the aquatic set shown below, the aquarium was partitioned so that the fish was confined to the front half, and thus in focus.

FIELD PHOTOGRAPHY/1

The secret of photographing wildlife in its habitat is to be in the right place at the right time. Any effort spent in planning is repaid many times over. Within a particular location, some spots will be better than others – either because there will be more animals or because they are easier to approach.

National parks and wildlife reserves offer the best opportunities. Some stand out as exceptionally fruitful. For example, the Ngorongoro Crater in Tanzania has few rivals for photography of the larger African animals: enclosed by the crater walls, it concentrates many species into a manageable area. Choosing the location is *the* top priority. Even if the best is more expensive, the investment is bound to prove worthwhile.

Closing in

These river turtles resting in midday shade were easily accessible and showed no apprehension at the approach of a human. In such circumstances, there was time to make a careful composition, using a 250mm lens to crop right in, so that the turtles filled the frame. 250mm Sonnar, ISO 400 Tri-X, 2¼x2¼in/6x6cm.

Timing is also important, as animal behavior often varies diurnally or seasonally. Consult field guides and visit national park centers to learn about migration patterns, courtship times, etc. For example, stopovers for migrating birds on America's Central Flyway may be devoid of action for most of the year, but become a rich source of interest for a few weeks. As for daily behavior patterns, dawn and dusk are usually good times, sometimes offering unexpected combinations of diurnal and nocturnal animals.

After selecting the place and time, you need to pay attention to more local factors — such as which particular watering hole is likely to give best results. The most valuable advice is usually to be had from local guides and park rangers. Early morning and early evening are the best times to see many species.

The two traditional techniques of field photography are stalking, and the use of blinds (concealed or camouflaged shelters). Stalking usually requires little preparation but considerable fieldcraft, and the results are always uncertain. Working from a blind is rather more predictable, but needs careful planning. Constructing a suitable collapsible structure calls for experience. To some extent, the choice between these alternative approaches is a matter of taste or

The problem of light
Although a 500mm lens would have made it easier to photograph this common squirrel monkey by allowing a more distant viewpoint, the f8 maximum aperture would have been too small for the light level. The 250mm f5.6 lens used instead required a stealthy approach.
250mm Sonnar, ISO 64 Ektachrome, $2\frac{1}{4} \times 2\frac{1}{4}$in/6x6cm.

HAND-HELD SHOOTING
Many systems include a range of accessories for improving handling in the field. For example, the Hasselblad 500ELX is shown here (above) equipped with a pentaprism finder (for panning), 70mm film back (for long, uninterrupted shooting sequences), and Special Grip, which includes a remote trigger and additional hand grip to stabilize the long telephoto lens.

temperament. However, the species also influences the decision. Stalking often works well with large and medium-sized animals, provided that there is good cover (by way of bushes or trees) and the subjects are not dangerous.

Both techniques rely on powerful telephoto lenses – the stock-in-trade of the wildlife photographer. The faster the lens (that is, the wider the aperture), the better. The further you are away from the animal, the less likely it is to be aware of your presence – or, at least, to feel threatened by it.

The choice of camera system is critical. The Pentax 6x7 has a special advantage because of its good range of long lenses, but any of the other systems that include a 500mm lens would be suitable. However, remember that 500mm on a $2\frac{1}{4}$x$2\frac{1}{4}$in/ 6x6cm or $2\frac{1}{4}$x$2\frac{3}{4}$in/6x7cm camera is the equivalent of about 300mm on a 35mm camera – better suited to large animals than to small ones. A teleconverter can be used to increase the magnification, but at the cost of a smaller effective aperture. Three cameras include a 1,000mm lens in their systems – the Pentax 6x7, Rollei SL66SE and SL66X.

A pentaprism is essential for field photography, both to allow eye-level viewing and to give a corrected left-to-right image (panning is almost impossible with the reverse image in a waist-level finder). A motor drive is also useful, as shooting opportunities in stalking are usually brief.

Stalking on foot with a medium-format camera and long lens is probably the most difficult approach. Stalking by

Selective focusing
The shallow depth of field of a very long lens can work in the photographer's interest when branches and foliage partly obsure the view. In this photograph of a great egret in a mangrove swamp, branches of other trees (useful for concealment) are reduced to a soft blur.
500mm Tele-Tessar, ISO 64 Ektachrome, $2\frac{1}{4}$x$2\frac{1}{4}$in/6x6cm,
$\frac{1}{250}$sec, f8.

vehicle, which is standard in open plains country and with dangerous animals, is much easier, as weight and bulk of kit hardly matter. For maximum control, blinds have their adherents. The camera is tripod-mounted, so again weight is not a problem.

Remote-control photography is a specialized area, capable of spectacular results – especially with a wide-angle lens. Triggering options include a remote lead operated by the photographer, or a sensing device triggered by the animal. An electronic camera with auto wind-on is essential. Unless the lighting is absolutely consistent (as with flash), auto exposure control is also an advantage. When setting up equipment, consider the animal's well-being. Making a disturbance close to a nest, for example, can easily drive the parent away, or alert other predators. As in all wildlife photography, the animals' safety should come first.

Focusing on the eyes
This black cayman was photographed from a river bank with a medium telephoto lens. The light was so poor that the maximum aperture had to be used, with the camera supported against a tree. There is almost no depth of field; but because the eyes are in focus, the image is perfectly acceptable.
250mm Sonnar, ISO 50 Agfachrome, $\frac{1}{60}$sec, f5.6.

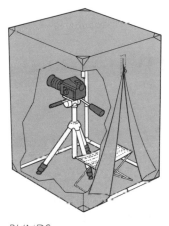

BLINDS
Entering and leaving the blind always needs care, as you are potentially visible to the animals. Ideally, enter before they arrive, or make sure that your approach is concealed. Sometimes you can fool an animal by entering with another person, who then leaves conspicuously; the animal will think the blind is then empty. Even so, if a human has been seen around a blind, it may take a long time for the wildlife to settle down to normal.

FLOWERS AND PLANTS

One area of wildlife photography that medium-format cameras are particularly well suited to is the field of flower and plant photography – subjects that lend themselves to slow, considered work. Depending on the scale of the subject, close-up techniques and equipment may be needed.

For individual flowers and groups of flowers, the magnification is likely to be in the order of one-quarter life-size to life-size. Cameras with built-in bellows, such as the Mamiya 67 and the Rollei SL66, are already equipped for such close-up work. Others, such as the Hasselblads and Bronicas, will need bellows or extension tubes. While bellows offer a more flexible choice, extension tubes are more rugged and better suited to fieldwork. Macro lenses are, naturally, ideal.

A tripod is virtually a necessity, for two reasons. First, you

Backlighting

The attraction of natural light is its variety. Here, backlighting and a dark background make the thin grasses glow in a late afternoon sun. Movement is a problem in close-ups, solved here by the relatively short exposure.
500 Tele-Tessar (+ 21mm extension), ISO 64 Ektachrome, $2\frac{1}{4}$×$2\frac{1}{4}$in/6x6cm, $\frac{1}{60}$sec, f11.

will need to hold the camera in a suitable working position – and this is likely to be close to the ground. Second, a small aperture and slow shutter speed will be required in order to obtain a reasonable depth of field in lighting that is often poor: many flowers grow in shade. Locking up the mirror will reduce the risk of vibration at slow speeds. In addition the plant itself may need to be kept still. Even a slight breeze can cause enough movement for blurring to occur, so equipment for serious flower photography in the field should include a windshield. A sheet of cardboard or plastic with some means of support may suffice, but for close views of the flower-head a short length of thick, pliable wire can be used to support the stem. For low-level shooting, a waist-level finder is useful.

The strongest argument for using daylight is that it helps to establish that the plant was photographed in its natural surroundings. The alternative is a portable flash, which gives more control and guarantees an unblurred image with increased depth of field, but runs the risk of making the picture look like a studio shot. If flash does have to be used, an extension cable allows you to place the unit in a natural and effective position, away from the camera.

Filling the frame
The light itself is the most important element in this shot of raindrops refracting the late afternoon sunlight on a lily pad. An extension tube was used to provide a close view so that the lily filled the frame horizontally. At a later stage, the image was cropped top and bottom to improve the composition.
250mm (+ 21mm extension), ISO 64 Ektachrome, 2¼x2¼in/6x6cm (cropped), $\frac{1}{125}$sec, f11.

JEAN-PAUL FERRERO

Jean-Paul Ferrero is one of the new generation of wildlife photographers who tackle long, difficult assignments to get detailed coverage of behavior. He turned his childhood interest in animals into a career. Having decided in 1973 to become a full-time wildlife photographer, Jean-Paul traveled constantly for almost ten years, on assignments for magazines such as *Geo* and *National Geographic*. Eventually he decided to concentrate his attention on a single region.

"At that time, for me it had to be either South America or Australia; these were the two least-photographed continents, and although difficult for photography, they had the greatest promise of new work."

Swayed finally by his strong interest in reptiles, he opted for Australia, and in 1982 moved there to live.

"At the start I had no idea that any format other than 35mm would be useful. Extremely long lenses and motor drives were the tools of the trade."

In time he discovered that his own way of working did not always fit the perceived wisdom.

"I feel there are two approaches to photographing wildlife. One way is to spy on your subject, by using long lenses or remote-controlled cameras; this can be done in a relatively short time. The other way is to get close to your subject by getting it to accept you, and find that you can use shorter lenses; this usually takes a lot of time. This is the approach I've come to prefer. I believe you can judge a good wildlife photographer by the focal length he chooses – the shorter the lens, the better the photographer.

"I used my first medium-format camera for a series on cats and dogs – not quite wildlife, but often wilder than expected. The camera was a Mamiya RB67, with three lenses, and it taught me the value of a large image, sharper than anything I produced on 35mm. I then used it for studio photography of reptiles and discovered one of the great hidden advantages of medium-format, the Polaroid back.

"One technique that I use a lot is to raise the mirror and shoot with the leaf shutter alone. Lens shutters are much less noisy than focal-plane shutters: I always have the camera in this mode for photographs of birds on the nest. Although they are usually alarmed when the mirror goes up, they soon get back to whatever they were doing. Then, when they appear to be in the position I want, I can shoot without fear of any time-lag.

"Besides the RB67, I also use a Pentax in the same format. The focal-plane shutter, which goes up to $\frac{1}{1000}$sec, allows fast-action photography almost as easily as with a 35mm camera. More recently, I've added a Plaubel 69W proshift. Its fixed Schneider 47mm lens gives me one of my favorite types of image: animals 'lost' in a huge natural landscape. On a 35mm frame, most of my clients overlook this kind of picture."

A captive insect

"I found this phasmid on a window flyscreen in my Canberra house. At first I had no idea what it was, and had no chance of quickly finding out how it lived. This meant that, in order not to endanger its life, I had to photograph it without being sure of a proper background. I decided to make a colorful shot, using some unusually red leaves from a eucalyptus growing in my garden. My studio flashes – a 2,000 joule and a 400 joule unit – were already in position, as I had spent the last few days taking pictures of insects and spiders. Two flash heads were aimed at a blue paper backdrop, giving me a reading of f11. Two other flashes lit the leaves from behind; there, the reading was f16. Two pieces of cardboard were used to shade the lights, to avoid flare in the lens. A white polystyrene sheet surrounding the lens reflected light back onto the insect. I used a fairly open aperture – f11 – to keep the more distant leaves pleasantly out of focus."
Mamiya RB67, 180mm lens (+ macro ring), f11.

JEAN-PAUL FERRERO

Antarctic penguins
"This creche of Adélie penguin chicks was being guarded by adults on Torgersen Island in the Antarctic Peninsula. The day was unusually hot – more than 15°C (59°F) – and the chicks were panting. It was the most beautiful and longest day I'd experienced in the Antarctic. I had plenty of time, and more light than I could hope for. I decided to shoot with the 69W proshift camera – the 47mm lens would give me an extremely wide angle and allow me to get quite close to the penguins in the foreground, while still including the beautiful cloud pattern. All very wide-angle lenses suffer from vignetting – the larger the format of the film, the more obvious it becomes. A centrally graduated filter helps to correct this deficiency, but unfortunately it needs more exposure. So, in order to get good depth of field I had to stop down to f 22. To make things even more difficult I had chosen to use a polarizing filter to bring out the white clouds. It resulted in an exposure of $\frac{1}{4}$sec."
Plaubel 69W proshift, 47mm lens, $2\frac{1}{4}$x$3\frac{1}{4}$in/6x9cm, $\frac{1}{4}$sec, f22.

PEOPLE

The traditional role of medium-format cameras has been in portraiture, where their measured, deliberate method of operation is well suited to the preparation and patience needed with a human subject and to the careful adjustment of lighting. However, the recent revival of the rangefinder camera has begun to extend the possibilities to encompass a more candid, casual style, exemplified by the picture shown here and the Mitch Epstein Portfolio on pages 174–177.

Detail can play an important part in a portrait, especially a head-and-shoulders close-up where precise rendering of skin texture can convey a strong impression of the subject's presence. The lines around the mouth and eyes and the texture of hair can all be captured on a moderately sized roll-film print – provided that they have not been obscured by the lighting or poor camera technique.

Lighting and composition are the two main technical elements in setting up a portrait indoors. Although the success of the final picture may turn on something less technical, such as a facial expression or unexpected gesture, the lighting and the setting must first be arranged to your satisfaction. It is as important to be meticulous about the preparations for a portrait as it is to be flexible and alert during the shooting. Once you have set up the shot, you can usually leave the camera mounted on its tripod while you concentrate on directing the sitter. Make sure you have a good stock of film: the first roll or two may be spent on just warming up. The 10 or 12 frames available on a 120 roll are usually sufficient for one uninterrupted sequence. (For a longer sequence, pre-loaded interchangeable magazines can be changed more quickly than 35mm cassettes.)

The informal approach
Although this type of picture (Brazilian settlers traveling along the Trans-Amazonian Highway) is normally the province of 35mm photography, a wide-angle, non-reflex, medium-format camera can capture more detail without losing the sense of spontaneity.
38mm Biogon, ISO 64 Ektachrome, $2\frac{1}{4} \times 2\frac{1}{4}$in/6x6cm, $\frac{1}{250}$sec, f4.5.

154

COMPOSITION/1

The setting of a portrait usually determines the choice of lighting. Thus, the first step in the preparation is to decide on location and composition. The more the face dominates the image, the less choice there is in the design. At one extreme, the face can completely fill the frame, to the point where the sides of the head are cropped in and the background is hardly visible. Full-face composition is useful if the setting is unattractive or irrelevant; more positively, it also gives an opportunity for a powerful, intimate portrait—a closer view of the face than we would normally see. In practice, it is easier to shoot with space around the subject and then crop in when making an enlarged print; at a closer shooting distance, any head movements are liable to spoil the focus and framing.

A head-and-shoulders shot is a looser version of the full-face composition, and probably the nearest thing there is to a "standard" portrait image. Usually, the background is chosen and lit for simplicity—a complementary frame for the subject. One problem at this distance is that the depth of field is never enough to keep a distant background in focus; and unrecognizable blurred shapes are liable to be distracting.

Both full-frame and head-and-shoulders shots are almost in the realm of close-up photography, and make certain demands on the selection and use of the camera and lens. Reflex viewing removes parallax problems, but the compensation mechanisms built into twin-lens reflex and rangefinder cameras are not difficult to use. As for lenses, the standard

Full face
The standard 80mm lens used for this photograph of a young Brazilian girl creates some distortion but also a strong feeling of presence. The background has been totally excluded to concentrate attention on the face. The high level of detail in the print enhances the sense of intimacy.
80mm Planar, ISO 400 Tri-X, $2\frac{1}{4} \times 2\frac{1}{4}$in/6×6cm (cropped), $\frac{1}{125}$sec, f4.

Head and shoulders
Normally, the tightest composition that is practicable for candid portraiture with a medium-format telephoto is a head-and-torso shot. This one shows an old Indian woman in the market in Huancayo, Peru. The out-of-focus background isolates the figure, emphasizing her etched features and colorful costume.
250mm Sonnar, ISO 64 Ektachrome, $2\frac{1}{4} \times 2\frac{1}{4}$in/6×6cm,

$\frac{1}{125}$sec, f6.3.

lens distorts the proportions of the face; in particular, the nose appears too large, and the general effect is not very attractive. The proportions become more conventional and pleasing if the perspective is compressed. Thus a medium telephoto is the usual choice for a portrait lens. The most popular focal lengths are 120mm to 150mm, but longer lenses can be used with success. With cameras that lack extendable bellows focusing, a long lens may not give you a close enough focus without the help of an extension ring. The Hasselblad's 250mm lens, for example, needs a 21mm extension ring.

The other effect of shooting at a relatively close distance is that focusing is critical. The eyes are psychologically the most important part of the face, and however deep or shallow the depth of field, they at least must be in focus. Ideally, the tip of

A figure in a square
To accommodate her full-length standing figure comfortably in the square format, this farmer's wife has been positioned to divide the frame unequally between two areas of texturally interesting background.
250mm Sonnar, ISO 64 Ektachrome, $2\frac{1}{4} \times 2\frac{1}{4}$in/6×6cm, $\frac{1}{60}$sec, f5.6.

the nose should be sharp when the lens is focused on the eyes; adjust the lighting level and choose an appropriate film speed to allow this.

Three-quarter and full-length shots offer more choice in the setting and the design of the image. Dress and pose are usually the most noticeable elements in the photograph – the face is too small to dominate, while the setting is still not so large as to command attention. The pose will work only if the sitter feels relaxed and self-confident. More than anything else, it helps if the photographer appears to be in full control. If you lack experience planning is all the more important: decide on the basic technical matters beforehand, and make sure that you have plenty of props and suggestions.

A seated pose is usually more successful than a standing one, but people tend to look more alert and attractive if they are sitting forward rather than slouched back. If a sitter feels awkward, the first evidence of this is likely to be in the hands; many people feel self-conscious about where to place them. Having something to lean on, such as a desk-top, is one solution, while just leaning forward in a chair lets the hands fall naturally onto the lap or legs.

For a picture of a figure within a setting, the location should generally be chosen as much for its relevance to the subject as for its visual interest. This is the approach often taken in magazines: the person seen in the context of his or her own home, or in surroundings associated with work or play.

Enhancing the contrast
The simple background and composition focuses the attention on the lined face. The use of black and white film increases the sense of austerity, and emphasizes the area of shadow beneath the hat.
ISO 125 Plus-X, $2\frac{1}{4} \times 2\frac{1}{4}$in/ 6x6cm (cropped).

LIGHTING/1

Both indoors and out, daylight offers a surprising number of options for portraiture, and can be controlled by reflectors, diffusers or black card. Also, it has a quality that can be most flattering. However, for total control – and the option of long sessions under constant light conditions – there is no alternative to studio lighting.

The most conventionally attractive type of daylight is hazy sunlight, when the sun is moderately low. A high sun throws shadows under the eyebrows, nose and chin. Too harsh a sun may cause the sitter to squint. Diffusion of some sort nearly always helps. Cloudy weather gives the most diffuse light, but this may be so extreme that there is no sense of modelling to define the face.

When the sun is high and bright, you can photograph in the shade, but this carries a hidden risk: if the sky is clear, shade contains a high proportion of blue. The only reliable solution is to measure the color temperature (meters are unfortunately expensive), and use a straw-colored light-balancing filter of the right strength to compensate for any undesirable color cast.

A 3-feet (1m) square of silvered fabric or aluminium foil is excellent for infilling shadows in a head-and-shoulders portrait. It can also be used to re-direct sunlight if the portrait is being taken in the shade. To soften direct sunlight, use a diffusing screen of muslin, thin white cloth or tracing paper. Another technique is the *creation* of shadows by means of

Light from a window (right)
The quality of light from a window is especially attractive for a posed interior portrait, but with two potential problems: one is the color temperature, which can be high if there is blue sky outside; the other is the light level, which is too low for hand-held shooting with normal film and good depth of field. In this portrait of the Proof Master of the London Goldsmith Company, a 81B filter was used, and a tripod for a slow shutter speed (some movement can be seen in the barrel).
90mm Super Angulon, ISO 64 Ektachrome, (+81B filter) $2\frac{1}{4}×2\frac{3}{4}$in/6×7cm, $\frac{1}{2}$sec, f16.

Diffused daylight
When you are photographing people in cloudy or overcast conditions the contrast range is lower than in bright sunlight, the shadows weaker, and the color temperature is constant over the whole image. Against this you have to balance the fact that light levels are lower, calling for slower shutter speeds – $\frac{1}{60}$sec with a wide-angle lens for this shot of old men playing dominoes on a street corner in Manaus, Brazil.
38mm Biogon, ISO 64 Ektachrome, $2\frac{1}{4}×2\frac{1}{4}$in/6×6cm,
160 $\frac{1}{60}$sec, f5.6.

LIGHTING/2

subtractive lighting: a sheet of black cardboard or black fabric placed close to the sitter will increase the modeling on a shadowless, overcast day.

When working in heavily diffused daylight, it is important to bear in mind that it is considerably weaker than direct sunlight: this will affect the choice of film. With slow or medium film, the wide aperture needed may prevent you from achieving sufficient depth of field for a close portrait. It may be possible to boost the light level with a flash. However, with a moderate enlargement, fast film can be used without too much graininess in the final print.

When you are working indoors, daylight can still be used. Diffused lighting from a window is the safest choice: you need only cover the window with a net curtain, tracing paper or something similar. However, if the window receives no sun the light is likely to be bluish. If you need to increase the light level, use a tungsten lamp with a blue gel or position a diffused flash unit on a stand outside the window.

Low-key

In an Amsterdam café, sunlight streaming through a window provides effective backlighting, creating highlights in the freshly-poured glass of beer and on the drinker's bald head. This type of lighting often causes a tricky exposure situation: a direct reading of the highlights would give an under-exposed image. Here, a reading was taken from the shaded side of the face. 250mm Sonnar, ISO 64 Ektachrome, $2\frac{1}{4} \times 2\frac{1}{4}$in/6×6cm (cropped), $\frac{1}{60}$sec, f5.6.

Normal (tungsten) room lighting is considerably weaker than either daylight or photographic lamps. An additional problem is that, with daylight color film, you may need filters to adjust the color balance. Alternatively, you can use one of the tungsten-balanced films. To boost the light level in a tungsten-lit domestic interior, add a photographic tungsten lamp, bouncing its light off a wall or ceiling, or covering it with diffusing material.

One problem with fluorescent light is that it causes a greenish cast on color film. To overcome this, aim photographic lamps at the fluorescent fitting so that the combination of orange and green light produces an almost neutral effect. Alternatively, if you place a green filter over a flash head (to complement the fluorescent light) and a magenta filter over the lens (which blocks green light) you will achieve the same effect.

The dual advantage of photographic lamps is control and high output. These benefits outweigh the time spent in

Reflective walls
In this English farmhouse scene, daylight from one window is the only light source, the reflection from the walls being sufficient to lighten the shadows. To add atmosphere and contrast, the viewpoint was chosen so that the window itself appears in shot.
40mm Distagon, ISO 400
Tri-X, $2\frac{1}{4} \times 2\frac{1}{4}$in/6x6cm
(cropped).

setting up equipment. Even when heavily diffused or reflected, a line-powered flash unit with an output of a few hundred joules is enough to give good depth of field in a close portrait. Equally important, the speed of the flash discharge will freeze any movement in the sitter.

A basic lighting set begins with a main light positioned above and slightly to one side of the sitter, softened with an umbrella (used either as a reflector or as a diffuser). The next step is to balance the contrast on the face by filling in some of the shadows: a large white sheet of cardboard or polystyrene is normally sufficient.

An alternative is to use more diffuse lighting, with stronger shadow fill, and rely on make-up to give the necessary modelling to the face. A lamp aimed at the backdrop will enable you to control its tone and shading. A spotlight aimed from behind the sitter can be used to highlight the hair and add some extra visual interest.

For a standing figure, side lighting is usual, either bounced off tall sheets of white polystyrene or diffused through tracing paper or thin cloth. To light a large sheet of background paper evenly, use at least two lights behind the model, one at either side; special trough-shaped lights are most effective for this (page 194).

Tungsten lighting (right)
This portrait of Dr Daniel Boorstin, Librarian of the Library of Congress, was lit by 3 photo lamps. Even so, it was necessary to use a slow shutter speed which demanded a pose that the subject could hold.
90mm Super Angulon, ISO 50 Ektachrome (tungsten-balanced), 2¼×2¼in/6×9cm, 1sec, f8.

Tungsten and daylight
In this Bavarian painter's studio, a blue-filtered tungsten lamp was used to supplement the daylight.
65mm Super Angulon, ISO 100 Fujichrome (+ 81B filter), 2¼×2¾in/6×7cm, ¼sec, f6.3.

BRIAN GRIFFIN

Highly innovative and one of the most sought-after portrait photographers, Brian Griffin has evolved a distinctive style that makes his work easily identifiable. He sees this style as the product of hard work and constant thought.

"My day normally starts at five in the morning, and I go on until seven or eight in the evening. I'd like to think that eventually, after twenty years or whatever, all of these individual assignments will marry together as a whole body of work. I try and make all the photographs fit my overall view."

Griffin, born in 1948 in Birmingham, England, left an emerging career as a mechanical engineer to study photography at the end of the sixties.

"At college, I was not interested at all in portraiture. It wasn't something that I left college to do, and I had no strong ambitions about it. When I moved to London, though, portraiture was the first kind of work that I was given. At that point I wanted two things: freedom to take photographs independently, and to exist financially."

His early assignments for *Management Today* and similar magazines — portraits of businessmen — were successful enough to channel his work in this direction.

Having started with Leica and Olympus cameras, Griffin changed to medium-format in 1978. The initial impetus came from the record sleeve assignments that he was starting to do.

"The albums are square, so it made sense to work in a square format. I quite like seeing the picture as it will end up, so I used $2\frac{1}{4}$x$2\frac{1}{4}$in/6x6cm. This format also meant that I could use Polaroids."

The camera he started with, and continues to use, is a Hasselblad 500C/M: "It seemed the best piece of machinery,

Manolo Blahnik, shoe designer, 1979
This portrait relies on a sense of enigma, reinforced by unorthodox use of shadows. The object held up by the subject looks more like a feathered cap than a woman's shoe, as the heel is not visible. The shelves of shoe boxes offer the subtlest of clues to the theme. The dynamic pose overcomes the potentially somewhat static effect of a square format.

the engineering was good, and I needed a Polaroid back." His range of lenses is very restricted: just a 150mm Sonnar and 60mm Distagon.

Griffin's portraits are markedly strong in ideas. They are characteristically surreal in mood, and have an imaginative intensity about them. He is not interested in a casual, easy approach: considerable depth of thought goes into each picture.

"Not so much into the exposure or anything like that, but into the circumstances of the photograph. It doesn't matter how strong a photographer's ideas are, it needs the magic of the sitter – a suggestion, a thought or something that comes from the sitter, and that is so specific and incidental that the photographer would never dream of it."

Involving the sitter in the session is crucial to Griffin's approach and depends upon his ability to transmit his commitment to the subject.

"Normally, people have a very flippant attitude toward the photographer, but when I'm taking a portrait most know that they are not going to get off the hook lightly. This idea – that I'm going to be demanding – actually helps to involve the sitter more. They feel obliged to try and contribute something."

Donald Sutherland, actor, 1985

In its offbeat, unsettling quality, with unconventional use of props, this is a characteristic Griffin image. "We were in the Savoy Hotel, London, where he was staying. I said to him 'What do you want? You can have a pillow or a chair.' He answered, 'I'll take the chair,' but then suggested having it above his head instead of sitting on it." *This idea accords with Griffin's declared belief:* "I think upside-down is the right way up" *(in the "Afterword" to his book, Portraits). A low viewpoint contributes extra drama to the shot.*

BOB GOTHARD

Fashion images receive immense public exposure and influence the taste of millions. A notable exponent in this field is Bob Gothard, who is now based in the United States, although he started in the late sixties in London. *Vogue* first identified his special skill in photographing men's fashion – the work for which he now is best known.

"More than ninety per cent of my work is now on location. The reason is that I love using daylight. You get marvelous opportunities that are missing in controlled studio work – strange quirks of nature, like the sudden appearance of a late sun against almost black clouds, that make all the other problems of daylight bearable."

Gothard's locations range across virtually the whole world – in one recent year he took teams of models to both Tibet and Alaska. Apart from the need for enticing backdrops, there is a sound practical reason for such extensive travel:

"Most fashion works in six-monthly batches. In the summer we're photographing autumn and winter clothes, and in the winter we're doing summer. I have to travel to find the right weather for the season.

"Also, we need some reliability in the weather, and that usually means predictable sunlight at the beginning and end of the day. Model fees are now incredibly high, and on a typical shoot I have three models for a couple of weeks. We can't afford non-shooting days."

Although Gothard carries 35mm equipment, most of his shooting is with Hasselblads.

"Because the clothes have to figure prominently, the detail has to be there – particularly for the texture of the fabrics. The format's perfect for controlled situations on location. It's not so good for taking moving shots with models running; not even the Hasselblad 500ELX really allows this.

"As to why a Hasselblad, well, when I started there wasn't much choice. There was the twin-lens Rollei, but that was out because its film back and lenses were fixed. The Bronica was an alternative, but the Hasselblad had the reputation for being trustworthy. In the 23 years of being professional, the only reason I've had to buy new ones is when I've had cameras stolen."

Gothard's traveling kit begins with two 500ELX bodies, a 500C/M body as a backup in case of problems, four film magazines and a Polaroid back. Lenses range from the standard 80mm, through the 120mm, 150mm (his favorite portrait lens), 250mm and 500mm.

"I hate wide-angle lenses and the distortion they give. When I started professionally, the wide-angle shot was always a gimmick. And I still don't like it. As far as I'm concerned, the longer the better. It's just a pity that Hasselblad don't make a wide-aperture long lens; the 500mm is f8 – you can imagine the problems with that."

On location

"This image is from a shoot in Barbados for a chain of high-street department stores – a case of having to fly somewhere warm and sunny in the winter to do summer fashions. One of my essential pieces of equipment is a color meter, which I always use. The clothes have to be the right color, and while I prefer shooting with a low sun because of the quality of light, the orange cast is often not what I want, however attractive it may look in many situations. Here, the meter showed that I needed to add an 80C blue filter. The setting, incidentally, was the men's toilet at the back of a beach bar."

250mm Sonnar, ISO 100 Ektachrome.

In the studio

"In this studio shot the backdrop is plain white paper, lit with four flash heads, each with a brolly, to create the brilliance. I wanted a floor-level shot with the camera almost on the ground. This meant laying down a sheet of white Plexiglas – it's impossible to get white paper on the floor looking clean and texture-free. The girl is lit by a single brolly and a large silver reflector lying flat on the floor in front of her. I like using lots of reflectors to soften shadows on the underparts of the face. To get the perspective I used a 250mm lens, and that meant a big studio."

250mm Sonnar, ISO 100 Ektachrome, 1/250sec, f11.

MITCH EPSTEIN

Mitch Epstein began in the late 1970s, studying at Cooper Union in New York, under the formative influence of the notable street-life photographer, Gary Winogrand.

"I discovered New York and photography at the same time. Studying under Gary meant that I saw a lot of the city's street life as I worked. At the time I was using a 35mm Leica camera and working with Kodachrome: this was an exciting and educative way to work. The resolution and intensity of Kodachrome was an integral part of the way I saw New York."

At the same time, Epstein studied photography through the medium of prints. Virtually all the great work had been done in black-and-white, and this formed the bulk of the archive collections, such as that of the Museum of Modern Art. He was gradually drawn more to the print as the final medium:

"As beautiful as a projected slide is, when I started to make prints from the transparencies, I found that I read them differently. When you have a print, you can get your eye up to it, and examine it in detail. After a couple of years I moved to medium-format color negative. There was a combined technical and esthetic motivation to change: I wanted to produce prints, and needed the inherent exposure latitude of a negative, yet I had become accustomed to Kodachrome's high resolution. At the time, 35mm color negative film was by no means as sharp, and the only way to achieve this quality was to move a step up, as I saw it, to a larger size."

However, there was no proprietary make of camera then available that fitted Epstein's specifications, although these were simple enough – he needed a medium-format range-finder camera that could be used at eye-level. His first camera was custom-made: a $2\frac{1}{4}\times3\frac{1}{4}$in/6x9cm adaptation of parts from the Mamiya Press, called the Siciliano.

"All of a sudden, I had a much greater range of detail and description in my pictures, and initially it changed my photography. I could not work as quickly as I had with the Leica, but I now had sufficient image quality – and had overcome the technical problems of highlight and shadow because of the greater latitude."

After the Siciliano came another custom-made camera, the Palm Press, which incorporated better lenses. Although Epstein continues to use $2\frac{1}{4}\times3\frac{1}{4}$in/6x9cm viewfinder cameras, he has moved on to a rangefinder model.

"The real problem with custom-made cameras is that they are not made for extremely precise work. There is no rangefinder, and the viewfinder is on top of the camera, which is fine with a wide-angle lens like the 65mm I have, but causes focusing problems in close-up or with a normal lens – then, you are into guesswork. I still use the Palm Press for wide-angle photographs, but now, more and more, I use a Fujica 690."

Carnival queen, Trinidad, 1987
Epstein no longer thinks consciously about the lighting and other technical details while shooting; his technique is instinctive. This photograph, taken during a break in the annual children's mini-carnival in Port of Spain, was framed so that the colorful fan formed a frame within the frame. The fast film enabled him to arrest movement while maintaining adequate depth of field.
ISO 400 Fujicolor, $2\frac{1}{4}\times3\frac{1}{4}$in/6x9cm.

Quayside, St George's, 1987
This shot of a small boy
preparing some bait was
taken on an evening walk
along the waterfront. The
shafts of light highlight the
fish, drawing the eye
downward. Close framing,
cropping off the boy's
shoulder and the top of his
head, has given the image a
dynamic quality,
strengthened by the
diagonals. The quality of the
evening light has been
caught superbly on
Fujicolor.
ISO 100 Fujicolor, $2\frac{1}{4} \times 3\frac{1}{4}$in/
6×9cm.

ARCHITECTURE

In architectural photography the aim is usually twofold: to make an attractive composition, whether a broad view or a detail, and to record a significant aspect of the building's character. It is not essential to have a background knowledge of the structure's history or style of architecture, but this certainly helps. Otherwise you can easily miss some of the more important features. On one occasion, for the sake of authenticity, it was necessary to reshoot a 1660 Colonial house in New England because anachronistic drapes were visible in the original photograph.

Any building, in its construction and detailing, reflects a mixture of social history, climate, available materials, engineering principles, fashion, and quality of design and workmanship. What makes architecture so interesting to photograph is the interplay between these influences.

The style, proportions and function of a building will often suggest a particular approach to composition. Massive monumental architecture, for example, is suited to dramatic treatment that emphasizes its impact – perhaps with a low camera angle, or strong lighting. Modern buildings often call for an abstract approach, with elements of pattern and geometry. The highly functional, undecorated buildings of America's 19th-century Shaker communities reflect a belief in order, simplicity and asceticism; I composed the photograph on page 189 with this in mind.

A sense of drama
A close, wide-angle view with the camera tilted strongly upward gives massive presence to the cylindrical glass towers of the Los Angeles Bonaventure Hotel. The traditional concern in architectural photography is to keep the vertical lines of a building parallel. However, this rule can often be overturned to dramatic effect especially when photographing modern cityscapes.
65mm Super Angulon, ISO 64 Ektachrome, $2\frac{1}{4}$x$3\frac{1}{4}$in/ 6x9cm (cropped), $\frac{1}{125}$sec, f9.

TECHNIQUE

Architecture is probably the subject that makes most call on lens shifts (page 89). Although there are times when a wide-angle lens aimed upward can create a dramatic image, there are many more occasions when the straight sides of a building ought to stay straight in the picture. As most of the available camera positions are at ground level, the only alternative to tilting the camera is shifting the lens. Take care to avoid just a slight convergence: strong, definite convergence at least looks intentional.

Rarely is the opportunity available to illuminate a building specially for a photograph – although this could be achieved with sufficient preparation and the finances to hire many high-power lights. With some buildings, the normal flood-lighting is worth considering: this can isolate the building from unattractive surroundings. Normally, however, the only choice is over time of day and weather.

When there is sunlight, certain times of day are likely to favor the building, and to discover these you will have to visit the site in advance. There may, for example, be a half-hour when the sun just grazes the facade, picking out interesting details of relief. But strong contrast can be a problem. Take a spot meter reading of the lightest and darkest parts of the scene, then determine whether the brightness range is greater than the exposure tolerance of your film. If so, filled-in shadows are normally more acceptable than bleached highlights.

Parallel sides
A bellows camera was used with vertical shift to keep the sides of this Federal house in Massachusetts, USA, precisely parallel, in a shot from a low viewpoint. The crisp early morning light creates high contrast between the white building and sky. The exposure was judged by an incident light reading taken with a hand-held meter.
65mm Super Angulon (on a Sinar Handy camera), ISO 64 Kodachrome, $2\frac{1}{4}$x$3\frac{1}{4}$in/6x9cm.

Squares of light (above)
*These Shaker buildings
in Kentucky were
photographed in winter,
about 45 minutes after
sunset. The interior light
levels were boosted by
3,200k photographic lamps.
A 20B blue filter enhanced
the wintry feeling.*
90mm Super Angulon, ISO
100 Fujichrome, $2\frac{1}{4} \times 3\frac{1}{4}$in/
6x9cm (cropped), 3sec, f8.

Sunlight and shadow (left)
*Raking evening light reveals
the studded horseshoes on a
gate in the abandoned
Indian city of Fatehpur-Sikri.
Such high contrast scenes
require careful metering.*
250mm Sonnar, ISO 50
Agfachrome, $2\frac{1}{4} \times 2\frac{1}{4}$in/6x6cm

COMPOSITION

Although it is tempting to start shooting immediately on arrival, a period of quiet, pre-camera thought is always repaid. Once you have a clear idea of the priorities of the architecture, your approach – what features to stress, the composition, the style of lighting, the most suitable format – will often fall naturally into place.

By their very nature, architectural subjects tend to offer a restricted choice of views – more so than with most landscapes. Many buildings are designed to look their best from just one or two approaches. If you allow enough time to walk around and observe, camera viewpoints will usually suggest themselves. However, the choice is not so easy when a building has been photographed so many times before that there is a need to do something different. One way is to concentrate on details – for example, the textures of brick, stone or timber, which roll-film can record in great depth. Another is to choose unusual lighting conditions, especially at dawn and dusk.

For a study of a single building, the final composition will be a permutation of lens choice and framing. The most conventional approach would be a frame-filling shot, with a narrow space around the building to locate it comfortably. However, the possibilities range from a cropped-in detail to an environmental view that shows the surrounding landscape or cityscape. If there is only one available viewpoint – say, a nearby rise of ground – then the only way to vary the composition will be to alter the focal length of the lens.

Checking all the possible combinations of lens, camera position and view can take some time, but may deliver an unexpectedly good shot. If you have difficulty in seeing where the more distant viewpoints might be, stand close to the building and see what accessible points are visible from there: these might include, for example, an upper window of another building.

To convey a sense of scale, a common practice is to include a human figure in the shot. This works best when the figure is kept small in the frame and is not distractingly colorful.

Architecture offers plenty of opportunities for compositional frames – pillars, window openings, arches and other features that can be used to convey a sense of depth or obscure unwanted details. To prevent frames from distracting attention from the main subject, either choose ones that are fairly simple, or expose to keep them in shadow.

One way to remove crowds of people and traffic from the foreground of a picture is to use a long exposure of many seconds, so that moving elements record only as a faint blur. Even using the smallest aperture, it may still be necessary to fit a neutral density filter to reduce the amount of light entering the lens. This technique works best with black-and-white film: on color film the extra-long exposure will cause a color shift due to reciprocity failure.

House and garden (right)
The combination of the diagonal view and the use of shadow emphasizes the volume of the building.
ISO 64 Kodachrome
$2\frac{1}{4} \times 3\frac{1}{4}$in/6x9cm.

Architectural groups (below)
The rooftops of this northern Thai temple complex just catch the last light from the setting sun. The site was visited earlier in the afternoon to see how the sun's angle would change, and the photograph planned for the evening.
65mm Super Angulon (on a Sinar Handy camera), ISO 64 Kodachrome, $2\frac{1}{4} \times 4\frac{1}{2}$in/6x12cm, $\frac{1}{8}$sec, f11.

INTERIORS

Mostly, our idea of a room is built up from walking around it and looking in all directions – a kind of composite wide-angle view. Showing the whole room in a single photograph is not possible, but the standard procedure of using a wide-angle lens from one corner is an attempt to come as close as possible to this. As an approach to interior photography, this is efficient, although stereotyped. In larger rooms it may be more rewarding to concentrate on specific features, emphasizing texture and detail – not neglecting the staircase.

The height and importance (that is, the decorative character) of the ceiling usually helps to determine the format and framing. In most domestic interiors, the ceiling is low and there is sufficient detail at coffee-table level to fill the lower part of the frame naturally. To include a high ceiling, a vertical frame may be best; and if the camera or lens has a rising front, it may be necessary to shift the lens upward (page 89).

In lighting an interior, the first decision is whether or not to include natural daylight through windows and doorways. When the sun is bright and contrast high, it may be best to hang a white sheet or some tracing paper across the outside of the windows. Reflectors may have to be used to lighten

Upward shift
Shifting the lens upward has brought the moulded ceiling into view without having to angle the camera. This increases the depth of the shot.

BOUNCED LIGHTING
Normally, avoid shining a photo lamp directly into the room, or it will create too harsh an effect. Instead, bounce it off a pale wall or ceiling or a large sheet of cardboard. When using a tungsten lamp, make sure that it is not so close as to burn the reflecting surface.

shadow areas. Photographic lights can be used to supplement daylight, either to boost the overall light level or, bounced off a wall or sheet of pale cardboard, to fill in shadows.

At dusk or at night, attractive use can be made of the room's own tungsten lighting. Chandeliers and other decorative forms of light can look inviting. When the lighting is mixed, the colors of the different light sources must normally be balanced in some way if you want to create a realistic effect – for example, you can replace household light bulbs with blue tinted light bulbs to match the daylight in the scene, or alternatively you can shoot on tungsten film and place sheets of orange plastic (the same color as an 85B filter) over the windows. To measure the color of the various light sources, a color meter is a useful, if expensive, accessory.

A graphic view
Stairs in a Shaker building in Pleasant Hill, Kentucky, needed a viewpoint that would reveal the flowing line. A 38mm lens provides adequate depth of field at the smallest aperture. Two tungsten photo lamps off-picture were covered with blue gels to match diffused daylight from the window. 38mm Biogon, f22.

As an indulgence, this is my own portfolio of architecture. I am not at all exclusively an architectural photographer, and this has given me more choice over assignments than a strict specialist would perhaps have. I prefer complex projects where there is plenty of time to think about the approach in detail.

Thus far into the book there is little to add about the way I work, except to stress the emphasis I place on planning. Unpacking the equipment initiates a familiar momentum, and for any professional there is a risk of following a predetermined pattern without really thinking – setting up the camera in an obvious position, fitting the usual lens, and so on. Habit is insidious, the more so with a subject such as architecture, whose dimensions, inside and outside, are often fairly similar from one building to another.

I have become used to switching from one type of camera to another, and regularly use the whole range from 35mm to a view camera. By choice, on the kind of assignment that has no baggage restrictions, I carry almost everything: 4x5in/10x12.5cm sheet film for the major shots that can be planned at leisure, 35mm for occasional quick details and photographs that need a long telephoto, and roll-film for the remainder.

For me, medium-format has two particular advantages over sheet film. One is that it is much quicker to use, so I find it has special value in changing light and when I need to cover a range of options quickly – such as several viewpoints in succession. The second is more recent, and something of a personal quirk: it enables me to use Kodachrome. I hesitate to recommend this emulsion unreservedly, as there are many fine alternatives that other photographers prefer. Nevertheless, I have a special affection for this classic reversal film and it influences my choice of equipment.

Initially, I worked with a Hasselblad – the first camera I used professionally. I had a 500C/M body with an 80mm Planar and 250mm Sonnar lens; but, as it turned out, the most useful equipment of all was a 38mm Superwide – the earlier version of the Hasselblad SWC/M described on pages 78–79. Its Zeiss Biogon lens was of such exceptional quality that the inconveniences of non-reflex viewing and lack of a shift mechanism were acceptable. The viewing problem was solved by using a focusing screen adapter and locking the lens open; as I always used a tripod, this was not such a chore. The lack of a shift to avoid converging verticals was more serious, but at least taught me to work harder at composition.

More recently I have been using a 2¼x3¼in/6x9cm Horseman roll-film back on a Sinar Handy view camera with a 60mm lens. One benefit of this is a weight reduction: I need only one body for roll-film and sheet film. The Handy has a standard helical focusing mount for its lenses – less awkward than a bellows – and a shift mechanism, which is rapid in use.

The Bank of England
Long before the first workers arrive in London's financial district, the facade of the Bank of England is at its most attractive as a summer sunrise throws the columns and statues into sharp relief. When photographing architecture at the beginning or end of the day, timing is the critical ingredient. The foreground pillar adds a sense of depth. 90mm Super Angulon, ISO 64 Ektachrome, 2¼x2¾in/ 6x7cm, 1sec, f32.

Shaker houses
This is an example of light and weather suggesting the photograph: the opposite of the usual planned approach in architectural photography. Clearing fog over a Shaker village in Maine creates a strange atmosphere, simplifying the image to complement the austere style of the buildings. This shot would not have worked in more normal lighting.
65mm Super Angulon (on a Sinar Handy 4x5in/ 10x12.5cm camera), ISO 100 Fujichrome, $2\frac{1}{4} \times 3\frac{1}{4}$in/6x9cm (cropped), $\frac{1}{2}$sec, f32.

STILL-LIFE

The still-life is the classic form of controlled photography. The subject is static and uniquely manipulable. There is time to plan every aspect of the shot, from the choice of background and props to the lighting.

A typical still-life can take a surprising amount of time to prepare—many hours in the case of a complicated advertising shot. With the camera on a tripod, you can build up the composition by stages with careful deliberation, adjusting and experimenting as you go.

The generous focusing screen of a medium-format camera is a major help in composition. A single detail that sounds a wrong note — such as a bruise on fruit, or a fingermark on a shiny surface — can sabotage the total effect, so you should closely scrutinize the objects themselves first. On a large print, the precise rendering of detail possible with roll-film can make such tiny flaws embarrassingly obtrusive. For close-ups, medium-format cameras with extendable bellows, such as the Mamiya RB67/RZ67 and Rollei SL66SE/SL66X, are the ideal choice, avoiding the need for attachments.

Professionally, still-life is a field dominated by advertising and commercial product shots, but the scope is obviously much wider than this. You can photograph the rare and beautiful or, with equal success, create a striking image from objects that are perfectly commonplace.

The portfolio of images by Luca Invernizzi Tettoni on pages 198–201 shows how the basic principles of still-life photography can be applied to the realm of sculpture and the fine arts.

Clarity and contrast
Simplicity and lack of
contrivance are qualities
easily overlooked in still-life
photography. In this image
of a sword and belt, in the
National Museum of
American History,
background, lighting and
composition were chosen
for maximum clarity. Black
velvet and a large area light,
reflected in the bright metal
and braid, combine to
create a rich contrast.
150mm Symmar, ISO 64
Ektachrome, $2\frac{1}{4} \times 2\frac{3}{4}$ in/6×7cm,
f32.

COMPOSITION

At its most straightforward, a still-life is simply a document, with the object or objects reproduced as clearly as possible – well-lit, well-focused, and with no attempt at the unusual. Although this approach might sound unimaginative, the ability to make a clear, elegant image is the basic craft of still-life photography. Once you have mastered the fundamentals, you can go on to develop a freer style.

Although the choice of backgrounds is enormous, few are unobtrusive, allowing the subject to stand out clearly. White and black are the simplest choices. The blackest material is black velvet, whose fine hairs absorb maximum light. While black is invariable, white can be lit in different ways to create all kinds of shading. Thick white paper will suffice, but it is easily marked and creased. More durable and smoother are plastic and Formica. Flexible sheets of these materials can be wiped clean, and have the additional advantage of bending in a smooth curve to form a seamless backdrop; overhead lighting gives this an even shading of neutral tone, as in the sundial image (right). To produce a brilliant white background, backlighting is necessary (page 195).

Filling the frame
In this daylight shot, vegetables are placed in context by old kitchen utensils and a wooden surface, evoking a 19th-century feel. The blackness of the objects ensures that they do not distract attention from the vegetables themselves. For maximum depth of field the lens was stopped down to its smallest aperture. This required a long exposure, and a filter to avoid reciprocity failure.
150mm, ISO 50 Ektachrome (type B – with 85B filter), 2¼×2¾in/6×7cm, 40sec, f32.

The limbo effect
A white Formica sheet curved gently upward creates a horizonless background, as if the subject were floating in limbo. In this view of a sundial the shading effect is created by a diffused flash head above the subject.
150mm, ISO 64 Ektachrome, $2\frac{1}{4} \times 2\frac{1}{4}$in/6x6cm, f32.

Plain black
A black velvet background has been used in this shot to focus all the attention on the richness of the gold plate. The flash lighting was bounced off the ceiling to avoid bright reflections in the shiny metal.
150mm, ISO 64 Ektachrome, $2\frac{1}{4} \times 2\frac{1}{4}$in/6x6cm, f22.

LIGHTING

For many still-life photographers, the greatest challenge is that of imagining and then putting into practice a lighting scheme over which there is total control. Such freedom can be inhibiting at first.

The ideal flash unit is line-powered and has an output high enough to allow working apertures of around f22, when diffused. (Small portable flash units are too weak for this.) For a table-size still-life set, a 500 to 800 joule unit would be sufficient. The most common type of fitting for a flash head is a box-like area light, fronted with a translucent screen of plastic or fabric: this produces a directional light, but with softened shadows. Other fittings include snoots and spots for a concentrated beam, strip lights for background, and barndoors for shading selected areas.

Bright, shiny surfaces can be a problem, as they reflect their surroundings — including the light source. However, if you use an area light, its reflections will be an attractive broad patch rather than a distracting bright point. When shooting a small object you can sometimes surround it with a cylinder or cone of tracing paper and direct the light through this.

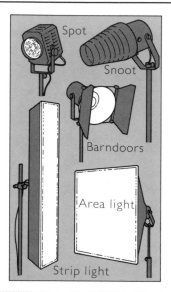

Spot
Snoot
Barndoors
Area light
Strip light

Textured light
On occasions, daylight indoors may have certain qualities that are extremely difficult to reproduce with studio lamps. In this picture, the high contrast was softened by the addition of a blue-filtered 1,100 watt studio lamp. A tungsten-balanced film, corrected to daylight with an 85B filter, was used to avoid a long exposure which would have caused a color shift.
ISO 50 Ektachrome,
2¼×3¼in/6×9cm, 5sec, f22.

Shiny surfaces

For this picture of pre-Columbian gold nose pieces, an area light (flash head with large diffuser) was positioned overhead so that its reflection was caught by the objects. The rough stone background was chosen for a contrast in texture. 80mm Planar (+ 21mm extension), ISO 64 Ektachrome, $2\frac{1}{4}\times2\frac{1}{4}$in/6×6cm.

Defining glass objects

Sheets of black cardboard at either side of this drinking glass, just out of view, were used to give emphasis to its curved edges. The backdrop is backlit milky Plexiglas. 150mm, ISO 64 Ektachrome, $2\frac{1}{4}\times2\frac{1}{4}$in/6×6cm (cropped), f32.

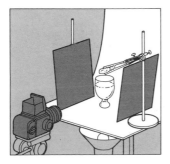

CLOSE-UP

Many still-life sets are relatively small, and border on close-up work. When, to focus close, the lens has to be moved so far from the film that the film receives significantly less light, the question of exposure compensation arises. This is where close-up photography starts.

A normal lens with a focusing system in the barrel will not extend sufficiently far forward to focus on subjects less than two or three feet ($\frac{1}{2}$-1m) away. So, cameras like the Hasselblads need attachments for close-up work. Supplementary lenses, that fit on the prime lens like a filter, are one possibility, but they allow only a modest magnification. The alternatives are extension tubes and extension bellows. Cameras like the Mamiya RB67 and RZ67 and the Rollei 66 focus using a rack-and-pinion system, and thus have built-in bellows, offering a respectable magnification without attachments.

If the camera has through-the-lens (TTL) metering, the exposure meter will automatically compensate for the light loss. If you are using flash, cameras with TTL off-the-film flash metering will make the same compensation; however, such cameras, including the Hasselblad 500 ELX, will work only with dedicated portable units. With mains flash you need to calculate the exposure increase, according to the following formula: exposure increase = ((lens focal length + extension) ÷ lens focal length)2. Use the table (right) to convert this figure to extra f-stops.

EXPOSURE INCREASE	EXTRA f-STOPS
1.2	$\frac{1}{3}$
1.4	$\frac{1}{2}$
1.7	$\frac{2}{3}$
2	1
2.3	$1\frac{1}{3}$
2.6	$1\frac{1}{3}$
3	$1\frac{1}{2}$
3.2	$1\frac{1}{2}$
3.6	$1\frac{2}{3}$
4	2
5	$2\frac{1}{3}$
6	$2\frac{1}{2}$
7	$2\frac{2}{3}$
8	3
9	$3\frac{1}{3}$
10	$3\frac{1}{3}$

Exposure compensation
A single photoflood, diffused through a sheet of tracing paper, was used to light this close-up of a World War I medal and aerial photograph. An 80mm lens, extended by 5$\frac{1}{2}$in/14cm, called for a lens-to-subject distance of 3$\frac{3}{8}$in/8.5cm. The exposure was calculated by using a TTL reading, then adding the necessary compensation – an additional 2$\frac{1}{2}$ f-stops.
80mm (+ 14mm extension), ISO 50 Ektachrome (type B), 2$\frac{1}{4}$x2$\frac{1}{4}$in/6x6cm, 1sec, f22.

Lens-to-subject distance
A gold hog worked into the vellum cover of an old book created a lighting problem typical of shiny surfaces. It needed to be lit by reflection (page 194), yet the working distance with a standard lens didn't allow room for the light. Instead, a longer focal length was used.
150mm (+ bellows extension), ISO 64 Ektachrome, 2¼×2¼in/6×6cm.

Supplementary lenses
For moderate close-ups, supplementary lenses can give sufficient magnification, and need virtually no compensation. In this shot of a pocket watch, a Proxar 1.0 and 0.5 were combined and added to a standard Hasselblad lens. With supplementary lenses, it is important to stop down in order to avoid loss of definition at the edges.
80mm (+ Proxar 1.0 and 0.5 supplementary lenses), ISO 64 Ektachrome, 2¼×2¼in/6×6cm, f16.

LUCA INVERNIZZI TETTONI

Tettoni's career as fine arts photographer started in northern Italy in 1968. He moved to Indonesia in 1978, and two years later to Bangkok, where he continues to be based. Although annual reports and advertising feature strongly in his professional work, his first love remains sculpture and archeology and he is the leading modern photographer of Southeast Asian arts.

"For me, one of the attractions of this region and its artistic styles is its manageable size. Thinking about, say, Javanese or Thai art, it's just possible to keep a mental picture of how cultures and styles interlock and succeed each other. Also, there are still many new and exciting treasures being found and many monuments in spectacular locations, like the Gedung Songo complex surrounded by volcanoes."

Tettoni's deep interest in fine arts is reflected in his working method, which begins with books rather than a camera.

"If you're to make a photograph that has any value, you must have some idea of what the piece is about. You also need to come to some personal opinion about what is beautiful and what is not, in order to select the pieces worth photographing. I believe the beauty of an antique object is often the result of the combined action of man and nature, which means that it may have been beautiful when built and ugly now. Weathering takes its toll, and people too. Some of the most venerated Buddhas in Mandalay have a halo of flashing disco lights."

Tettoni uses a Pentax 6x7, and has done so since 1979, when it succeeded a 6x6 Japanese Kowa of pensionable age.

"Most of my work was already on medium-format, which is large enough to sell well, but convenient enough to carry around in locations that are sometimes a little primitive. Of course, you would like to have your Tirukkalukkunram temple on 8x10in/20.5x25.5cm, but when you set up all that equipment in India, people think you are shooting a movie, and thousands come out of the woods to wait for the actress.

"The Pentax is still unchanged in all its basic features, which is an advantage. Structurally, it's very basic, and that's the main reason why I prefer it. In any case, it does not pay to have a European camera in this part of the world – there are very few spare parts and nobody here can repair a Hasselblad or Rollei with any confidence.

"The Pentax's two weakest points are the film advance lever, which is subject to a lot of stress (especially if you use 220 film), and the diaphragm pin, which can break without your knowing it. The lenses, on the other hand, are one of its strengths – a wide range, and simple in construction, without leaf shutters. The lenses I use most are the 105mm macro (the most useful for sculpture, although not so good with light backgrounds because of flare), standard 90mm, wide-angle 55mm and a 300mm telephoto."

Stone head
"This sandstone head from Wat Mahathat, Thailand, is in the Lopburi style. It's now in Thailand's National Museum. The Khmer influence is very strong; this is a piece with powerful, masculine features. To do justice to this, I felt that it needed hard lighting and distinct contrast, and chose a single Bowens flash head, fitted with a snoot. The light position is quite high and almost opposite the camera, with the macro lens carefully shaded. On this format, I needed a minimum f16 for the depth of field, so four flashes were needed."
Pentax 6x7, 105mm macro lens.

Cave temple

"The Chiang Dao caves, in northern Thailand, are located along the road from Chiangmai to Fang, and were transformed into a temple more than 200 years ago. Although they are in Thailand, most of the Buddha statues have a distinctive Burmese-Shan character. Burmese wood merchants often paid for the creation of this kind of cave temple, in an attempt to appease the forest spirits that they had displaced when cutting down trees. With the shutter held open, I used a combination of existing light filtering through the ceiling and multiple flashes from a portable flash head: to fire these flashes I positioned myself behind each of the Buddhas in turn. Apart from this, the most important light, for the general effect of the photograph, was from the candles."
Pentax 6x7, 55mm lens.

201

GLOSSARY

Angle of view
The angle over which a lens accepts light. The longer the focal length of the lens, the narrower its angle of view.

Bellows
A light-tight extending sleeve set between the lens and the camera body which is used on cameras where the lens moves relative to the film.

Between-the-lens shutter
see LEAF SHUTTER

Bleach
A chemical bath used in color processing to convert the black metallic silver that forms a photographic image into a compound such as silver halide, which can then be dissolved or dyed.

Blix
A combination of BLEACH and FIXER used to shorten color processing.

Chromatic aberration
The inability of a lens to focus the light from a single source, but of different wavelengths, on the same point.

Color-balancing filters
Filters used to adjust the color balance of light entering the lens when it differs radically from the COLOR TEMPERATURE for which the film is designed. These filters are often used to convert tungsten-balanced film for use in daylight and vice versa. In the first case an 85B filter is used, in the second an 80A.

Color temperature
Term used to describe the color quality – particularly the redness or blueness – of a light source. Color temperature is measured

with a special meter and is expressed in Kelvins (K).

Curvature of field
A lens aberration in which the image of a flat subject at right angles to the lens is formed on a curved plane of focus. The phenomenon is reduced by stopping down.

Dark slide
A metal sheet which is slid between the back of the camera and the film back to prevent fogging of the film when the magazine is detached.

Depth of field
The zone of acceptable sharpness in a picture. Depth of field is determined by three variables: the size of the aperture, the lens-to-subject distance and the focal length of the lens.

Developer
A solution used to convert a latent image on an exposed photographic material into a visible image.

Diopter
The unit used to measure the power of a lens. It is the reciprocal of the focal length. The power of a converging lens is positive, while that of a diverging lens is negative.

Exposure latitude
The extent to which a light-sensitive material can be over- or underexposed and, with normal processing, still provide an acceptable result.

Exposure value
A system of values, often referred to as EV, in which each EV is used to relate aperture/speed combinations that permit a specified amount of light to reach the film.

Fill-in
Additional illumination used to supplement the principal light source and brighten shadows.

Fixer
A chemical bath used to render a photographic image stable after development.

Focal-plane shutter
A shutter comprising two blinds situated immediately in front of the camera's focal plane. The parted blinds move together across the focal plane at a fixed speed to expose the film, the gap between them determining the length of the exposure.

Focusing hood
A light-proof device used to prevent extraneous light from falling on the focusing screen.

f number
A number used to express the maximum aperture of a lens in relation to its focal length. It is calculated by dividing the focal length of the lens by the effective diameter of the aperture.

Graduated filter
Filter with a clear section and a tinted area, the intensity of the latter decreasing toward the center of the filter. It can be used to introduce stronger color into part of a scene – a sky, for example – or to reduce the color contrast between different areas of the image.

Hyperfocal point
The nearest point to the camera which, with the lens focused on infinity, is acceptably sharp. With the lens focused on this point,

depth of field extends from infinity to a point halfway between the camera and the hyperfocal point.

Incident-light reading
The measurement by an exposure meter of the light that falls on the subject, as distinct from that which is reflected from it. For such a reading, the meter is pointed from the subject toward the camera.

Large-format camera
Generic term for any camera with a 4x5in/10x12cm format or larger.

Leaf shutter
A shutter situated in a compound lens, normally close to the iris diaphragm. Also known as a bladed or between-the-lens shutter.

Neutral density filter
A gray filter used to reduce the amount of light entering the camera.

Open flash
Firing the flash with the shutter held open at the "B" setting to allow repeated flashes.

Optical axis
An imaginary line through the center of a lens.

OTF flash metering
A method of determining the required amount of flash illumination in which an in-camera electronic device calculates the amount of light reflected "off-the-film" surface.

Pentaprism
A five-sided silvered prism employed to correct in the viewfinder the lateral reversal of the image produced by the lens.

Push-processing
Extending development time, usually to compensate for underexposure caused by the film having been uprated to permit a faster shutter speed than the light allowed.

Rack-and-pinion focusing
A mechanical focusing system in which a knob or wheel is turned to move the lens relative to the film.

Reflected-light reading
The measurement by a light meter of the amount of light reflected from a subject, as distinct from that falling on it. TTL METERS use reflected-light readings.

Resolution
The degree to which a lens or a photographic emulsion can reproduce fine subject detail, usually expressed in terms of the number of lines per millimeter that are clearly recorded.

Ring flash
A ring-shaped flash unit used on the front of a lens to provide even, frontal illumination in close-ups.

Stop bath
A weak acidic solution used in processing between the DEVELOPER and the FIXER. It halts development and neutralizes the alkaline developer, so preventing it from lowering the acidity of the fixer.

Supplementary lens
A simple lens that fits over the main lens to alter the focal length, usually for close subjects.

TTL metering
"Through-the-lens" metering, in which light-sensitive cells in the camera register the intensity of image-forming light that passes through the lens. The various systems meter the light in different ways. Usually the whole picture area is metered but with a "center-weighted" bias; or an "averaged" reading is taken of the whole area. Some cameras use the "spot-metering" system, reading a small central area.

Teleconverter
An optical device that fits between a standard or telephoto lens and the camera to increase (usually to double or treble) the focal length of the lens and so magnify the image.

Type-A color film
Color film designed to be used with artificial lighting with a COLOR TEMPERATURE of 3,400K.

Type-B color film
Color film designed to be used with tungsten light with a COLOR TEMPERATURE of 3,200K.

Vignetting
The falling-off in illumination at the edge of an image, typically caused by very wide-angle lenses and the more evident the larger the film format. It can also be caused by a lens hood or other attachment that partially obscures the FIELD OF VIEW of the lens. Vignetting also refers to a printing technique in which the periphery of the image is made to fade out to black or white.

Wetting agent
Chemicals normally added to the final wash of film to reduce the surface tension of water remaining on it and so aid drying.

INDEX

Page numbers in **bold** type refer to main entries.

INDEX

INDEX

ACKNOWLEDGMENTS

Special thanks to Paul Bookbinder, and to Cowbell Processing. Thanks to
the following for technical information, and/or permission to use
equipment photographs: Hasselblad (UK) Ltd; Johnsons of Hendon,
distributor for Mamiya; AV Distributors (London) Ltd, distributor for
Rollei; Bronica (UK) Ltd; Fuji Professional; Pentax (UK) Ltd; George Elliot
& Sons Ltd, distributor for Exacta; Fotadvise (MEW) Ltd, distributor for
Plaubel; Linhof Professional Sales; Edric Audio Visual Ltd, distributor for
Widelux; Keith Johnson + Pelling Ltd, distributor for Horseman and
Panoscope; Studio Workshop Ltd, distributor for Sinar.

Picture credits
p.137, 138-9: Photographs by Ansel Adams. Courtesy of the Trustees of
the Ansel Adams Publishing Rights Trust. All Rights Reserved.
p.151, 152-3: Jean-Paul Ferrero/Auscape International
p.166/7, 168-9: Brian Griffin
p.171, 172-3: Bob Gothard
p.175, 176-7: Mitch Epstein
Equipment photographs: see above
All other pictures: Michael Freeman

Artwork credits
p.79, 116-119, 122-125, 184: Kuo Kang Chen
p.15, 51, 88-89, 98-99, 143, 147, 193, 194-195, 197: David Mallott
p.12-13, 17, 19, 29, 45, 73, 75, 97, 110, 120-121: Stan North
Systems charts prepared by Shaun Deal